# Eugène Atget
## 1857–1927

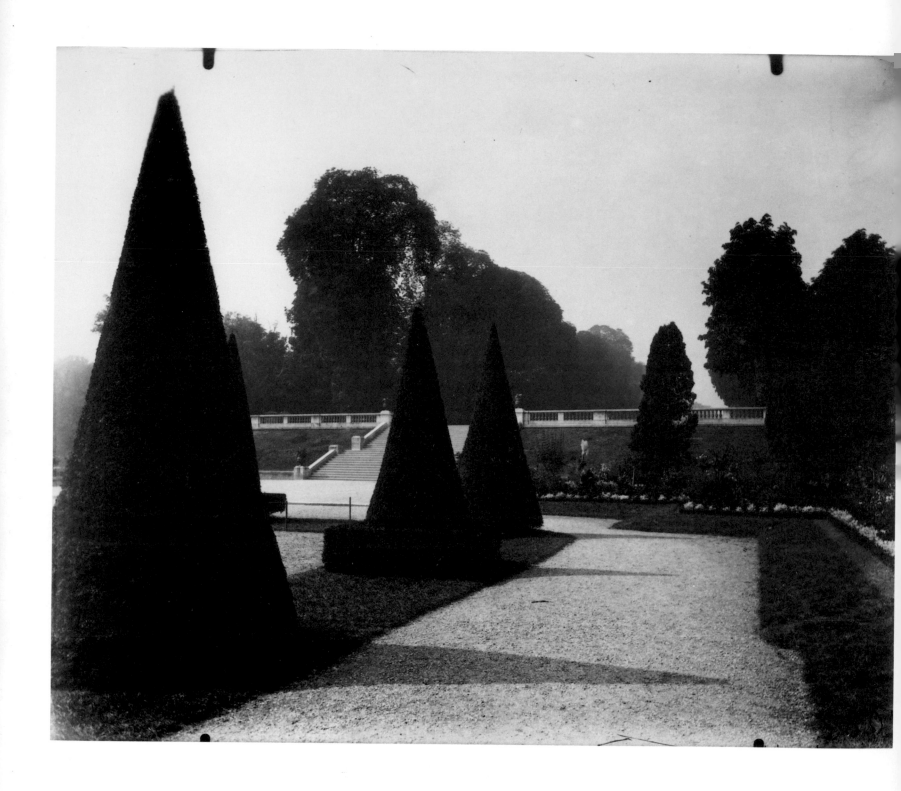

Eugène Atget
*Saint-Cloud, Park* 1921–1922
(Cat. 118)

# Eugène Atget
## 1857–1927

James Borcoman
Curator of Photographs
National Gallery of Canada

National Gallery of Canada, Ottawa, 1984

PRINTED IN CANADA

Design: Gregory Gregory Limited

*Aussi disponible en français sous le même titre.*

## Canadian Cataloguing in Publication Data

Borcoman, James          (0001-F-6580)

  Eugène Atget 1857–1927

Includes index.
Bibliography: p.
Issued also in French under title: Eugène Atget 1857–1927

ISBN   0-88884-510-3

1. Atget, Eugène, 1857–1927 – Catalogs
I. Atget, Eugène, 1857–1927
II. National Gallery of Canada

TR647 .A827 B67 1984      779'.092'4      C84-097600-3

National Museums    Musées nationaux
of Canada          du Canada

Canadä

# Contents

## Foreword

This book and the exhibition it accompanies document a significant area of the National Gallery's photography collection. Just as Eugène Atget is considered a founding father of modern photography, our holding of photographs by him is a cornerstone of our collection. Through two major purchases, the first in 1970 and a second in 1974, we were fortunate to acquire more than 100 photographs from the Museum of Modern Art's vast Atget collection, donated to them by Berenice Abbott. This group of photographs has been added to over the past decade through smaller purchases, and while not a large collection, it is remarkable for the superb quality of the prints as well as their historical range. Through the 149 photographs that now comprise the collection, it is possible to trace Atget's development as an artist from just before the turn of the century up to the final years before his death in 1927.

The National Gallery first organized this exhibition for showing in Ottawa in the summer of 1982. In keeping with the National Gallery's long tradition of circulating major exhibitions based on its collections to other galleries and museums in Canada, the exhibition is now being shown in Hamilton, Victoria, and Calgary. We are proud to have this important collection seen outside of Ottawa and to have it accompanied by this publication, which documents the National Gallery's complete collection of photographs by Eugène Atget and places the artist in a historical context.

We are grateful to Jim Borcoman, Curator of Photography, for his care of and attention to the Atget material – a concern clearly reflected in this publication.

Special acknowledgement is due to the Glenbow Museum in Calgary and its Director, Duncan Cameron, who provided encouragement for both the circulating exhibition and this book.

Joseph Martin
*Director*
*National Gallery of Canada*

## Preface

The present book is the result of an exhibition held at the National Gallery in the summer and early autumn of 1982. Although not designed as a catalogue of the exhibition, it does follow its theme: an investigation of Atget's work, his style, and his photographic antecedents. It has been the custom to show Atget in isolation. The representation of nineteenth-century French photography in the National Gallery's collection leads quite naturally to looking at Atget in the larger context, particularly that of the evolution of French photography from its beginning. That Atget was both a continuation of a tradition as well as an innovator becomes apparent when he is seen in relation to the founding fathers of French photography such as Hippolyte Bayard, Charles Nègre, Gustave Le Gray, Édouard Baldus, Charles Marville, Henri Le Secq, the Bisson brothers, along with later practitioners such as É. Durandelle, J. Andrieu, P. Émonds, and Jules-César Robuchon, among others.

The National Gallery owes a special debt of gratitude to John Szarkowski, Director of the Department of Photography, Museum of Modern Art, New York, for his sympathetic support and encouragement, enabling the Gallery to build one of the most important collections of Atget's work in North America. Without his help the National Gallery's exhibition would have been impossible.

Although Atget has been described as one of the most important photographers of the twentieth century, few books have been written about him. Berenice Abbott's *The World of Atget*, which appeared in 1964, was the first to treat him as a serious artist. Jean Leroy's *Atget: Magicien du vieux Paris*, published in 1975, gave more information about his life than had been previously available. But it is to the still incomplete four-volume publication, *The World of Atget*, begun in 1981 and authored by John Szarkowski and Maria Morris Hambourg, that the reader must turn for an authoritative scholarly study of the life of Atget.

Future writers on Atget will forever be in their debt. Maria Hambourg's extensive research has unearthed information about Atget hitherto unavailable to the public. The knowledge and insights of both authors have added dimensions to our understanding of Atget.

I am indebted to Maria Hambourg, as well as to Jean Leroy, for much of the biographical information in this book. With this in mind, the only possible excuse for another book on Atget, at this point in time, lies in my attempt to fill out the context in which he lived and by which he was formed, and to situate him in the mainstream of nineteenth-century French photography. The two interpretive chapters of the book, personal though they are, may provide a key to making Atget's work more accessible and more meaningful to the reader. Should this happen, then the book will have served the most important purpose of all. In practical terms, the catalogue at the end of the book provides the reader with its most useful contribution – an illustrated listing of the National Gallery's complete Atget holdings. Jacques Hillairet, *Dictionnaire historique des rues de Paris*, Paris: Les Éditions de Minuit, 1964, has been an invaluable aid in compiling the information for the descriptive notes in the Paris section of the Catalogue, as has François Souchal, *French Sculptors of the 17th and 18th Centuries*, Oxford: Cassirer, 1977, and William Howard Adams, *Atget's Gardens*, Garden City, N.Y.: Doubleday, 1979, for the sections on Saint-Cloud, Sceaux, and Versailles. I am grateful to Michael Pantazzi, Assistant Curator of European Art, and to Myron Laskin, Curator of European Art, both at the National Gallery, for allowing me to partake of their vast knowledge of French architecture in my preparation of a number of these notes.

Apropos of the catalogue, I am in Maria Hambourg's debt for her invaluable help in dating the works in the Gallery's collection. I am also indebted to Denise Leclerc, at that time a member of the Gallery's Education staff, for her work in organizing and collating the Atget collection; to my English and French editors, Lynda Muir, and Hélène Papineau and Serge Thériault, for their patience, tolerance, and helpful insights; to Claude Lupien and Charles Hupé of the Gallery's Photo Services for their painstaking care in copying the Atget photographs; to the support provided by the Gallery's Publications Division, and especially to the helpful suggestions of its Chief, Peter Smith; to the long suffering patience of its Photograph Editor, Colleen Evans, and to the watchful ministrations of its Production Officer, Arnold Witty.

I save two people for the last, without whose support this publication would not have happened: Jocelyne Bisson-Savard, Secretary to the Photographs Collection, for her cheerful, uncomplaining, and careful typing and re-typing of the manuscript in its various versions, and Duncan Cameron, Director of the Glenbow Museum, Calgary, for having suggested the book and forced its production in the first place, and for his faith in my ability to produce it. To both, I am eternally grateful.

James Borcoman

# Chapter 1
# Atget and His Times

In 1857, when Eugène Atget was born, photography was officially eighteen years old, and the first great generation of photographers and inventors had already made or were at the peak of their contributions to the medium. Daguerre had been dead six years and Robert Adamson nine. In the same year Fox Talbot was fifty-seven years old, Bayard fifty-six, and Charles Nègre thirty-seven. The first vicious attacks against photography had been launched by the art community in the previous two years, and the first spirited defence was published three weeks after Atget's birth.[1] While the medium was entering a period of technical refinements, many of the trained painters who had taken to photography with such enthusiasm were on the verge of abandoning its artistic potential.

In the art world generally, Realism was in the ascendancy. Courbet's gigantic canvases, *The Artist's Studio* and *Burial at Ornans*, had been exhibited independently at the Paris Exposition universelle in Courbet's own Pavilion of Realism during the summer of 1855. The moment of Atget's birth coincided with the turning point of the French novel. Flaubert's *Madame Bovary*, published in the spring of that year, established the realistic novel as an exact record of contemporary society based upon detailed research and documentation. Incidentally, Flaubert had set about the writing of this, his first novel, immediately after his voyage with Maxime Du Camp on a two-year photographic tour of the Middle East between 1849 and 1851.

The second Empire was already into its fifth year under the rule of Napoleon III. The industrious Baron Haussmann had put in three active years on the reconstruction of Paris. The restoration of Notre-Dame was almost complete and that of the Cathedral at Chartres was in full swing.

## Myth and Conjecture

Jean Eugène Auguste Atget was born at Libourne, some thirty kilometres from Bordeaux, on 12 February 1857; he studied acting at the Conservatory of the Théâtre national de France between 1879 and 1881; he had opened a studio in Paris by 1892 and made his first major sale of photographs in October 1899; and he died at Paris on 4 August 1927 at two in the afternoon. Until recently, few additional facts about his life had come to light. Like Molière two centuries before him, Atget endured years of hardship playing one-night stands with touring theatrical companies in remote parts of France. Unlike Molière, he returned to Paris not in triumph but in defeat. Rejected by his great love, the theatre, living the rest of his life as an obscure photographer, he had to await death to be discovered as one of the great artists of all time.

Solitary and uncommunicative, he had few friends. Other than the thousands of photographs he produced, a biographer has little to work with – a few facts upon which to spin a thin web of conjecture. Most of what was known in earlier years we owe to Berenice Abbott, the American photographer who preserved the bulk of Atget's estate after his death, and to Jean Leroy, the French journalist who has continued since 1957 to wrestle with the elusive mystery of Atget's life.

The greatest stride forward in Atget research, however, has been taken only recently by Maria Morris Hambourg of the Museum of Modern Art, New York.[2] Painstakingly she has unearthed the essential facts of his career, and exploded, once and for all, the myth of Atget as an untutored primitive who began photographing late in life – a legend that grew immediately upon his death.

## Boyhood in Bordeaux

Atget's earliest years must have been reasonably comfortable. His father and grandfather were skilled craftsmen, saddlers and carriage makers. On the maternal side was a family of bakers. The grandfather, Jean Atget, had moved the family business from Anduze, near Nîmes, to Libourne after the Napoleonic Wars, and married the local baker's daughter in 1816. The only surviving child of the marriage was Jean-Eugène, Atget's father, born in 1817. When he was nearly forty, Jean-Eugène set up housekeeping with Clara Adeline Hourlier, daughter of a clerk at the Gare d'Orléans, the railway freight station for Bordeaux. They never married.

When Eugène was two, the paternal grandfather returned to Anduze, and his parents moved from Libourne into Bordeaux. Jean-Eugène abandoned his trade to become a travelling salesman. He pursued this occupation until his untimely death in June 1862 in a Paris hotel room on one of his many business trips. Clara followed shortly after, leaving Eugène orphaned at the age of five, without brothers, sisters, or cousins. For the rest of his childhood, Eugène lived with his mother's parents.

Nothing is known of his schooling. According to Leroy, Atget's correspondence shows him to have received a better than average education. He studied Greek and Latin. There is even a suggestion that he may have attended a seminary and been destined for the priesthood.[3] What is certain is that after leaving school sometime in his teens, in the early 1870s, he went to sea.

As we might expect of any youth who had spent his early years in Bordeaux, the sights, sounds, and smells of a seaport with its forests of rocking masts beckoning to adventure would be too strong to resist. Shipping out either as a cabin boy or an apprentice, Atget's experiences, as Maria Hambourg has pointed out, would have been similar to those of Joseph Conrad, his exact contemporary, who first served in sailing vessels out of Marseilles in 1874.[4]

## Paris: The Early Years

By the autumn of 1878, Atget's sailing days were over and he had moved to Paris. There he took a cheap room on the Rue de Flandres among the slaughterhouses and railway yards of La Villette at the edge of the city. On 28 October of that year, he applied for admission to the Conservatory of the Théâtre national de France, the most prestigious acting school in the country. What motivated him to do so remains a mystery. There is no record of any acting experience nor even of a prior interest in the stage. Certainly he did not impress the examiners, and he was turned away, not only because of his lack of experience but possibly for his physical appearance as well which, according to Maria Hambourg, was at the time that of an uncouth provincial:

> He had not been blessed with the noble features and statuesque physique of a leading man. He was short (about 5 feet 5 inches), rather squarely built, and had dark hair and small grey eyes. With a prominent nose, strong cleft chin, long upper lip, and straight, severe mouth, his was not a handsome face for glamorous roles; the features were too large and discordant, and they were ruled by a contracted intensity of will.[5]

Although he may have lacked the attractive appearance of the more conventional stage type, this description suggests strength of character and determination. And determination he had, for exactly a year later he applied for admission again; this time with success. Meanwhile, however, immediately after his failure to enter the Conservatory in October 1878, he was inducted into the army for his compulsory military service, and was placed with the Sixty-third Infantry Division as a fulltime soldier.

Although Atget was admitted to drama classes at the Conservatory in the fall of 1879, he still had to fulfil his military duties. In the end this proved to be his undoing. His first examinations, passed in January 1880, resulted in praise from his teacher Edmond Got: "Intelligent, and with a really bizarre, serious way of playing comedy, to which his accent even adds a bit. Will amount to something, I hope."[6] With the June examinations a few months later, Got was less hopeful: "His career as a soldier ... allows very little time to study, and that is a pity, for despite his accent, he has truly personal qualities."[7]

By January 1881, Atget had fallen so far behind in his studies that Got could no longer find any virtues: "...has had scarcely any time to work and has retained therefore a certain natural, untempered bluster unredeemed by a strong and inelegant accent. Moreover, is almost completely lacking in previous dramatic education. Though a recent death in the family will let him legally leave the military, will he achieve a better result here? I rather doubt it."[8] And so he was dismissed from the Conservatory. As Hambourg has pointed out, his wits were sufficient to gain his admission, but without hard work they were not enough to keep him there.

The death to which Got referred was that of his grandfather, Auguste Hourlier. His grandmother died soon after, leaving him alone in the world. No doubt this was ample reason for staying on in the army, at least until he had some hope of establishing himself in civilian life.

In spite of the demands of serving two masters, these years in Paris must have been exciting times for Atget. As with many young hopefuls, he had been drawn to Paris by the powerful magnet of its artistic community to which he yearned to belong. The army provided for his material needs. Paris fed his soul. That the year-and-a-half at the Conservatory was a failure does not deny the importance of those early years in his artistic formation.

French theatre was in a state of transition, moving surely toward Realism. Sarah Bernhardt's reputation as the greatest actress of her day was well established. She could be seen in such masterpieces as Eugène Scribe's *Adrienne Lecouvreur*, in Dumas *fils'* *La Dame aux camélias*, and triumphantly in 1882 in *Fédora*, written for her by Victorien Sardou. Henri Becque's bitter masterpiece, *Les Corbeaux*, was performed in the same year.

The Impressionists were holding their annual spring exhibitions, including works by Degas, Gauguin, Monet, Morisot, and Pissarro. They no doubt provided Atget with his introduction to Monet's painting, which possibly was to have some bearing on his later development as a photographer. Rodin's *Age of Bronze* was shown at the Paris Salon and Zola's *Nana* was published, both in 1880.

In December 1878, photographs by Eadweard Muybridge (1830–1904) showing the motions of a horse's gait were reproduced in *La Nature*, a magazine published in Paris and edited by Gaston Tissandier. Two years later, Muybridge himself arrived in Paris to stay for the autumn. The scientific and artistic communities of Paris were agog with his zoöpraxiscope projections of animal and human locomotion photographs.

## The 1878 Exposition and Davanne's Lectures

Two events occurred at the beginning of Atget's stay in Paris that may have had tremendous consequences for him. On the Champs de Mars, by the Seine, the Exposition universelle was the great attraction in Paris for the year 1878. As usual, it contained a large exhibition of photographs. Among the medallists and prize winners were Alinari, Baldus, Bonfils, Carjat, Ducos du Hauron, Durandelle, Franck de Villecholle, Henderson (Montreal), Liébert, Livernois (Quebec City), Marville, Nègre, Neurdein, Notman and Fraser (Toronto), Quinet, H.P. Robinson, Sebah, and Skeen (Ceylon).[9] A high proportion of these were showing architectural, archaeological, and city views.

The exhibition, which opened in May, did not close its doors until November, after Atget had sat for his first entrance examinations at the Conservatory. The great Paris world fairs, held every decade or so, drew visitors from around the world. That of 1878 was upon a far larger scale in every way than any previous international exhibition anywhere. By the time it closed, total attendance had reached thirteen million.[10] There is little doubt that the young Atget, fresh from the provinces, would have been an enthusiastic partaker of its riches and delights.

The second event was a series of free public lectures on photography, the first ever to be offered in Paris, given by Alphonse Davanne (1824–1912) at the Sorbonne every Tuesday evening from 2 December 1879 to mid-January 1880. Illustrated with photographic lantern slides, a new lecturing aid, the talks dealt with the history, definitions, and principles of photography as well as its technique, discussing the contributions of Niépce, Daguerre, and Talbot, and demonstrating all the processes in current use.[11]

No one was better qualified to present a thorough and informed introduction to the medium. Davanne had been a founding member of the Société française de Photographie in 1854. A chemist, photographer, and critic, he participated in early successful experiments in photolithography in 1853 and published important research in photographic chemistry during the 1850s and 1860s. Davanne was later to become chairman of the governing council of the Société française de Photographie and, incidentally, was grandfather to the then year-old Francis Picabia, the twentieth-century Cubist and Dada painter.

Davanne's course of lectures was aptly timed for anyone whose interest had been excited by the richness of the photography display at the Exposition universelle of the previous year. A similar course was again given by Davanne on Tuesday evenings at the Sorbonne, beginning 26 February 1881.[12] Although his attendance at Davanne's lectures can only be speculated on, the means were at hand to stimulate the young Atget's interest in a medium no doubt encountered in Bordeaux, but never in a quantity or of a quality to provide such an impact as that to be found in Paris between 1878 and 1880.

## Life in the Theatre

Atget left the army in September 1882, after having been stationed at Tarbes in the Pyrenees for the last few months of his service. Upon his return to Paris, he settled on the Left Bank, in the heart of the art students' quarter, at 12 Rue des Beaux-Arts, around the corner from the École des Beaux-Arts.[13] Although this was to be his base for the next few years, he earned his living by acting in the provinces.

There was a certain natural talent for dramatic inventiveness in Atget, even though his career as a professional actor, failure as it was, would tend to belie it. For throughout his later life he made somewhat larger claims for that career, laced with invented successes that are not borne out by the facts. According to André Calmettes (1861–1942), his closest friend and an actor celebrated in his own time, Atget had rather hard features and therefore was given unflattering and usually minor rôles.[14]

Contrary to Atget's own statements, probably the closest he ever came to playing in Paris theatres was in the suburbs. For the most part, his six to ten years[15] on the stage were spent with touring companies working the provinces: perhaps often reduced to one-night stands in schoolyards, town halls, and farmers' barns. The existence of the strolling actor in the nineteenth century was probably much as it had been for centuries, a life of physical hardship and social ostracism, offering a bleak future. Once the troupes left the railway network and penetrated more deeply into the provinces, they inherited all the problems of the wandering medieval mummer. When roads became impassable for wagons, the actors were forced to carry stage props and wardrobes on their backs from village to village. Often going hungry, certainly ill-rewarded, these itinerant actors lived wretched lives indeed.

The real rewards for Atget during these years, however, must have been the intervals between engagements when he could return to Paris and watch the great performers of the day, and discuss current art theories with a roistering crowd of young painters, being part, if only vicariously, of the boiling ferment of artistic and intellectual exchange that Paris has always provided for aspiring painters, poets, and actors.

Although André Calmettes had entered the Conservatory in Paris at the same time as Atget, the two contemporaries did not become fast friends until after 1882 when Atget was living on the Rue des Beaux-Arts. They were to remain lifelong friends. In fact, after Atget's death Calmettes became executor of the estate and the only source of information about the photographer's early life. According to Calmettes, they both shared an interest in painting, having in common a number of acquaintances who were painters. Atget even expressed a desire to become a painter.[16]

## The 1880s: Political Ferment and Artistic Activity

Although the 1880s may have begun quietly enough, there were rumblings of discord to come. In a spirit of forgiveness, amnesty was extended to the Communards of the Paris uprising that followed the Franco-Prussian War in 1871, too late to be of value to the now deceased Gustave Courbet. But the decree dissolving the Jesuits and other religious teaching orders in 1880 began a series of political skirmishes that were to erupt in a near coup d'état by the end of the decade.

Manet was awarded the Légion d'honneur, signifying that Impressionism was no longer the threat to the art world it had been considered to be a few years earlier. Nevertheless, the movement was still capable of producing a gem or two. At the 1882 Impressionist exhibition, Atget could have seen Renoir's *Le Déjeuner des canotiers*, while at the Paris Salon, Manet was showing his *Bar at the Folies-Bergères*. In the same year, Atget had simply to walk around the corner from his rooms to see the Courbet retrospective exhibition on view at the École des Beaux-Arts. Manet, too, was honoured by a retrospective in 1884, a year after his death.

If Impressionism had lost its rôle as the pioneering art movement of its time, it nevertheless spawned an energetic successor in the more loosely-knit and less easily definable generation of Post-Impressionists. One of the latter's first great master-pieces was shown in the Impressionists' final exhibition in 1886, Georges Seurat's *La Grande Jatte*, while Henri (Le Douanier) Rousseau exhibited for the first time at the Salon des Indépendants. At the beginning of the same year, Van Gogh had arrived in Paris. In 1888, he left for Arles, in the south of France, where, in the remaining two years of his life, he painted his masterpieces. With Van Gogh's death in July 1890, the decade was truly over.

If the emotional temperament of the art world had heated up with the appearance of the Post-Impressionists after the mid-1880s, so had the political scene with the arrival of Boulangism. The panache and martial air of General Georges Boulanger appealed to Bonapartist and Royalist alike, and for a brief moment he became a cult figure. Financed by the Duchesse d'Uzès and supported by both the army and the Catholic Church, Boulanger was elected to the Chamber of Deputies in April 1888.

The "general on horseback," as he came to be known, riding through the Paris streets on his black charger, had also caught the imagination of the Paris crowds. In the Paris elections of January 1889, he won an overwhelming majority. The way was prepared for a coup d'état. But Boulangism, bursting on Paris like a flash of lightning in 1886, had turned to hollow thunder within three years. For reasons unknown, Boulanger let the opportunity pass, and when the Republican government issued a warrant for his arrest on charges of conspiracy, he fled ignominiously in the night across the Belgian border. Two years later, in what must surely have been the last gasp of the Romantic movement, the General took his own life in a cemetery in Brussels, beside the grave of his mistress.

## Commitment to Photography

The dynamic spectacle of the world of art and politics that unrolled before Atget's eyes in Paris of the 1880s did not have a parallel in photography. Perhaps it was significant that the decade opened with the death of Charles Nègre (1820–1880), one of the most important of the pioneers of French photography. Ernest Lacan (1830–1879), a central figure in much of early photographic literature and criticism, had died the year before. Within two years, the photographic community had lost Antoine Adam-Salomon (1811–1881) and Henri Le Secq (1818–1882), to be followed in 1887 by the death of Hippolyte Bayard. The last of the generation of great pioneers were rapidly disappearing. Photography in Paris was now dominated by the pedestrian approach of the commercial community on the one hand, photographers such as Neurdein and P. Émonds, or the cautious conservatism of the scientific community on the other, represented by Alphonse Davanne. Perhaps it was significant for French photography during these years that, while Davanne was emphasizing the science and technique of photography in his lectures at the Sorbonne, P.H. Emerson (1856–1936) in England

was lecturing and writing on the aesthetics of the medium, overthrowing the ideas of H.P. Robinson (1830–1901) that had dominated British photography since 1869.

It was in this climate that Atget made his commitment to photography. Calmettes claims that he arrived at photography through painting.[17] Before the end of the decade, for a brief period, Atget moved out of Paris to Picardy in northern France. For military purposes, his name was placed with the recruiting office at Amiens on 12 March 1888.[18] The reason for the move is unknown.

Nor do we know whether Atget had left the theatre for good by this time. He had met an actress, Valentine Delafosse Compagnon, daughter of a theatrical family of some renown. Her grandmother, under the stage name of Caroline Dupont, had been a celebrated actress and member of the Comédie-Française for twenty-five years. Caroline's real name had been Delafosse, and it was under this name that Valentine appeared before the footlights. Ten years Atget's senior, Valentine had begun her acting career as a child, had played in theatres at Suez, Marseilles, and Paris. She was in Paris between 1883 and 1886;[19] there she and Atget had met and probably even performed together in the suburban theatres, and it was during this Paris stay that Valentine became, in the words of Calmettes, Atget's *amie*.[20]

Their professional association must have been fairly brief because the years 1887 to 1891 find her in the southeast of France at Grenoble, while he was at the opposite end of the country in Picardy. In 1891, Valentine was back in Paris and at Dijon in 1892, followed by a somewhat longer stay in Paris from 1893 to 1896. Even before this latter period, Atget had established a studio in Paris. Then she was off for a lengthy engagement at La Rochelle from 1897 to 1902.[21] Finally, in 1902, she left the stage and moved in with Atget to become his companion until her death in 1926. It has been said that she was a kind person, devoted to Atget, and that "her support was essential to his well-being."[22]

Recent research has shown that the romantic legend of the destitute actor who, in middle age, turned himself overnight into a photographer to eke out a hand-to-mouth existence has no basis in fact. On the contrary, there is ample reason to believe that Atget was still in his twenties when he began to photograph. Maria Hambourg speculates that, having started before he moved to Picardy in 1888, it was there that he mastered his materials.[23] The number of photographs of rural scenes made in the countryside around Amiens in the collection of the Museum of Modern Art, New York, – possibly the earliest surviving photographs by Atget – would seem to bear this out. If they are indeed from this period, they show that Atget already had developed a distinctive eye for significant detail as well as an awareness for the presence of the object, which we have come to accept as so much a part of his perception.

The following announcement appeared in the February 1892 issue of *La Revue des Beaux-Arts*:

> We recommend to our readers, M. Atget, photographer, 5 Rue de la Pitié (Paris), who has for artists: landscapes, animals, flowers, monuments, documents, foregrounds for artists, reproductions of paintings, will travel. Collections not commercially available.[24]

The address was in the fifth arrondissement, several blocks from the Jardin des Plantes, and relatively close to Montparnasse. After leaving Picardy and establishing himself once again in Paris, around 1890, Atget opened a studio specializing in subjects for painters, printmakers, and sculptors, and offering his services for copying works of art. He did not follow the usual path of the commercial photographer who sold scenic views to the public at large either through his own shop or by distributing through other retailers, but restricted his trade to a limited clientele as a private photographer. Perhaps this was done out of a desire to associate exclusively with the art world, or perhaps as a means of evading commercial taxes.

Although it was no doubt a shoestring operation, Atget had acquired sufficient reputation as a specialist by 1892 to create apprehension among artists' models. A correspondent in the periodical *Art et critique*, who signed himself "Un modèle Olympien," obviously saw Atget's service as a threat to the modelling profession. According to the writer, Atget already had made a trip to Boulogne-sur-Mer to photograph sailors in their natural setting for the painter Georges Maronniez (1865–?). He had photographed the Rue de la Paix for Edmond Grandjean (1844–1908/9), whose work was currently on exhibition. Were Atget to continue thus, the letter concluded, models might look forward to a bleak future.[25]

Édouard Detaille (1848–1912), a history painter and former pupil of Meissonier, as well as Luc-Olivier Merson (1846–1920), prize-winner in the Salons, Légion d'honneur, and from 1894 professor at the École des Beaux-Arts, also used Atget's services in the early years. Calmettes claimed that it was Merson's recognition of his work that finally placed Atget's precarious business on a more substantial footing,[26] although Florent Fels suggests that Detaille was the benefactor.[27]

The location of Atget's studio, so close to the Jardin des Plantes and within easy walking distance of both the Luxembourg Gardens and the Bièvre River, which was not yet entirely covered over at this time, was a convenient source of subjects for his camera during the period when plants, landscapes, and gardens formed an important part of his repertoire. Later in the 1890s, however, he shifted his attention to an entirely new range of material.

## The Destruction of Old Paris

The interest in the Middle Ages that had begun with Victor Hugo's *Hunchback of Notre-Dame* in 1831 took concrete shape in the restoration of the Cathedrals of Notre-Dame and Chartres in the 1840s and 1850s. In the 1890s, it reached the proportion of a ground swell of public opinion determined to halt the destruction of Old Paris, the Paris of pre-Haussmann days in general and of the *ancien régime* in particular. Because of the significant rôle these events were to play in Atget's development as a photographer, it is important to examine in some detail the origins of the changes and the extent of their immense impact upon the physical character of the city.

Napoleon III's dreams of establishing Paris as the great showcase of French culture and the grandest city in all Europe began to take effect even before his assumption of the throne in November 1853. While still president of the Second Republic, Louis Napoleon turned over to the people the Royal Forest at the western edge of the city, known as the Bois de Boulogne, on condition that the municipal council pay for its improvements. Inspired by Hyde Park in London, Napoleon wished to produce its equal in Paris. In the end, the Bois surpassed its model.

But work progressed slowly, frustrated by a reluctant city council, until the Emperor appointed an experienced administrator in the civil service, Baron Georges Haussmann (1809–1891), to the position of Préfet de la Seine, the chief administrator of Paris, on 30 June 1853. Although the overall concept of a modernized and grandiose Paris had been Napoleon III's, the shape and detail were given by Haussmann working with his assistant Adolphe Alphand, a young landscape architect whom he had inherited from his predecessor's staff.

The first project to be completed was the Bois de Boulogne, but by the summer of 1854 the streets of Paris began to rumble with the demolitions and excavations that prepared the way for opening up the crowded and dark old city to light and air. The Bois de Boulogne was balanced at the eastern end of the city by the Bois de Vincennes, and in the north by the Parc des Buttes-de-Chaumont, all designed by Alphand.

## Haussmann's Reconstruction

In the end, the plan to transform and embellish Paris can be seen to take three principal stages. The first of these consisted of a variety of projects in the old city, including the building of the new Louvre, the beginning of the great boulevards, the widening of existing streets, the creation of parks and squares, and the construction of new buildings to line the new streets with a uniform façade according to Haussmann's specifications. Along the lengths of the new thoroughfares, and against the wishes of Napoleon III, rows of mature trees were immediately transplanted to soften the severity of the new architecture.

The second stage produced the great traffic arteries that criss-crossed and surrounded the city, requiring the destruction of many of the slums, including that of the Latin Quarter and the Île de la Cité. In 1859, Haussmann dismantled the *octroi* (customs) wall that had surrounded Paris since 1786. At the same time, the narrow roadways on either side were merged to create a ring of boulevards around the outer edges of the city. Neighbouring communes and villages were absorbed, and the city limits were extended to the Thiers fortified wall that continued to surround Paris until the end of the First World War. The final stage brought the famous sewers of Paris and, for the first time, the introduction of fresh drinking water to the city in 1865.

The Exposition universelle of 1867 on the Champs de Mars was Haussmann's final triumph. With the advent of a large liberal majority in the legislature, Napoleon III was no longer in a position to protect his protégé, and in May 1869 Haussmann was dismissed from office.

Under Haussmann, twenty-two new boulevards were begun, and streets and avenues such as Lafayette, Quatre-Septembre, Rivoli, Friedland, Hoche, and Kléber were created. The churches of Saint-Augustine, the Trinity, Saint-Ambroise, and Saint-Clothilde were constructed or completed. The Châtelet, Lyrique, and Vaudeville theatres were built and the Opéra begun. The Hôtel de Ville was greatly enlarged, the old Hôtel-Dieu was demolished and a new one erected; Les Halles (the central market) was built of glass and steel. The new Solferino, Alma, and Change bridges were thrown across the Seine. Much of this was done at the sacrifice of existing structures, many of which, according to the conservationists, resulted in the loss of an irreplaceable heritage.

The demolition and reconstruction begun by Haussmann maintained a momentum well into the Third Republic as new arteries penetrated the old quarters. Between 1892 and 1902, 171 new streets were introduced within the city. For example, the western extension to the Rue Réaumur on the Right Bank from Saint-Denis to Notre-Dame-des-Victoires in the second arrondissement was put through only in 1895 to 1896. The Rue du Louvre did not finally link up at its northern end with the Rue Montmartre in the second arrondissement until 1906. In 1890, extensions begun to the Boulevard Raspail on the Left Bank southward across the seventh and sixth arrondissements finally joined the Boulevard Montparnasse. The inauguration to celebrate the opening of its entire length was held only in 1913.[28] Sections of the first arrondissement were demolished after the turn of the century. The Rue des Deux-Écus in that quarter disappeared in 1907, one of the streets photographed by Atget during demolition (see fig. 1).*

Local groups throughout the city, concerned with the impact of the work begun by Haussmann, organized to preserve what remained of the past. Publications documenting the Old Paris that still survived from the Middle Ages to the Revolution began systematically to appear. A. de Champeaux's detailed series of illustrated articles on the decorative ornamentation of Old Paris architecture was published in the *Gazette des Beaux-Arts* between 1890 and 1895.[29] The Marquis de Rochegude's *Guide à travers le vieux Paris* came off the press in 1903, a copy of which Atget owned.[30] So evident was the nostalgia that the Exposition universelle of 1900 included a turreted, towered, and gabled reconstruction of medieval Paris on the river bank.

Fig. 1
Eugène Atget
***Rue des Deux-Écus during Demolition***
September 1907
Albumen silver print,
18.1 × 21.9 cm
(Cat. 27)

---

*All works in the collection of the National Gallery of Canada.

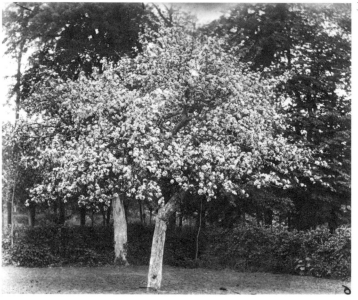

Fig. 2
Jules Hautecoeur (French,
active 1890s)
*La Porte Saint-Denis,
Paris* c. 1890
Albumen silver print,
11.2 × 18.7 cm

Fig. 3
Eugène Atget
*Apple Tree, Abbeville*
before 1900
Albumen silver print,
16.9 × 20.8 cm
(Cat. 73)

Resistance to the continued destruction of Old Paris resulted in the creation of an official municipal body known as the Commission municipale du vieux Paris in November 1897. Its first meeting was held January 1898.[31] Two of the founding members were old acquaintances of Atget's: Édouard Detaille, the painter, and Victorien Sardou, the most celebrated French dramatist of his time.

## Documenting Old Paris

At about the time of the founding of this committee, Atget made a radical change in the direction of his concerns. The making of documents for artists became of secondary importance. From this moment on, he concentrated his attention upon meeting the needs of the new market provided by the mushrooming interest in the Paris of the past. Either Atget sensed the possibilities on his own, or the committee had a direct hand in persuading him to become involved. According to Calmettes, Victorien Sardou "told him which houses, which sites and châteaux, which spots were doomed to disappear."[32]

There was a brief period of groping around as he searched for subjects that avoided the already crowded field of typical views of Paris for tourists, which can be found in the work of such established photographers of the period as Neurdein, P. Émonds, and Jules Hautecoeur (see fig. 2). Soon he narrowed his attention to more precisely defined aspects of the city: the traditional street trades and the art and architecture of Old Paris.[33]

This turning point in his career was of immense significance: not only did it establish the direction for the Atget we have come to know, it widened his market far beyond the narrow field of his earlier specialty. In addition to the visual artists – painters, portraitists, engravers, and etchers – he also began to sell to architects, designers, stonecarvers, metalworkers, and other craftsmen, and even more important to a broader clientele of museums, libraries, art schools, archives, as well as to private collectors of documents of Old Paris.

The earliest of his big sales to an institution occurred scarcely more than a year following the change. On 16 October 1899, he made his first large sale of Old Paris photographs to the Bibliothèque historique de la Ville de Paris, 100 photographs for a total of 125 francs. Similar sales were made to this one institution at the rate of several times a year, and sometimes as often as five times, over the next fifteen years. Other institutions also began to make substantial purchases – the Bibliothèque nationale, the École des Beaux-Arts, the Musée Carnavalet, the Musée de Sculpture comparée, and the Union des Arts décoratifs. Nor were sales limited to Paris. The Victoria and Albert Museum, London, purchased hundreds of photographs.

It is possible that the sudden expansion in his clientele changed his economic situation sufficiently to warrant a move to more comfortable quarters. In 1899, he moved to 17 *bis* Rue Campagne-Première, where he was to spend the rest of his life. It is a short street on the edge of Montparnasse, running from the Boulevard Montparnasse to the cemetery, in a neighbourhood that was then being developed and was already showing signs of becoming the artists' quarter of Paris. Among his neighbours Atget could count painters, sculptors, architects, and craftsmen of one kind and another.

## The Working Photographer

Atget's relatively long life as a working photographer, from the 1880s to 1927, may be divided into three phases. In the first, which lasted until he was about forty, he was known to a limited circle of visual artists as a provider of source documents for their use (see fig. 3). Then came his second phase, as a documentor of Old Paris and the country palaces of the *ancien régime* (see fig. 4).

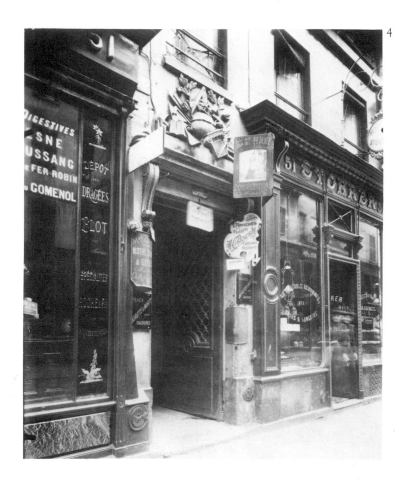

4

Fig. 4
Eugène Atget
**The Compas d'Or,
51 Rue Montorgueil** 1907
Albumen silver print,
21.6 × 18 cm
(Cat. 26)

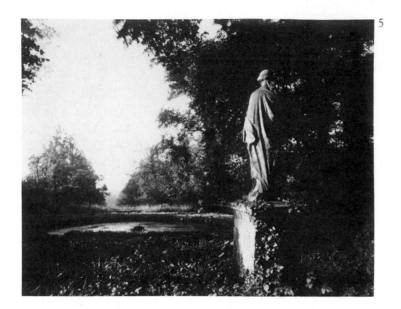

Here he established his life-long reputation and became known to a larger clientele. In his third and last phase, he appears as the tragic artist, the figure who has matured beyond his audience and now embarks upon a lonelier path of personal exploration and expression moulded by the wisdom of years (see fig. 5). The bulk of Atget's work was produced during the second phase, a period of productive energy. During the first four years alone, by 1902, he made some 1 400 glass negatives of the city and the surrounding countryside.[34]

Just off the grand Boulevard Henri IV in the fourth arrondissement, on the Right Bank, lies the quiet little street of de Beautreillis. It was just one of many locations in which Atget placed his camera and tripod in the year 1900 and is typical of his choices. Henri IV was a creation of Haussmann's in 1866; broad and spacious with imposing architecture, it had been run through the ancient gardens of the Couvent des Célestins. De Beautreillis, on the other hand, dates from 1556 and is on an altogether different scale. Number 7, which Atget photographed in 1900, opens from the street through heavy wooden doors set in a stone wall with a Roman arch, and was built in 1596 as a home for a bourgeois family. The doors open into a quiet courtyard to disclose, in Atget's photograph, a simple and unpretentious architecture that creates an atmosphere of intimate charm and grace (see pl. 3).

In that same year, and only a block away, Atget also photographed the fountain on the Rue Charlemagne. Although the street itself dates from 1180, the fountain was installed only in 1846. This time the character of the subject is no longer simple. It has the formal details of classical pilasters and pediment (see fig. 6).

Two years earlier, in about 1898, Atget photographed the door in the pentagonal tower of the Cluny Museum in the Latin Quarter, formerly the residence of the monks of Cluny (see pl. 2). It is a magnificent example of late fifteenth-century Flamboyant Gothic design.

Fig. 5
Eugène Atget
**Sceaux** June 1925
Gelatin silver print,
17.8 × 22.6 cm
(Cat. 134)

Although the first subject represents the unpretentious vernacular, the second the sophisticated formal public architecture, and the third medieval sculpture and design stemming from religious architecture, all are typical choices for Atget because they are subjects off the beaten path, seen intimately and in detail, quite unlike the usual Paris photograph of the time. All three show the range of Atget's architectural subjects, from the Middle Ages to pre-Haussmann. Photographing anything produced during the Second Empire, or following it, was out of the question because it did not meet the needs of the preservationists. Nor did modern manifestations of French civilization equate with Atget's own interests. The most photographed object in Paris after 1889 was surely the Eiffel Tower. Atget steadfastly avoided it as a subject. Yet it does appear, as if by accident, in his view made in about 1900 of *Passy, Rue Berton*, where Balzac had lived.* Seen in miniature through the haze on the horizon in the distance, it is a discreet but insistent reminder of time.

Atget also avoided other well-photographed monuments such as the Conciergerie, the Louvre, the Sainte-Chapelle, and the Tour Saint-Jacques, as well as the remains of Roman Paris. A wealth of photographs already existed of these subjects. Either through personal astuteness or as the result of commissions from knowledgeable persons, or both, Atget's speciality became the less well-known street, the hidden Gothic detail, or the Louis XV façade off the beaten path.

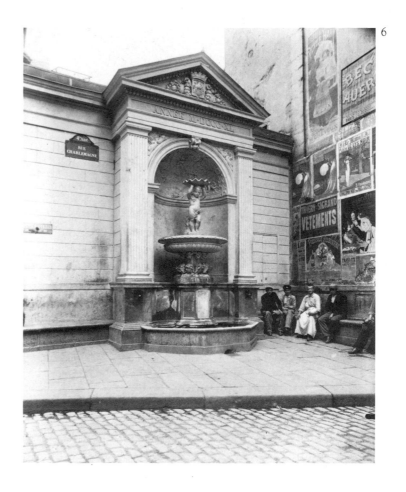

6

Fig. 6
Eugène Atget
**Fountain, Rue Charlemagne** 1900
Albumen silver print,
21.5 × 17.4 cm
(Cat. 10)

---

*See pl. 95 in *The Work of Atget*, vol. 2, *The Art of Old Paris*, New York: Museum of Modern Art, 1982.

Chapter 1  Atget and His Times

Atget's most active years were those between 1898 and the outbreak of the First World War. A self-portrait made in the early part of the century shows a stocky, muscular individual about whom it is quite possible to believe the stories of long hours of tramping through the streets of Paris with forty pounds of camera, tripod, and glass plates on his back, and making even more arduous expeditions into the surrounding countryside, to Versailles, La Varenne and Vaux-de-Cernay, to Meaux, Long-jumeaux and Rouen, to Saint-Cloud and Beauvais.

## Catalogue of a Civilization

To list the subjects Atget photographed in Paris alone is to catalogue a city and a civilization: the old streets, courtyards, and squares, walls plastered with posters, shop exteriors, shop interiors, signs, kiosks, cafés, restaurants, bars, markets, junk shops, street fairs, horse-drawn tramways, carriages and wagons, parks, trees, flowers, fountains and outdoor sculptures, bridges, barges, and the quays of the Seine, churches, confessionals, monuments and rag-pickers' hovels, embassies, mansions, windows, doorways, doorknockers, architectural ornaments, livingrooms, diningrooms, bedrooms, fireplaces, staircases. Crowds and individuals are seen as though they were characters in a theatre of the streets, with a special emphasis on street com-merce: basket-sellers, flower-sellers, rag-pickers, bread-boys, news-boys, waiters, town criers, street musicians, street labourers, porters, garbage collec-tors, prostitutes, beggars, and tramps.

Although he did not photograph the architec-ture as systematically as some,* his selection was enough to suggest the character. In his choice, Atget was often idiosyncratic, and for this reason the view he presents is highly personal. He disliked commissions, it is said, because people did not know how to see.[35]

Within months after his first sale to the Bibliothèque historique, Atget conceived the idea of presenting his photographs in albums with cap-tions, grouped according to relationships and themes, each album containing as many as sixty prints.[36] The albums are proof that Atget was not photographing indiscriminately. Each image con-tributes a building block to a concept of a civiliza-tion that was passing or had already passed, evi-dence of an analytical and accumulating vision, a collecting and classifying intelligence.

Working independently gave Atget the free-dom to photograph what and how he liked, and this was of prime importance to him. Nevertheless, he did accept commissions from both individuals and institutions. One of the largest of his career came from the Bibliothèque historique de la Ville de Paris when it commissioned him around 1907 to make a systematic topographical survey of several sections of Paris.[37] *Rue des Deux-Écus during Demoli-tion*, September 1907 (fig. 1) may have been made for such a purpose. He continued to work at this project over the next few years. In 1910, the Bibliothèque historique added another commission – to photograph the Tuileries Gardens and its statuary. And the Bibliothèque nationale may have commissioned a series of illustrated albums on the fortifications of Paris, the boutiques of Old Paris, and the rag-pickers.[38]

## Lecturer and Social Observer

Although Atget may have retired from the stage in the late 1880s, he certainly did not abandon his interest in the theatre. That this interest was serious and profound is proven by an activity that parallelled his life as a photographer during the pre-war years. Not only did he give lessons in diction to private students,[39] he lectured once or twice a year, and sometimes oftener, at the *Univer-sités populaires* in various quarters of Paris. These varied from being neighbourhood community centres to the more prestigious École des Hautes Études Sociales.

---

*For example, Étienne Houvet, custodian of Chartres Cathedral, who made a methodic and detailed photographic inventory of all aspects of the Cathedral just before or during the First World War.

The earliest lecture of which there is evidence occurred on 30 April 1904 at the Université populaire Émile Zola. Its topic was Molière's *Tartuffe* and *Misanthrope*, with readings. Over the years, the subjects of these lectures touched upon Émile Augier, Dumas *père* and *fils*, Victor Hugo, Octave Mirabeau, Molière, Alfred de Musset, François Ponsard, Racine, Schiller, with Molière being most in demand.[40]

That these presentations went beyond readings and demonstrations may be seen in a handbill reproduced in Leroy's *Atget: Magicien du vieux Paris* announcing Atget's lecture on Molière's *Le Médecin malgré lui* given at the École des Hautes Études sociales, 2 April 1913.[41] According to the description on the handbill, Atget must have given a detailed and scholarly talk. Among the points discussed were Molière's attitude toward physicians, the first appearance of physicians in his plays, an analysis of *Le Médecin malgré lui*, physicians in three other comedies by Molière, Molière as actor in both *Le Misanthrope* and *Le Médecin malgré lui*.

Maria Hambourg has suggested that the theme running through all these lectures shows less concern for theatrical criticism than for social and political issues.[42] This interpretation is borne out by the printed ephemera that Atget collected over the years. In 1911, he donated to the Bibliothèque historique de la Ville de Paris his collection of socialist and labour union newspapers: *La Bataille syndicaliste*, *La Guerre sociale*, and *Le Mouvement social*. Six years later, in 1917, when France's faith in its military leaders was at its lowest ebb during the war, he sold his collection of newspaper clippings and caricatures on the Dreyfus Affair, including Zola's letter *J'accuse*, which he had put together between 1898 and 1906, to the Bibliothèque nationale.[43]

Through an analysis of Atget's photographs of his apartment, and of the books inherited by Valentin Compagnon*, Valentine's grandson, Maria Hambourg has been able to give an impressive, if only partial, description of his library.[44] Apart from the reference books on Paris and other studies related to his photographic pursuits, he owned the complete works of Aeschylus, Sophocles, Euripides, Racine, Corneille, Molière, Shakespeare, Voltaire, Byron, Hugo, Delavigne, Dumas *père* and *fils*, de Musset, de Vigny, and Émile Augier. In addition, there were studies on theatrical and literary history. Quite obviously Atget was not the simple primitive that legend has made him out to be.

## The War

The year 1914 marks the end of an era, not only for Europe but for Atget as well. If Atget may be said to have earned a reasonably comfortable living, even that degree of affluence was coming to an end. On 27 May, he made his last sale to the Bibliothèque historique de la Ville de Paris, having over the years sold to that institution a total of at least 3 294 photographs.[46] Within this year his production diminished. The opportunity for lecturing also came to an end. With the outbreak of war, the Universités populaires were suppressed. France mobilized its army on 1 August, calling up, among many others, the painters Georges Braque, André Derain, Fernand Léger, and Jacques Villon. Two days later, France and Germany were at war. The first German air raid on Paris occurred on 30 August. The week before, the French had been defeated in the Ardennes, and by the end of the first week of September, German guns were thundering along the Marne, scarcely twenty miles from Paris.

---

* Valentine had one child, a son, Léon Compagnon, who was ten years old when she first met Atget. He was killed at the front, 28 October 1914.[45]

Later in the fall, the Germans were pushed back to the Aisne River and into Picardy, and the war acquired the more static character of trench warfare. As a result, Paris no longer was in immediate danger; nevertheless its antiquarian interests had been dealt a death blow. Understandably, the Parisian's interests in preservation had moved onto a more fundamental level. Since the market had all but evaporated, Atget photographed very little during the first two years of the war. In the early summer of 1915, he ventured outside the city limits to photograph at Charenton (see pl. 15), a village south of the Bois de Vincennes at the eastern end of Paris where the Marne joins the Seine, and at Châtillons in May 1916, a village to the south between Paris and Sceaux. Apparently he did not photograph at all in the last two years of the war.[47]

How Atget survived the war years is a mystery. Perhaps the explanation lies in the frugality, even parsimony, with which both he and Valentine lived their lives, possibly together with the continued sales to old clients of a few prints now and then from his stock of photographs. There were no more commissions. An equally important problem was the scarcity of photographic supplies during the final years of the war. From the end of May to early August 1918, the Germans were once again on the Marne within shelling distance of Paris. When German shells fell in the Luxembourg Gardens only a few blocks away, Atget feared for his fragile negatives and stored them in the basement of the apartment building.

The last frightful offensive, begun by the Allies in August and led by General Foch, pushed the Germans away from the Marne and back into the Ardennes and to Flanders where, after devastating casualties on both sides, Ludendorf sued for peace. When hostilities finally ceased on 11 November 1918, the number of known dead for all participants reached a staggering ten million with another twenty million wounded. The French dead and wounded alone came to four-and-a-half million.

The world would never be the same again. Significantly, as a reaction against the traditional values that had brought mankind to such a pass, the Dada movement in art was in full swing. The architects and craftsmen who had been the core of Atget's clientele now wanted to sweep away the past and begin afresh. Nostalgia for Old Paris had become a casualty of the war.

## The Final Years

Recovery was slow in coming, yet by the summer of 1919, photographic materials were once again available and Atget was back at work. He now entered the third phase of his career, in which the motivation for photographing was almost entirely his own. Re-photographing many of his favourite haunts in Paris, Versailles, and Saint-Cloud, he brought to the work of this period a new strength and vision. Now in his early sixties, it is as though the fallow years of the war had provided a breathing space that allowed the wisdom of age and the accumulated years of skill to ferment into a mature understanding of his purpose. More concerned with mood than with place, with idea than information, with invention than convention, the new work resulted in many of the greatest photographs of his career.

Although Atget had always maintained a degree of independence to allow himself the freedom to photograph the way he wished, the commissions had interfered to a certain extent, and he was aware that his clientele required the maximum amount of information transferral through the photograph. To photograph the way others wished seemed a waste of time in the declining years of his life. But if this new freedom were to be pursued, an economic base was required.

The situation was further complicated by Atget's health. For years he had suffered from a digestive problem, having been known to eat only milk, sugar, and bread for periods of time.[48] Both age and a diet such as this must have undermined his strength, in spite of the fact that between 1919 and his death in 1927 he produced hundreds of negatives a year together with the necessary prints. Much of this provided little in the way of income, and so the time had come to cash in on the capital so laboriously acquired over the years. Unlike most of the photographers who provided photographs for the Commission municipale du vieux Paris or to the institutions, Atget sold only prints, never his negatives. This was a measure of his independence. By this means he kept control over and title to his work. The result was, of course, a large accumulation of negatives.

On 12 November 1920, Atget wrote to Paul Léon, Director of the Département des Beaux-Arts, the agency that supervised all aspects of the government's involvement in the arts, offering to sell the part of his collection of negatives known as L'Art dans le vieux Paris. He described it as consisting of sixteenth- to nineteenth-century architecture, mansions, historic houses, façades, doors, woodwork, door knockers, old fountains, staircases, interiors in whole and in part of such churches as Notre-Dame, Saint-Gervais, Saint-Séverin, Saint-Julien-le-Pauvre, Saint-Étienne-du-Mont, Saint-Roch, and Saint-Nicolas-du-Chardonnet.[49]

In a subsequent letter dated 22 November, his asking price for the 1 053 negatives with albums of proof prints was 10 francs per negative, but rounded off to 10 000 francs. This price was obviously based upon the amount he had been paid in earlier years for a print when reproduction rights were included in the sale.* At the same time, he described the contents of a second part of the collection, Paris pittoresque, as containing mainly general views, fountains, signs, and some architecture. He stressed the importance of this group because most of the original subjects had disappeared, especially the district of Saint-Séverin, which he claimed to have photographed over a period of twenty years, through its demolition, until 1914.[54] If his memory was accurate, the implications are that Atget had begun photographing Saint-Séverin as early as 1894. This would suggest that his interest in documenting Old Paris predated the Commission du vieux Paris by some four years.

After Paul Léon had expressed an interest in both collections, if the price were reasonable, Atget replied by suggesting 10 000 francs for both, a total of 2 621 negatives with the proofs. On 22 December 1920, the sale was made official by the Ministre de l'Instruction publique et des Beaux-Arts for delivery of the collection to the Département des Monuments historiques.

---

* The prices for individual prints before the war had ranged from 0.25 to 1.25 francs by 1911. Later they went as high as 5 francs,[50] and 10 francs when a publisher wished to purchase reproduction rights.[51] As an indication of the value of the franc, in 1907 a dinner in a luxury restaurant on the Right Bank could cost 12 francs, but the average small restaurant de quartier charged from 1 to 3 francs for a meal. A cup of coffee cost 40 centimes, a glass of beer 30 centimes. A room in a better hotel on the Left Bank began at 3 francs. A second-class Metro ticket cost 15 centimes, while a trip by train from the Gare Montparnasse to Versailles would have cost Atget 90 centimes, one way, second class.[52] However, with inflation in 1919, Parisians paid four-and-a-half times more for an egg than in 1914.[53]

Although a modest sum, given the importance of the work, the sale undoubtedly left Atget free, for his remaining years, to pursue his own ends without economic worries. Individual sales to private collectors and to artists, however, resumed in the 1920s. In a letter to Jean Leroy, the painter André Dunoyer de Segonzac (1884–1974) recalls having met Atget through André Derain when they were both living on the Rue Bonaparte, off Saint-Germain-des-Prés. De Segonzac referred to the special interest that Derain took in Atget's work and described the photographs as having been made for pleasure and out of love for the humble themes of the street.[55] Whether this refers to the pre-war or post-war period is in question, as it is for the purchases made by Braque, Foujita, Kisling, Matisse, Luc-Albert Moreau, and Utrillo, although the latter more than likely made his purchases before 1914.

After the war, a new group of collectors appeared. Man Ray (1890–1976) arrived in Paris in July 1920, and soon moved to Montparnasse. In time he was to have a studio on the same block as Atget. In the last years of his life, among the admirers and collectors who would drop in to see Atget were Man Ray's assistant Berenice Abbott (born 1898), the young Julien Levy fresh from New York and later to become an art dealer, the American artist Eyre de Lanux, American writer and publisher Robert McAlmon, art dealer Léopold Zborowsky, and Florent Fels, editor of the periodical *L'Art vivant*.[56]

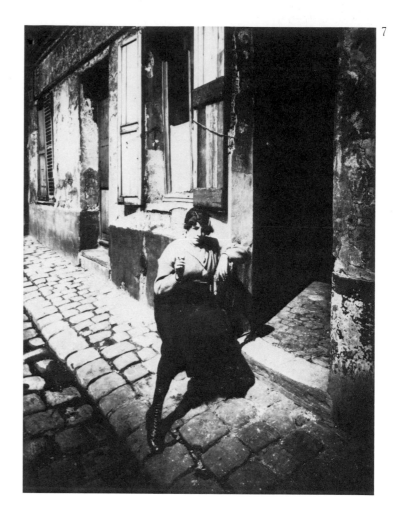

Fig. 7
Eugène Atget
**Prostitute Taking her Shift, La Villette**
April 1921
Gelatin silver print by Berenice Abbott,
23.5 × 17.5 cm
(Cat. 57)
Gift of Dorothy Meigs Eidlitz

In spite of his statement at the time of the sale of his negatives to the Monuments historiques, that he had photographed everything there was to photograph in Old Paris,[57] he announced in that same year that he had embarked on a new series, *L'Art décoratif dans le vieux Paris*, and *L'Art dans les Environs: Seine, Seine-et-Oise, Seine-et-Marne*.[58]

There was at least one commission after the war – one which Atget found distasteful. In 1921, the painter André Dignimont (1891–1965) commissioned him to photograph prostitutes for a book he was preparing. Atget worked on the project between April and June. The best known among these are of prostitutes shown in front of their brothels (see fig. 7). Whether the nudes among his photographs are part of this same commission is not known. Apparently Atget had a reputation, according to Jean Leroy, for photographing frequently in brothels.[59] If this is accurate, it is possible that such work dates from the beginning of his career when he was building his stock of documents for artists.

Man Ray published in *La Révolution surréaliste* of 15 June 1926 three of Atget's photographs from his own collection: *Boulevard de Strasbourg*, 1912 (see cat. 49 and fig. 46), *Versailles*, 1921 (showing a prostitute standing in a doorway), and a view of a group of people standing on a streetcorner watching an eclipse of the sun. This was followed by a photograph of a staircase in the issue of 1 December 1926. These four photographs are an excellent indication of the Surrealist interest in Atget. *Boulevard de Strasbourg*, with a single corseted dummy caught in mysterious movement while the remaining dummies are static, suggests the fragile edge that the Surrealists saw between reality and fantasy. The fact that Atget's photographs were not credited in *La Révolution surréaliste* was at the photographer's own insistence, according to Man Ray, who claimed that Atget did not want any publicity.[60]

That Man Ray did not regard these photographs as the product of a serious artist is confirmed in a later statement: "Atget was a very simple man, almost naive, like a Sunday painter... I don't want to make any mystery out of Atget at all."[61] In spite of the fact that Man Ray claimed to have discovered Atget, the beauty of the gold-toned albumen and gelatin contact prints seemed to have escaped him. Man Ray offered to print some of his negatives to show how much modern technique would improve the images. Fortunately, Atget declined.[62] Undaunted, Man Ray offered to publish some reproductions of the work. According to Jean Leroy, Atget replied with a curt, "If you do, do not put my name to it."[63] In the light of this reply, what Man Ray took for shyness, in reality may have been the decision of a man, demanding in his standards, who refused to allow the quality of his work to be compromised.

This was not the first time Atget's work had been reproduced, although it was probably the first recognition he had been given by a journal of contemporary art. In 1908, for example, one of his photographs was included in the *Société d'Iconographie parisienne*, volume 1. A year later, *La Voie publique et son Décor* published a number of plates by him.[64] In fact, Atget often sold reproduction rights for his work.

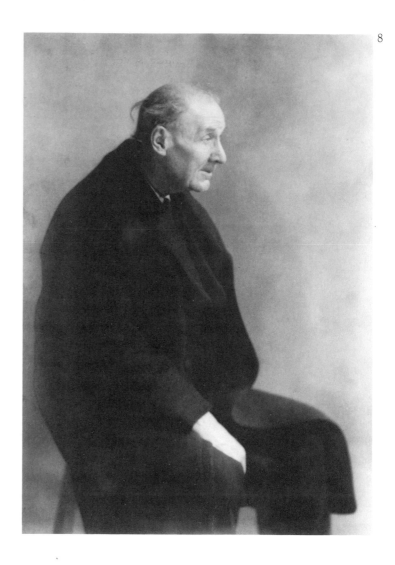

The spring of 1926 was a particularly productive period for Atget. Between March and June he made sixty photographs in the park at Sceaux, the country residence of Jean-Baptiste Colbert, the seventeenth-century superintendent and master organizer of France. In Atget's time it was still in the country, overgrown and neglected, about five-and-a-half miles south of the Paris city limits. Nor was this the only location he worked in during that spring. Some of the most dazzling photographs of his career were made at Saint-Cloud in the same period.

On a June day in the park at Saint-Cloud, Atget placed his tripod near the circular pond of the Grande Gerbe. Between his lens and the graceful, curving rim of the pond a dark tree inserted itself, an ominous presence, burdened with a canopy of leaves, the heavy trunk bleeding light faintly at its edges. The result is one of Atget's most moving photographs, a summation of his visual sensibilities, a metaphor with warnings of mortality (see pl. 24).

In that same month of June, on the twentieth, tragedy struck in a life that had been anything but easy. Valentine, Atget's companion for almost thirty years, died at the age of seventy-nine. It is said that his suffering was immense, that now more lonely than ever, depressed, hardly eating at all, he spent his last months shuffling about his apartment, a sick old man. In fact, during July, within weeks of Valentine's death, Atget was once again photographing in the Luxembourg Gardens and on the streets of Paris. And he continued to photograph both in Paris and its environs right up to his own death.

Fig. 8
Berenice Abbott (American, born 1898)
*Eugène Atget* 1927
Gelatin silver print,
34.4 × 24.2 cm
Gift of Dorothy Meigs Eidlitz

Berenice Abbott, who had first met Atget through Man Ray in 1925, made several portraits of him in her own studio shortly before he died (see fig. 8). The photographs show a frail and bent old man, in whose eyes a piercing intelligence still gleams. She describes how she climbed the stairs to his apartment some time later to show him the portraits, and found the sign "Documents pour Artistes" gone from the door. Hurriedly she rushed to the concierge, who broke the news of Atget's death.[65]

On 3 August, after several days of immense suffering, Atget scrawled a note to his friend Calmettes: "I am in agony come quickly!"[66] With his last remaining strength he struggled to the stair landing where, with a final theatrical gesture, he cried out to the world, "I am dying!", and collapsed. He passed away the following day.[67]

The familiar figure in the patched, old clothes and the threadbare coat, bowed under the burden of his old camera, would be seen no more trudging through the streets of Paris. In the municipal cemetery at Bagneux, south of Paris, in the heart of the countryside where he had spent so many years wandering up and down the byways with his camera, Atget was buried, without ceremony, in an unmarked pauper's grave.

# Chapter 2
# Photography in France: The Early Years

To understand the importance of Atget's work, and indeed its impact upon our whole perception of photography, it is important to look at the beginnings of the medium in France. Brief though its history may be – there is after all less than a generation between the discovery of photography and the birth of Atget – photography evolved at an extraordinarily rapid pace and quickly became the dominant visual medium in the minds of the public, bringing about a profound change in visual language.

Arriving unheralded upon the scene, unsung in his own lifetime, Atget may now be seen as the climactic event of nineteenth-century French photography. It is scarcely an exaggeration to proclaim, as has one critic, that "the art of the nineteenth century comes to an end in the work of Atget. He was the last of the great photographers of the Paris School, and with him an intellectual voyage of discovery, which can only be compared with the Italian Renaissance, comes to a close."[1]

French photography in the nineteenth century, along with so many other intellectual and artistic occurrences, had its centre in Paris. Its origins, however, are to be found in two places, both unexpected: firstly, in the invention of an English scientist, and secondly, in a pictorial tradition of handmade images begun years before the discovery of photography. These two sources, brought together and shaped by a ferment of artistic exploration and technical discovery occurring in the middle of the nineteenth century, lead directly to Atget.

Although the birth of photography in France is the result of the separate labours of Louis Jacques Mandé Daguerre (1787–1851) and Hippolyte Bayard (1801–1887), neither had the long-term impact upon French photography as that produced by William Henry Fox Talbot (1800–1877). Daguerre's silver-plated sheets of copper known as daguerreotypes, with their photographic image made of a fragile layer of mercury particles, certainly captured the excitement of the majority of the French public and continued to dominate photography in France until the mid-1850s. But his experiments on paper and the early ones by Bayard produced only unique images. There was no negative from which additional prints could be made. The daguerreotype, charming though it was in its appearance, allowed for little artistic manipulation and soon proved a dead end. Bayard abandoned his unique process in favour of Talbot's shortly after its appearance. And so it was left to Talbot's discovery of the paper negative, from which a positive print on paper could be made, to establish the direction photography was to take in the long run.

## The Paper Process

Talbot, scientist and mathematician, had announced his negative-positive process in 1839. In May 1843, he travelled to France specifically to open an agency in Paris to promote his invention, even before he established his photographic printing firm at Reading, England, in December of that same year. He stayed in Paris throughout the month of June, giving demonstrations in a temporary workshop on the Place du Carrousel and making the final arrangements for the Marquis de Bassano (Eugène ? Maret) to operate a calotype studio under his licence.[2]

Although the venture came to nothing, the trip was important, partly because of the publicity it gave to his paper process, but also because of the photographs that Talbot made while there. On the way to Paris in May he photographed at Calais and Rouen. While in Paris he roamed as far as Orléans and Chambord on the Loire, where he photographed in June. The earliest surviving paper photograph of Notre-Dame Cathedral in Paris was made by Talbot in the same month, while the location of his workshop on the Place du Carrousel resulted in a number of photographs of the Tuileries.

Talbot's photographs of churches and châteaux in France include overall views as well as details of architectural ornamentation. They were typical of the archaeological spirit which was soon to inspire French photography. Views of ports, bridges, streets, and boulevards in Rouen, Calais, and Paris are seen in the documentary manner that foreshadows French photography of the 1850s (see fig. 9). Apart from the technical debt that French paper photography owes to Talbot, no attention has been paid to his possible influence upon the vision of the first generation of French photographers, some of whom were art students in Paris at the time of Talbot's visit and who were to establish in the 1850s the great tradition of French photography. The beginnings of this tradition are now seen to have the stamp of a special energy and aesthetic, unique enough to warrant being recognized within the medium as the Paris School.

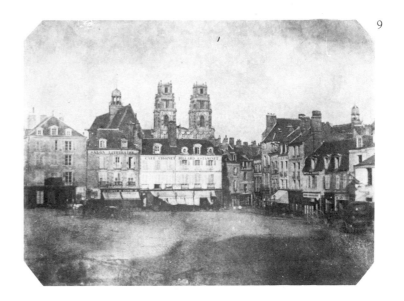

9

Archaeological spirit of French Photo ?

Fig. 9
William Henry Fox Talbot
(English, 1800–1877)
*Orléans* June 1843
Salted paper print,
16.5 × 20.7 cm

Chapter 2  Photography in France: The Early Years

Hippolyte Bayard, an employee of the Ministry of Finance, had been struggling with his own version of paper photography since the beginning of 1839. His earliest work, exhibited in Paris during the summer of that year, seems to have consisted exclusively of still-lifes and interiors. The earliest dated views of Paris monuments and streets by Bayard are from about 1845, which would suggest that he may not have taken his camera out onto the street until after Talbot's visit (see fig. 10).

Interest in paper photography in France continued to fall behind that shown in England. Not until Louis-Désirée Blanquart-Evrard (1802–1872), a chemist and wealthy businessman from Lille, began to experiment with Talbot's invention and to improve upon it, did the process acquire a permanent foothold. Blanquart-Evrard presented his findings to the Académie des Sciences on 26 September 1846, and in 1847 published his improvements to Talbot's process for both negatives and positives. From that moment in France, the paper process acquired a degree of technical reliability that previously had been lacking. Nevertheless, daguerreotypes continued to dominate photography in France until the mid-1850s.

## The Topographical Tradition

The second guiding force upon French photography in its early stages is to be found in an already well-established art form – the topographical view – especially as seen in printmaking, but also in drawing and painting. The topographical view, the concern of which is the depiction of place, especially of towns, buildings, ruins, and countryside, has an ancient history. Its chief concern always has been the communication of information which, over the centuries, has striven to become more and more realistic. By the beginning of the nineteenth century this realism was close to optical experience, and had been for some time. Nevertheless, it was filtered through a screen of pictorial conventions determined by the laws of painting, drawing, and printmaking.

Increasing travel in foreign lands by artists and a curiosity on the part of the public for information about exotic places, eventually resulted in a corresponding interest in topographical views of the scenery at home. To a large extent, responsibility for this new attention given to the local countryside may be attributed to Baron Isidore Taylor (1789–1879). A naturalized French citizen, born of English parents in Brussels, Taylor was trained as an artist in Paris. A student of the Middle Ages and an enthusiastic supporter of the Romantic movement, he eventually became Inspector-General of the Fine Arts and Museums of France (see fig. 11).

The idea of documenting the early architectural monuments of France, many of which had fallen into ruin since the Revolution, had come to him as a young man. The recently discovered reproductive printing process of lithography, so much less expensive than engraving, made the possibility of producing a series of elaborate publications, illustrated with topographical views, a practical one. The plan, originally conceived in 1810, consisted of devoting one or more volumes to each of the provinces. Its purpose was to describe and represent "all the monuments of antiquity, of the Middle Ages and of the Renaissance, which have contributed so powerfully to the glory and the intellectual richness of France."[3]

*Glory of monument*
*Photo metaphor for temporality of Glory.*

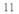

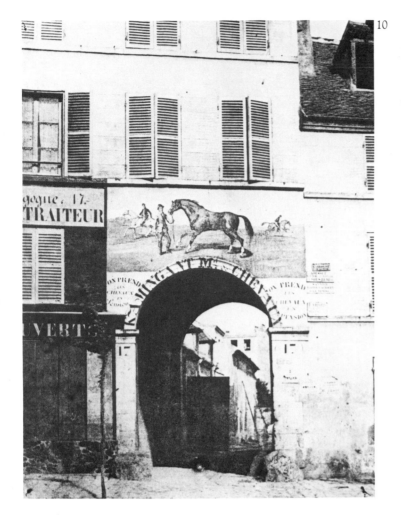

Fig. 10
Hippolyte Bayard (French,
1801–1887)
***Horse Dealer's Sign***
*c.* 1845
Modern gelatin silver print
from the original negative in
the collection of the Société
française de Photographie,
Paris, 21.8 × 16 cm

Fig. 11
Nadar (pseudonym of
Gaspard Félix Tournachon)
(French, 1820–1910)
***Baron Isidore Taylor***
*(1789–1879)* *c.* 1858
From *Galerie Contemporaine*,
1877
Woodburytype, 24 × 19.1 cm

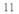

Chapter 2   Photography in France: The Early Years

## Voyages pittoresques

Taylor's brainchild, published under the title of *Voyages pittoresques dans l'Ancienne France*, began to appear in 1820. The first volume, *Ancienne Normandie*, with texts by poet and novelist Charles Nodier (1780–1844) and architect Alphonse de Cailleux (1788–1876), contained eighty-five plates lithographed by various printmakers after drawings produced by Baron Taylor, Daguerre, A.-É. Fragonard (1780–1850), Jean-Baptiste Isabey (1767–1855), Horace Vernet (1789–1863), and lesser-known artists. The publication continued to be produced serially until 1878, eventually consisting of approximately twenty folio volumes, with contributions by over 150 artists.[4]

*Voyages pittoresques* laid the basis for the conventions of topographic imagery in France; firstly, in the kind of subject, and secondly, in the manner of rendering it. Two concepts provide the direction: the pictorial effect and the picturesque. For a number of generations, painters and engravers had been trained to see pictorial effect – the play of light and shadow – as the prime means of animating the surface of a picture, creating a focus for the composition, and establishing a mood. The second element – the picturesque – began to flourish as an art movement at the end of the eighteenth century. It voiced a nostalgia for the innocent past, and its settings were usually rural or wilderness landscapes. *Voyages pittoresques* gave to the movement a particular French flavour by its choice of historic ruins set in a rustic French countryside.

The images of the picturesque are characterized by roughness, irregularity, and intricacy. Lush foliage serves as an organic frame for the composition. Ivy and moss soften the outlines of crumbling stonework. Light and shadow create distinct oppositions, yet flow into one another in harmonious designs as the picture's central theme emerges from the shadows of encircling darkness. Trees and grass are dappled with light and shadow. Shafts of light pierce the surrounding gloom to accentuate the details of ruins (see fig. 12).

*Voyages pittoresques* both heralded and fed a romantic nostalgia for the past. In such fertile soil, Victor Hugo and his followers flourished. Architectural monuments were seen to be a concrete link with a noble past, symbols of heroic times, and a spur to poetic imaginings. Although photography did not make its public appearance until 1839, its roots in France may be traced to the pictorial tradition established by *Voyages pittoresques*.

## Excursions daguerriennes

In much the same spirit, N.P. Lerebours (1807–1873), a Paris optician and early daguerreotypist, undertook the publication of *Excursions daguerriennes*, beginning in 1841. The plates consisted of handmade aquatints after daguerreotypes commissioned by Lerebours of a number of daguerreotypists, and included not only views of France, but also of Canada, England, Greece, Italy, Malta, Russia, Spain, Switzerland, and the Middle East. Unlike the lithographs of *Voyages pittoresques*, however, the daguerreotype rendered the world with mirror-like precision and a maximum of visual information. As a unique object, however, the daguerreotype could be reproduced only through handmade copies by an etcher, engraver, or lithographer.* Much of the sharp definition of the daguerreotype was lost in this process; nevertheless, some of its characteristics were retained by the more sensitive printmakers, with the result that the plates in *Excursions daguerriennes* were seen as adding something new to the tradition of the topographical print (see fig. 13). As Sir David Brewster remarked in *The Edinburgh Review* in 1843, "They actually give us the real representation of the different scenes and monuments at a particular instant of time, and under the existing lights of the sun and the atmosphere."[5]

---

*Three of the 114 plates published by Lerebours in the combined editions of 1841 and 1843 were printed from actual daguerreotype plates etched by Hippolyte Fizeau (1819–1896).

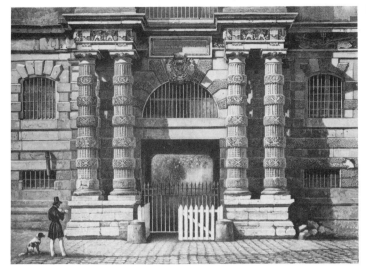

Fig. 12
Alexandre-Évariste Fragonard
(French, 1780–1850)
**Fragments, Large Church of the Abbey of Saint-Wandrille** 1820
From Baron Isidore Taylor,
Charles Nodier, and
Alphonse de Cailleux,
*Voyages pittoresques et romantiques dans l'Ancienne France*, vol. 1, *Ancienne Normandie*, Paris, 1820, pl. 24
Lithograph in black ink,
graduated tint stone, by
Godefroy Engelmann
(1788–1839) after drawing by
A.-É. Fragonard,
32.7 × 19.1 cm

Fig. 13
Sigismond Himely (French,
1801–1872)
**Entrance to the Library, the Louvre** 1843
From N.M.P. Lerebours,
*Excursions daguerriennes*,
2nd series, Paris, 1843,
reprinted by Dusacq et Cie.,
c. 1843
Aquatint on mounted china
paper, after a daguerreotype,
16.2 × 21.7 cm

## Commission des Monuments historiques

Nostalgia for the past, fostered by the Romantics, combined with a growing interest in historical research in France, led by historians such as François Guizot, resulted in the formation in 1837 of an official government body, the Commission des Monuments historiques, whose purpose was to oversee conservation and restoration projects. Through the work of the Commission, the documentation of national monuments became much more systematic when, in 1838, it established a census of all historic monuments in France as the basis for its archive of plans and drawings of restorations already in progress. Among those who sat upon the Commission were the novelist and archaeologist Prosper Mérimée (1803–1870), who had been Inspecteur-Général des Monuments historiques since 1834, and Baron Taylor.

Many archaeologists, architects, and draughtsmen had been employed over the years by the Commission to provide the required documentation. It was laborious and costly work. On two occasions, the Commission had flirted with the idea of using photography to augment its archive: first in March 1839, when a brief reference was made to the daguerreotype at one of its meetings, even before the process was available to the public. Baron Taylor had been closely connected with Daguerre for many years and was familiar with the new process. He appears to have promoted its use by the Commission, but without success. A second attempt was made in August 1849, when Hippolyte Bayard was asked to make six photographic views. Since no record of the existence of these photographs has survived, it is assumed that Bayard never completed the request.[6]

The flirtation became serious when, in February 1851, a sub-committee on photography was struck within the Commission, consisting of Mérimée, Léon de Laborde (1807–1869), Charles Lenormand (died 1859), Léon Vaudoyer (1803–1872), and Henri Courmont (1813–1891), Secretary-General of the Commission.[7] Since de Laborde was enthusiastic about photography and had studied the medium under Gustave Le Gray, the sub-committee looked to him for guidance.[8] Between the end of February and early May, five photographers were chosen to conduct photographic missions throughout France: Bayard, Édouard Baldus (1815–1882), Gustave Le Gray (1820–1882), Henri Le Secq (1818–1882), and O. Mestral (active 1840s–1850s). Together with de Laborde, they were all founding members of the newly formed Société héliographique, the first photographic society in France.[9]

Each was assigned a precise territory to cover, with instructions as to which buildings and, occasionally, the view to be taken and the details to be singled out. Since the project was not exhaustive and the monuments chosen were not necessarily of the first importance, it seems likely that the project was more in the nature of an experiment to examine the usefulness of photography for the Commission's purpose. Nevertheless, it was a large enough enterprise involving several months of extensive travel during the summer and fall of 1851. Slightly over half the districts of France were represented, with some 120 sites.*

---

*For a detailed description of the districts covered by each photographer, see La Mission héliographique, Paris: Musée de France, 1980.

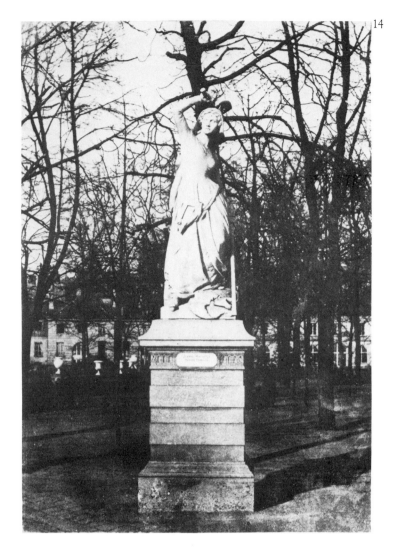

14

15

Fig. 14
Anonymous (French,
active 1850s)
***Jeanne Hachette, after***
***M. Bonnassieux,***
***Luxembourg Gardens,***
***Paris*** *c.* 1851
From *Mélanges photogra-*
*phiques*, Lille: Imprimerie
photographique Blanquart-
Evrard, 1851–1853
Salted paper print,
21 × 14.5 cm

Fig. 15
Charles Marville (French,
1816–**c.** 1879)
***Portico of the Château***
***d'Anet, Paris*** *c.* 1851
From *Mélanges photogra-*
*phiques*, Lille: Imprimerie
photographique Blanquart-
Evrard, 1851–1853
Salted paper print,
21.1 × 14.2 cm

When the project was over, approximately three hundred negatives were deposited in the archive of the Commission. Unfortunately, there they remained, unused and unseen by the public. Except for a handful of works acquired over the next several years by a few other photographers, such as Charles Nègre (1820–1880), no significant addition was made until 1870 when Médéric Mieusement (active 1860s–1890s), a photographer from Blois, was contracted to photograph and employ the services of a number of photographers throughout France.[10]

Although from the point of view of the Commission des Monuments historiques the project may have been a failure, it did have two important results. First, it gave employment to a group of photographers in Paris at a particularly crucial time in the development of paper photography, thus encouraging the nascent photographic community. Secondly, it provided these photographers with a direction – a direction that was amplified in September 1851 with the appearance on the market of the first in a series of photographic portfolios published by Blanquart-Evrard, the man who had improved upon Talbot's process five years earlier.

## Blanquart-Evrard's Albums

For several years, Blanquart-Evrard had wrestled with the problem of founding a photographic printing establishment that would be capable of producing a sufficient quantity of prints for use as illustrations in books and travel albums. Discovering a developing-out process that increased the sensitivity of the salted paper print, he was able to organize an assembly-line technique for producing as many as 250 prints from a single negative in less than two hours, according to an eye-witness.[11]

The first portfolio published by the Imprimerie photographique at Lille, *Album photographique de l'Artiste et de l'Amateur*, issued serially over the following twelve months, eventually comprised twelve salted paper prints, each mounted on a plate paper with a gold border and a lithographed legend below the photograph.[12] In that same fall Blanquart-Evrard began to issue two more albums, *Mélanges photographiques* (see figs. 14 and 15) and *Paris photographique*.[13] Before it closed down at the end of 1855, the Imprimerie photographique had published some twenty-four albums (see fig. 16) and printed the photographs for five archaeological albums, including Maxime Du Camp's *Égypte, Nubie, Palestine et Syrie* (1852) (see fig. 17), J.B. Greene's *Le Nil* (1854) (see fig. 18), and Auguste Salzmann's *Jérusalem* (1856). The subjects ranged from archaeology and architecture to landscapes, picturesque rural and genre scenes, as well as painting and sculpture. As Francis Wey, journalist, novelist, and critic, wrote in *La Lumière* in October 1851, "In the space of several months, photography has formed the basis for a pictorial and archaeological museum in France."[14]

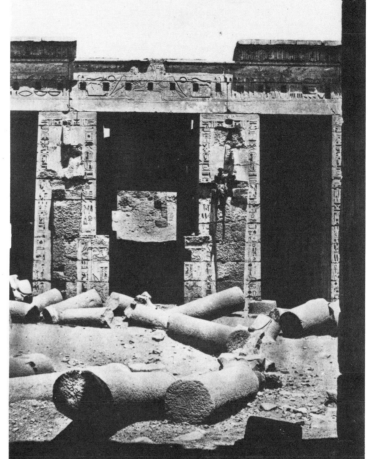

Fig. 17
Maxime Du Camp (French, 1820–1894)
**Medinet Habou, Thebes. East Side of the Peristyle of the Palace of Ramses, Beloved of Amun** c. 1850
From *Égypte, Nubie, Palestine et Syrie*, Paris, 1852
Salted paper print by the Imprimerie photographique Blanquart-Evrard from the negative by M. Du Camp, 21 × 15.6 cm

Fig. 16
Anonymous (French, active 1850s)
**Farmyard** 1853 or earlier
From *Études photographiques*, Lille: Imprimerie photographique Blanquart-Evrard, 1853
Salted paper print, 21.4 × 17 cm

Fig. 18
John B. Greene (American, born Marseilles 1832–died Egypt 1856)
**Constantine, Algeria** 1855–1856
Salted paper print, 23.5 × 29.7 cm
Gift of Ward C. Pitfield

The Blanquart-Evrard albums became the showcase for the best in French photography in the early 1850s. In addition to including his own photographs, he relied upon a number of amateurs and professionals to provide him with negatives. Among the best known are Hippolyte Bayard, E. Benecke (active 1850s), E. Desplanques (active 1850s), F.A. Fortier (died 1882), Henri Le Secq, Édouard Loydreau (1820–1905) (see fig. 19), Charles Marville (1816–c.1879), Victor Regnault (1810–1878), and Louis Robert (1813?–1882) (see fig. 20). Marville, having been the most prolific, provided over one hundred negatives (see figs. 21 and 22).[15]

## The Paris School

But the publications from the Imprimerie photographique at Lille represented only part of French photography at the time. Among those who remained independent from it were Count Olympe Aguado (1827–1894), Baldus, the Bisson brothers, Alphonse Davanne (1824–1912), Eugène Durieu (1800–1874), Baron Louis Humbert de Molard (1800–1874), Le Gray, Léon-Eugène Méhédin (1828–1905), F.J. Moulin (c. 1800–after 1868), Charles Nègre, Paul Perier (1812–?) (see fig. 23), Eugène Piot (1812–1891), Alphonse Poitevin (1819–1882), Félix Teynard (1817–1892), and Pierre Trémaux (1818–?). These photographers, amateurs and professionals alike, together with those represented in Blanquart-Evrard's albums, were located, for the most part, either in Paris or its immediate vicinity. They constituted the core of the Paris School. They were the early masters who formed the fertile ground from which grew the great harvest of nineteenth-century French photography.

19

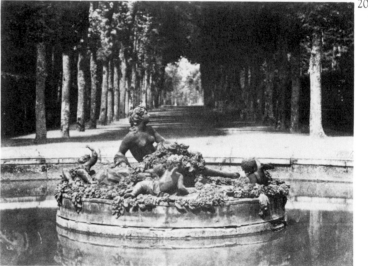

20

Fig. 19
Édouard Loydreau (French, 1820–1905)
**Untitled** 1853 or earlier
From *Études photographiques,*
Lille: Imprimerie photographique Blanquart-Evrard, 1853
Salted paper print, 15.9 × 21 cm

Fig. 20
Louis Robert (French, 1813?–1882)
***Fontaine de Flore, Versailles*** 1853 or earlier
From *Souvenir de Versailles,*
Lille: Imprimerie photographique Blanquart-Evrard, 1853
Salted paper print, 22 × 29.9 cm

Fig. 21
Charles Marville (French,
1816–c. 1879)
**Main Entrance, Portal of
Saint-Wulfrand, Abbeville**
1853
From *L'Art Religieux*, Lille:
Imprimerie photographique
Blanquart-Evrard, 1853–1854
Salted paper print,
31.5 × 25.5 cm

Fig. 22
Charles Marville (French,
1816–c. 1879)
**Untitled** 1853
From *Études photographiques*,
Lille: Imprimerie photo-
graphique Blanquart-Evrard,
1953
Salted paper print,
15.8 × 20.3 cm

Fig. 23
Paul Perier (French,
born 1812)
**Hôtel du Cheval blanc**
c. 1855
Albumen silver print,
29.1 × 23.2 cm

Unparallelled in any other country in the decade of the 1850s was the broad scope of the Paris photographers' interests. The spirit of adventure with which they were imbued is summed up in Charles Nègre. His instantaneous market scenes made along the quays of Paris in 1851 (the first of their kind), the genre studies of street musicians, street vendors, road workers and craftsmen, the archaeological views of the Midi, the Paris monuments (see fig. 24), the documentation of Chartres Cathedral in breathtaking mammoth plates, the nude studies, the informal portraits, the superbly rich photogravures derived from his own patented process, all show the inventiveness of the best of that generation.

Some are better known today for more specialized interests: Eugène Durieu and F.J. Moulin for their intimate and sympathetic nude studies, Humbert de Molard for his rural genre studies made as early as 1848, Baldus for his exhaustive survey of the Louvre and his photographs made for the railways (see fig. 25), Marville for his architectural views and later documentation of the streets of Old Paris, Gustave Le Gray for his sweeping views of the Seine in Paris, the dramatically lit marine views, and his quiet woodland studies made in the Forest of Fontainebleau (see fig. 26), the Bisson brothers for their broad coverage of the architectural heritage of France (see figs. 27 and 28) and the early views of the Alps, Henri Le Secq for his detailed studies of the Gothic ornamentation of church architecture (see fig. 29), his strangely mysterious still-life studies, and his fundamentally radical approach to forest and rocky landscapes that were years in advance of their time. After the mid-fifties the great Paris portrait photographers opened their studios – Nadar (see fig. 11), Carjat, Pierre Petit, and Antoine Adam-Salomon.

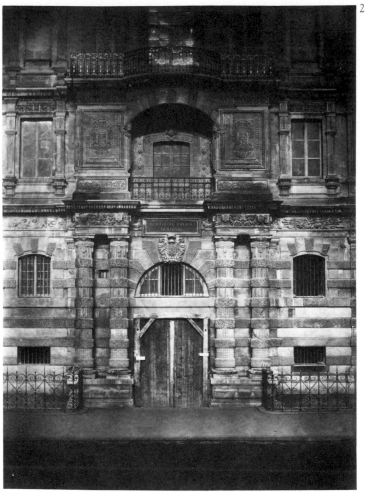

Fig. 24
Charles Nègre (French, 1820–1880)
*Paris: Entrance to the Imperial Library of the Louvre* c. 1855
Salted paper print, 32 × 23.3 cm

25

26

Fig. 25
Édouard Baldus (French,
1815–1882)
**Between Creil and Pont
Sainte-Maxence: Village
of Nogent-les-Vierges.
Away from the Railway
to the West** *c.* 1852
From Baldus, *Chemin de Fer
du Nord. Paris-Compiègne Line
through Chantilly. Small
Photographic Views*, Paris:
Baron James de Rothschild,
*c.* 1852
Albumen silver print,
7.4 × 15.6 cm
Gift of Benjamin Greenberg

Fig. 26
Gustave Le Gray (French,
1820–1882)
**Study of Trees** *c.* 1855
Albumen silver print,
31.5 × 37.1 cm

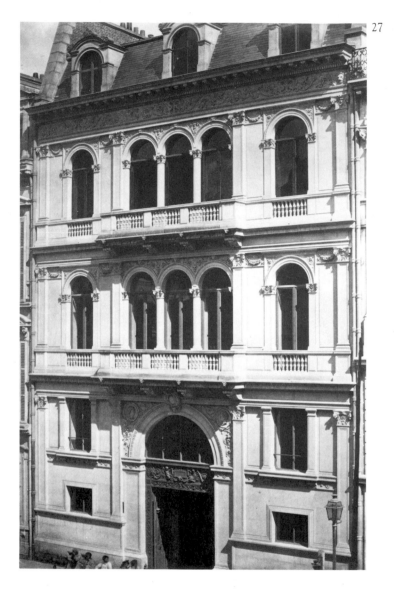

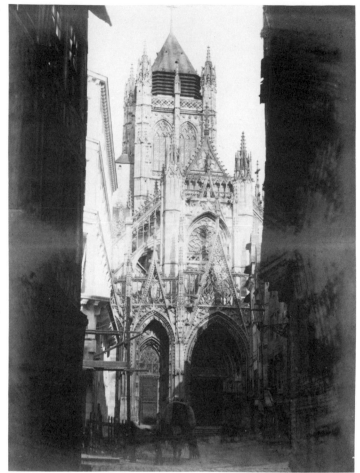

Fig. 27
Bisson Frères (French; Louis-
Auguste, 1814–1876;
Auguste-Rosalie, 1826–1900)
**Untitled**  *c.* 1859
Albumen silver print,
33 × 21.5 cm

Fig. 28
Bisson Frères (French; Louis-
Auguste, 1814–1876;
Auguste-Rosalie, 1826–1900)
***Saint-Maclou, Rouen.
West Façade***  *c.* 1855
Albumen silver print,
41.6 × 31.5 cm

In the earlier years, the work of the Paris School is characterized by the qualities of the salted paper print made from paper negatives. By the mid-fifties many were using various combinations of glass negatives with salted paper or albumen positives. Of all the negative processes, however, paper was thought to provide the most artistic results, a belief that persisted for many years. The salted paper print made from a paper negative produced an unusual combination of softness and solidity. By this process, objects are described simultaneously with both precision and breadth through subtle tonal nuances alone. The special qualities that result from the opposition of light and shadow in such a combination of papers were used by the best photographers to create a pictorial effect that is vibrant and flowing. More than one critic of the time remarked on the way in which the salted paper print absorbed the image into the fibres of the paper so as to create the illusion of being able to sink one's hand into the shadows without encountering the paper.[16] Against such a background of palpable shadow, objects emerge, brushed gently by light, the texture of their surfaces blending with the warmth and tactility of the paper. Air surrounds them and space breathes. Such prints have the power of giving to objects a mysterious presence and a monumental tranquillity.

Paris photographers of the early 1850s showed a greater willingness than those of other countries to take risks with format and technique. Although Nègre was quite capable of working with intimate sizes of 10 centimetres square, he also produced breathtaking contact prints from a single negative as large as 73 by 51 centimetres. Baldus exhibited a print 1.3 metres wide called *Lac* at the 1855 Exposition universelle in Paris. According to Ernest Lacan, editor of *La Lumière*, it was one of the most beautiful moments of photography he had ever experienced.[17]

Fig. 29
Henri Le Secq (French, 1818–1882)
*Chartres* c. 1851
Photolithograph on stone by Lemercier, Lerebours, Barreswil, and Davanne, 1853, from the negative by Le Secq, 33.5 × 23.7 cm

Chapter 2 Photography in France: The Early Years

The use of more than one negative to create a final image may have had its beginnings in Paris. By July 1852, Bayard was already introducing clouds into his landscapes and architectural views by printing the sky area from a separate cloud negative.[18] Although the new technique was recognized as a means of exerting artistic control over the photograph, for the most part photographers contented themselves with opaquing the sky area on their negatives to create a clean, empty space.

The national characteristics of the photographic print were seen by the critics to be of a slate grey in France and reddish brown in England. Nevertheless, the French did experiment with a wide range of print colours from greys to soft browns and even cold purple-browns.

Artistic control was found in other ways as well. As early as 1851, Blanquart-Evrard advised varying the strength of the sensitizing solution of the paper negative in order to give a scene the desired pictorial effect.[19] Since many of these photographers had studied painting, they were well aware of the principle of the pictorial effect, the distribution of light and shade across the picture plane to create the breadth of form that establishes and directs the thrust of the movement in a composition. Such theories were the basis of all art students' training in the nineteenth century.[20] Means were sought, both through such chemical controls as advocated by Blanquart-Evrard as well as in the variation of exposure times, to enhance the effect of light and form in flat scenes. Exposure times were varied not only at the negative stage; the image was altered at the printing stage as well by controlling the amount of light through burning and dodging. And because they had been trained as painters, they did not hesitate to work on the negative with brush or pencil to heighten the effect and animate the surface of the print, thus making the photograph correspond to the pictorial conventions established by *Voyages pittoresques* and other topographical works.

If French photography was born out of a tradition begun by *Voyages pittoresques*, with its emphasis upon pictorial effect and the romantically picturesque, it was also nurtured by an increasing demand for realism in the pictorial document. By comparison with the lithographs of the *Voyages*, photography presented a decidedly realistic view of the world. Its mathematical precision and orderly logic appealed both to the public and to the new generation of artists and critics in France.

## The Critics Respond

The strength of the Paris School was established not only by the creative imagination of its photographers, but in an important manner by the perceptive insights of its critics. No group of art critics in any other country caught on so quickly to the artistic potential of photography with such a continuous outpouring of intelligent writing as occurred in Paris during the early 1850s. One of the most brilliant of the critics was novelist and journalist Francis Wey (1812–?). If, in the beginning, he was not completely convinced of photography's value as an art form, he was soon to be won over. In his first article for *La Lumière*, in February 1851, he saw paper photography as a hyphen between art and science. Science because chemistry and physics produced the image, art because the image imitated nature. He, like others of his generation, was entirely captivated by science. The idea that science could play a rôle in art was the most fascinating concept of all. "It may be seen," he wrote in the same article, "that photography, performed on a flat surface like the canvas of a painting, reproduces the image and the effect with mathematical exactitude."[21]

But Wey warned that the medium must be used intelligently, for "absolute reality, if it were possible, would be far from being one of the essential conditions of what we call truth in art."[22] Wey was aware that the paper photograph reproduced the tonal masses of nature, unlike the daguerreotype with its unnatural clarity, its overwhelming amount of detail, and its tonal flatness. Given its fibrous and porous nature, the paper process was able to suppress surface information in favour of the broad effect, making it a supple medium in the hands of the artist. Nevertheless, in February 1851, he was still of the opinion that photography remained the faithful and pedantic translator of nature, rather than its imaginative interpreter.[23]

By 18 May, however, Wey was prepared to give his wholehearted support to paper photography as an artist's medium. In a review of Charles Nègre's *The Rag-Picker* he remarked that this image "is no longer a photograph, it is a deliberately organized composition, executed with all the qualities foreign to the daguerreotype."[24] Nor was he alone in his beliefs. Louis de Cormenin, the art critic who succeeded Wey a year later in the pages of *La Lumière*, summed up the nature of the fascination for photography with these words: "If photography... has the inflexible and mathematical exactitude of a science, it also has the charm and caprice of an art, and, on these grounds, all intelligent minds are addicted to it."[25]

## Nineteenth-Century Aesthetic Ideals

Undoubtedly, one of the reasons for this addiction lay in the subtle tension that existed in paper photography between what was known as the "theory of sacrifices," with its emphasis upon tonal masses, and the ability of the medium to render the surface information of the world with detailed definition and at the same time a velvety softness. In 1852, Gustave Le Gray noted that the "artistic beauty of a photographic print lies almost always in the sacrifice of certain details, in a manner to produce the effect which sometimes rises to the sublime of art."[26] A year earlier, an unknown reviewer had described Bayard's prints as having definition of detail throughout without taking away from the vigorous general effect. This combination, he claimed, was photography's most admirable quality.[27]

The concept of the theory of sacrifices can be traced back to at least the early eighteenth century in the literature of painting. One author proclaimed in 1715 that pictures must not contain "many little parts of an equal strength."[28] Eugène Delacroix, the foremost Romantic painter of the nineteenth century and a founding member of both the Société héliographique in 1851 and the Société française de Photographie in 1854, continued this tradition when he wrote in his *Journal* for 1 September 1859 that "the photographs which strike you most are those in which the very imperfection of the process as a matter of absolute rendering leaves certain gaps, a certain repose for the eye, which permit it to concentrate on only a small number of objects."[29]

These ideals, which represent the position of the colourists among nineteenth-century painters as opposed to those who emphasized line, are present in such photographs as Charles Nègre's *Chimney-Sweeps Walking*, autumn 1851 (fig. 30), Victor Regnault's *View of Sèvres taken from the Factory*, 1853 or earlier (fig. 31), and Auguste Salzmann's *Jerusalem: The Temple Wall, Jehoshaphat Postern*, 1854 (fig. 32).

In spite of the ability of photographers to emulate the appearance of pictorial effect, when compared with the lithographic views of *Voyages pittoresques* these photographs have a starkness that was shocking to the eye trained in the formal aesthetic of the period. The photographers of the 1850s were searching not only for a delicate balance between the romantically picturesque and the realistically rational, they were engaged in an activity that was to have far-reaching consequences for the visual arts. In fact, they were learning to see photographically, and the excitement this engendered is apparent in their work.

All languages, whether verbal or visual, have their own peculiar rules of grammar, syntax, and logic. Within the visual arts these had established, by the mid-nineteenth century, strict attitudes toward such elements as scale, foreshortening, overlapping, composition, and linear and aerial perspective. The rules fixed the proper connection between foreground, middleground, and background. They established the function of negative and positive space and their relationship to the picture plane. Finally, the rôle of the picture's edge and its impact upon the composition was determined. The rules, evolved over centuries, created a firmly established set of visual hierarchies that ordained what a picture should look like.

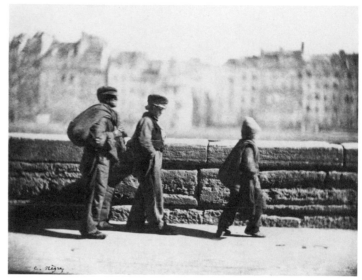

30

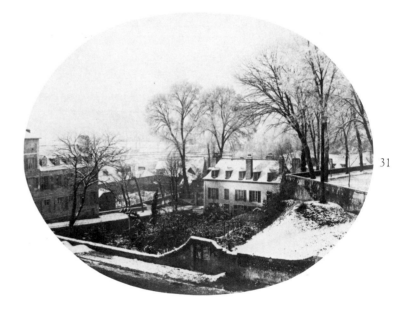

31

Fig. 30
Charles Nègre (French, 1820–1880)
**Chimney-Sweeps Walking**
autumn 1851
Salted paper print, 15.2 × 19.8 cm

Fig. 31
Victor Regnault (French, 1810–1878)
**View of Sèvres taken from the Factory** 1853 or earlier
From *Études photographiques*, Lille: Imprimerie photographique Blanquart-Evrard, 1853
Salted paper print, 22.6 × 28 cm

Eugène Atget 1857–1927

Fig. 32
Auguste Salzmann (French, 1824–1872)
**_Jerusalem: The Temple Wall, Jehoshaphat Postern_** 1854
From _Jérusalem_, Paris: Gide et Baudry, 1856
Salted paper print, printed by the Imprimerie photographique Blanquart-Evrard, 32.8 × 23.3 cm

## A New Way of Seeing

In the space of a few short years, the camera destroyed these hierarchies and challenged the viewer with a new set of visual priorities. Among other things, the picture edge sliced through the world in such a recalcitrant and capricious manner that new and unexpected juxtapositions were often created within the image. The camera discovered that the world was layered in a way far different from the conceived formulas of the painter and the printmaker. Overlapping of objects and of boundaries in the photograph created startling and arbitrary relationships responsible for initiating a whole new pictorial logic. Maxime Du Camp's _Medinet Habou, Thebes, c._ 1850 (fig. 17) is only one example among many in which traditional relationships of pictorial space are radically assaulted by both the camera optics and the tonal scale of photographic paper. Atget was not only the inheritor of this revolution, his genius was to carry it to levels not previously explored. Such discoveries were to lead eventually to some of the major art movements of the twentieth century.

Although the uniqueness of the Paris School may be defined by its wide-ranging interests, its artistic experimentation, and its sense of humanity, its character is tempered by the strong current of a dual architectural-archaeological motif that drives through its core, the result of a need to give meaning to a national heritage. When they were at their best, the Paris photographers showed an honest awareness for the presence of their subject coupled with a sensitivity for their photographic materials. None of this should be surprising when we realize that the School is the product of a special set of circumstances. As one author has observed, Paris was at this time the only place in the world where an entire group of artists, in the space of several years, changed their predominant medium to that of photography.[30]

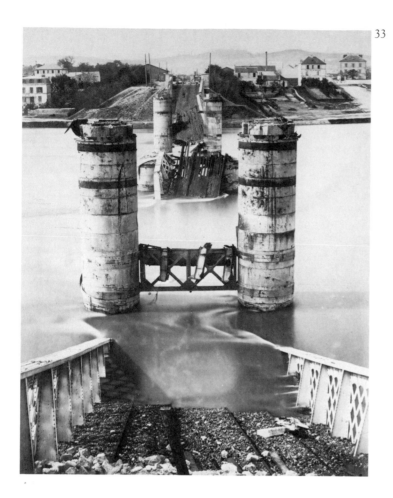

33

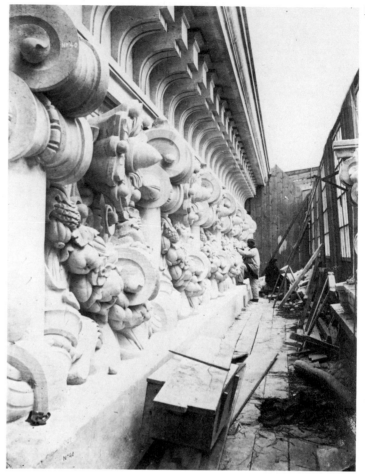

34

Fig. 33
J. Andrieu (French,
active 1860s–1870s)
**Disasters of War: Pont
d'Argenteuil**  1871
Albumen silver print,
37.7 × 29.4 cm

Fig. 34
Édouard Durandelle (French,
active 1860s–1890s)
**Frieze and Cornice of the
Stage**  before 1875
From *Le Nouvel Opéra de
Paris: Sculpture ornementale*,
Paris, 1875, pl. 40
Albumen silver print,
37.4 × 28.1 cm

Eugène Atget  1857–1927

If the inventiveness of French photography began to fade after 1860 with the increasing commercialization of the medium, a documentary tradition continued that is reflected in the work of such photographers as J. Andrieu (active 1860s–1870s) (see fig. 33) and A.J. Liébert (1827–1914) during the Franco-Prussian War of 1870–1871, in the views of demolition and construction work in Paris by É. Durandelle during the 1870s (see fig. 34), and in the archaeological photographs of Jules-César Robuchon in the 1860s to the 1890s.

The legacy of the 1850s may also be found in the increasing use of photography for documentary purposes by French government departments in the later decades of the nineteenth century. As mentioned earlier, the Commission des Monuments historiques finally began to make serious use of photography in 1870. The Ministry of Public Works established an extensive collection of photographic documentation of public works projects, including bridges, port facilities, and mines. Photography played an essential rôle in the recording of scientific projects of one kind and another, such as geological investigations and studies in astronomy. By the 1890s the Ministries of War and of Justice were also sponsors of photographic projects. In fact, government use of photography in France probably was unrivalled by any other country in the nineteenth century.

Photography satisfied the growing need for realism in art. It rendered the form of things and the detail of surfaces with a precision no previous medium had ever attained and in a manner utterly convincing. The nineteenth century saw a photograph as a catalogue of an event, rationally ordered, rich with information, and chock full of surprises. Fact is piled upon fact until the viewer is overwhelmed by the tangible presence of reality.

Photography was also capable of shocking traditional sensibilities: through the starkness of its images in comparison with handmade pictures, the arbitrary relationships the camera revealed, and the unexpected and even unpleasant realities it often discovered in the world.

But photography also satisfied the nineteenth century's romantic longings for the grandeur of the past. Photographers found in architecture the expression of a cultural heritage. More so than any other artists, photographers were able to illustrate the significance of Victor Hugo's words in *The Hunchback of Notre-Dame*: "When one knows how to look, one finds the spirit of a century and the physiognomy of a king even in the knocker of a door."

# Chapter 3
# Influences on Atget

The preceding chapter provides a brief introduction to the evolution of photography in France during the nineteenth century. It describes the dual legacy of the picturesque and the topographical traditions and their rôle in shaping ideas about photography. At the same time, reference has been made to the manner in which photography challenged pictorial conventions. These form the basis for understanding Atget's roots. In combination with an additional factor, Baron Haussmann's reconstruction of Paris after 1854, we have the soil from which Atget later grew. The next step is to understand the immediate milieu that nourished him.

Artists are forged from a great melting pot of ideas – heritage of the ages – according to a formula that is so complex and so variable as often to be undetectable to the eyes of later generations. The manner in which the artistic and photographic communities contributed to Atget's development during his formative years can only be guessed at. Undoubtedly, his own intelligence must stand foremost in line for credit.

### Roots in the Art Community

First, we must remember that André Calmettes and Atget, in the early years of their friendship, shared an interest in painting and in painters. Atget even tried to be a painter. We might expect, therefore, to find Atget attending exhibitions of painting. Given the notoriety of the Impressionists and Post-Impressionists during the 1880s and 1890s, it would seem likely that Atget was aware of the work of such painters as Manet, Monet, Renoir, Seurat, Toulouse-Lautrec and, later, Cézanne and Van Gogh. What are the chances of Atget having met Van Gogh during the latter's two-year stay in Paris between February 1886 and 1888? Slim, perhaps. Nevertheless, as John Fraser has remarked, there is a notable similarity between Van Gogh's and Atget's recognition of the significance of the commonplace.[1] Certainly Atget's own

paintings, which he continued to produce from time to time throughout his life, show the influence of Impressionist brush technique.

The work of Monet may have a special pertinence. One of the few painters to conceive of his work in series – a practice more commonly found among photographers – Monet exhibited his first series, the *Haystacks*, in May 1891, followed by the *Poplars* in March 1892, *Rouen Cathedral* in 1895, *Mornings on the Seine* in 1899, and the *Water-Lilies*, the largest series with forty-eight canvases, in 1909. The nature of the response in the press would have been difficult for Atget to ignore. The Rouen Cathedral paintings were seen to express the spirit of Gothic architecture. Critics wrote enthusiastically of the chromatic variations of the atmosphere, of the concept of time within the series, and of the grand decoration of the whole.[2]

The possibility of a relationship between Atget's trees and Monet's *Poplars* poses an intriguing question. The concept of the tree as *the* subject, distinct from an element in the landscape, especially emphasized through the series format, is a radical one for painting. In photography, however, the tree had served as subject since the early days of the medium (see fig. 35). Monet began the *Poplar* series in 1891. Atget photographed trees throughout his life, certainly from before 1898 until a month or so before his death. Like Monet, Atget frequently saw the tree in time segments. Certain trees he photographed again and again over a period of years. But, whereas Monet's *Poplars* are concerned with light, air, and colour, Atget saw the tree as a life force.

Eugène Atget 1857–1927

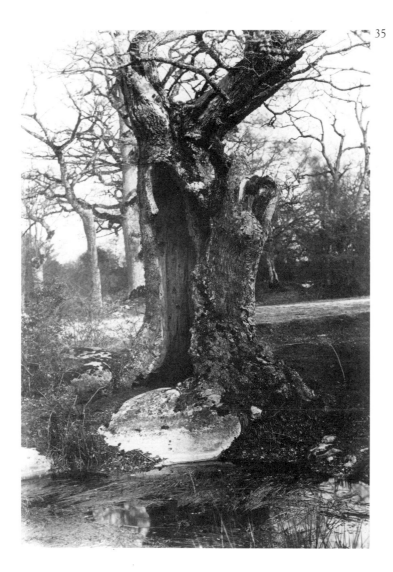

The intimate view that Monet gives of his water-lilies at Giverny, which he began to paint about 1900, finds a parallel in Atget's water-lilies, some of which were photographed before 1900 and some much later in life (see cat. 89). Incidentally, Monet had a darkroom built at Giverny around 1898 in order to photograph his garden and his water-lilies. Atget's misty morning views along the Seine and in the Bois de Boulogne (see pl. 23) were made only after the First World War, yet there is a remarkable similarity between these and Monet's *Mornings on the Seine* exhibited in 1899.* Perhaps more than most photographers of the time, Atget's roots were in the art community, and not only by virtue of his producing documents for artists.

## The Photographic Milieu

If we are to search for possible influences on Atget within his own medium, we need look no further than the topographical photographers of the 1880s and 1890s, whose work could be seen in a hundred shop windows in Paris. Atget's technique was the standard commercial formula of the period, the gelatin dry plate negative on glass with albumen paper for making contact prints, a combination to which he remained faithful throughout his career. Later he added gelatin and collodion papers. These processes were designed to produce images characterized by clarity and definition in order to render the maximum amount of visual information about the world.

Fig. 35
Anonymous (French, active 1850s)
**Tree Study**  *c.* 1855
Albumen silver print, 38.9 × 26.5 cm

*Compare, for instance, Atget's *Bois de Boulogne*, 1923 (cat. 72) with Monet's *Morning Mists*, 1897, reproduced in Joel Isaacson, *Claude Monet, Observation and Reflection*, Oxford: Phaidon Press, 1978, pl. 112.

By way of contrast, let us not forget that another approach to photography was emerging in France in the early 1890s centering around the Photo-Club de Paris, a society that held its first exhibition in January 1894. Its purpose was to prove that photography was an art form by mimicking the more obvious characteristics of handmade images. Rouillé-Ladêveze introduced the gum-bichromate process as an art photographer's printing medium to Paris in 1894, at which time Robert Demachy (1859–1936) and Constant Puyo (1857–1933) immediately began to work with it. For the art photographer the advantage of gum printing lay in the possibility for extensive hand manipulation to modify the photographic image.

Demachy, leader of the French art-photography movement at the turn of the century, had become interested in photography around 1880, about the same time as Atget. Like Atget, Demachy also painted. But there the similarity ended. The two men came from different worlds. Son of a wealthy banking family, and determined to prove that photography was a legitimate art medium, Demachy went to great lengths to deny that straight photography could ever have any virtue as art. His notorious statement, made in 1907, was the art photographer's battle cry: "Meddling with a gum print may or may not add the vital spark, though without the meddling there will surely be no spark whatever."[3] Just possibly Atget and Demachy may have passed each other on the street one day in Paris with their cameras on their shoulders. Other than that, there is no known connection between the two. Neither in his use of processes nor in his style did Atget ever acknowledge the existence of Demachy and the movement for which he stood.

It is doubtful that Atget was aware of the work of Paris photographers of the 1850s, of Le Gray, Baldus, or Charles Nègre. That material had been long relegated to the attics; yet the possibility does exist that Atget may have consulted their work at the Bibliothèque nationale. Photographers of the 1850s continued to exert an influence, for example, through the ideas that survived in the debate between straight photography and art-photography. Photography at the turn of the century was, in a real sense, the brainchild of the 1850s.

Reference has been made earlier to the possible influence of the photographer Davanne, as the kind of teacher to whom Atget might have had access during his early years in Paris; but in considering photographers whose work may well have served as a model for Atget in his formative years, one name comes readily to mind. Jules-César Robuchon had been documenting architectural monuments in the provinces since the 1860s, both as archaeologist and photographer. A member of eight archaeological, antiquarian, and art societies, Robuchon had been a prizewinner of the Société archéologique française in 1864, and was a recipient of a silver medal at the Paris Exposition universelle in 1889. His major work was *Paysages et Monuments du Poitou*, published serially in 400 copies from about 1883 to 1894, and consisting of 228 issues lavishly illustrated with woodburytypes and photogravures of the landscapes, towns, and monuments of the province of Poitou. Published with his own photographs and extensive texts by archaeologists, these were studies produced in the antiquarian spirit of the nineteenth century. They included not only overall views of certain archaeologically or historically important buildings but also architectural details and interiors (see for comparison figs. 36 and 37).

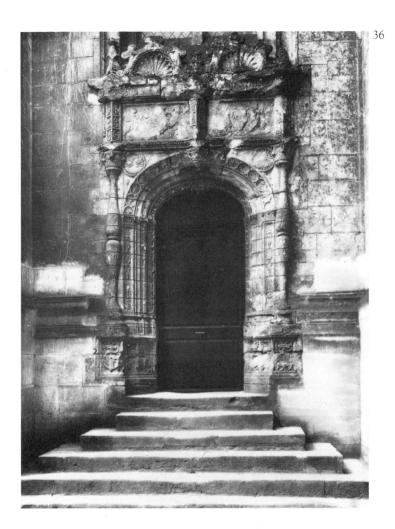

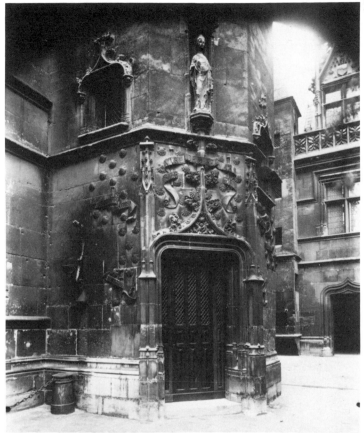

Fig. 36
Jules-César Robuchon
(French, active 1860s–1890s)
***Thouars, Deux-Sèvres.***
***Doorway to the Château's***
***Chapel. South Façade***
before 1886
From *Paysages et Monuments*
*du Poitou*, Paris, 1886
Woodburytype, 21.6 × 15.9 cm

Fig. 37
Eugène Atget
***Door, Hôtel de***
***Cluny*** 1898
Albumen silver print,
21.5 × 17.9 cm
(Cat. 1)

Chapter 3  Influences on Atget

Since this publication was printed in Paris, on the Left Bank, and was distributed to subscribers by 1884, there is a good chance that Atget was familiar with the work. The fact that Robuchon's photographs were shown at the 1889 Exposition would have made them easily accessible to Atget. Once Atget had decided to shift his emphasis from providing photographs of landscapes, fauna and flora for painters to photographing Old Paris, Robuchon, with his informed documentation of architecture as the concrete witness to the glory of French civilization, may have provided Atget with a systematic direction and purpose. Furthermore, Robuchon referred to himself as "photographe-archéologue." Atget used this same designation on his albums around 1900.[4]

## Decorative Art in Old Paris

Having looked at the artistic and photographic environment of which Atget was a part in the last two decades of the nineteenth century, a third factor remains to be considered, one that relates directly to his interest in Old Paris. Victorien Sardou is reputed to have guided Atget in his choice of subjects for Old Paris. But there are other possible sources.* One of the most likely of these, as mentioned earlier, may have been A. de Champeaux's nineteen lengthy and well-documented articles on decorative art in Old Paris, published in the prestigious journal of the art establishment, the *Gazette des Beaux-Arts*, between 1890 and 1895. The timing of these articles was apt, appearing as they did when Atget was preparing his ground for documenting the city. De Champeaux's theme, that architecture and decoration are the means by which an age expresses its spirit, is elegantly stated in the opening lines of his "L'Art décoratif dans le vieux Paris":

> The interior decoration of rooms is a typically Parisian creation, created to serve as a setting for bygone French society, who sought nobility in everything, in the arts as well as literature, and who took pleasure in elegant magnificence.[5]

De Champeaux discussed exterior as well as interior ornamentation of all kinds, noting the locations and stressing the details, and pointing out that "toward the end of the last century, Paris had become a vast museum, the incomparable riches of which were to be found scattered equally throughout religious buildings and public monuments as well as in private dwellings."[6]

---

*The Marquis de Rochegude's *Guide à travers le vieux Paris*, 1903, has been referred to already in this context.

The many line engravings that accompany the series provide useful models for anyone intent upon creating his own documentation. Simple, concise, and straightforward, these drawings present – either frontally or slightly on the oblique – close-up views of carved panels and mouldings, doorways of churches and residences, grillwork in gates and balconies, ornamented façades, ornate fireplaces, public fountains, and courtyards. Atget's eye for the deliberate choice of decorative detail and architectural motif may have been formed by studies such as these (compare figs. 38 and 39); but his genius extends de Champeaux's ideas to other levels. If the carving around an ornate doorway defines the nobility of the class for which it was created, then the plain, worn door of a humble dwelling may also describe the soul of its creator. And the two together may describe the fabric of a civilization.

38

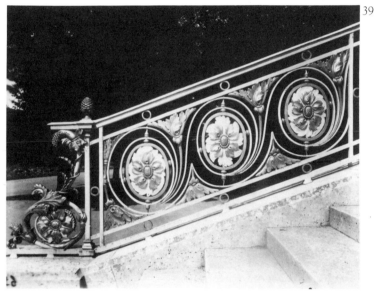

39

Fig. 38
**Banister of the Grand Staircase of the École militaire (Louis XVI Period)**
Copy photograph from *Gazette des Beaux-Arts*, 1 August 1891, p. 137 Engraving after a line drawing

Fig. 39
Eugène Atget
**Grand Trianon**  1905
Albumen silver print, 18.2 × 21.8 cm (Cat. 146)

Chapter 3  Influences on Atget

# Chapter 4
# Style

The subject and style of Atget's work may be analyzed as part of a continuum begun by the Paris School in the 1850s. On one level, the concept of photography as a pictorial and archaeological museum, first declared by Francis Wey in 1851, is an integral part of Atget's vision. Atget's desire to record the evidence of the former glories of French civilization and his sensibility to the presence of the object are direct links with the perception of the earlier photographers. Even his photographs of street trades (see pl. 1) have their roots in such genre studies as Charles Nègre's *Chimney-Sweeps Walking*, autumn 1851 (fig. 30).

On another level, less obvious than the first, is the manner in which Atget continued certain pictorial traditions employed by the first generation of French photographers. And yet, in apparent contradiction to these traditions, the emphasis upon surface information in Atget's work suggests, at first glance, a radical change in formal priorities – an approach more in keeping with French photography after 1860.

## Theory of Sacrifices

Atget's technique, which depended upon the transparency of the glass negative and the clarity of the albumen print, emphasized sharply defined surface information and would seem, therefore, to be at odds with the theory of sacrifices practiced by the photographers of the early 1850s. Enfolding shadows, framing shadows, and obscuring shadows, so essential to the picturesque tradition and adapted as much as possible by many of the early photographers, became more and more prominent in Atget's work as it evolved over the years from the early visual records to the later more personal response to the mood of place.

Surface information remains important in the work, but often is accompanied by large areas in which information is reduced or suppressed entirely. In fact, one of the most important factors in Atget's style is the manner in which he chose to play with the theory of sacrifices. Atget's prints are often known for their deep shadows and washed-out highlights, large enough in size to create broad abstract shapes. Although it has been assumed that these were the product of careless printing techniques, it is remarkable how such shapes operate as strong formal elements within his pictures. At times, Atget chose to strengthen this quality even further by printing on mat albumen paper (see fig. 40 and pl. 10). The character of the mat papers, with their soft surfaces and lack of emulsion, is very close to the salted papers of the 1850s. Although they are capable of producing precise definition, at the same time they lend themselves well to the suppression of information. Highlights are soft and shadows sink into the paper.

Although Atget's style may have some of its roots in aspects of early French paper photography, there is also a vast difference. The theory of sacrifices that underlay the concept of pictorial effect in photography of the 1850s trod a close path to the picturesque style of handmade images, often employing the hand to achieve the effect. Atget, however, arrived at his broad effect of light and shadow through photographic means alone, resulting in what we have come to identify as a purely photographic vision, unlike that of his contemporary Robert Demachy. Although Atget and Demachy sometimes chose similar subjects, including landscapes, architecture, nudes, and views along the Seine, the results could not have been further apart (compare fig. 41 with pl. 9).

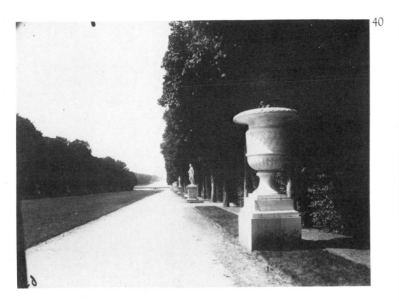

Fig. 40
Eugène Atget
**Versailles, Park**   1902
Mat silver print,
17.6 × 23.6 cm
(Cat. 141)

Fig. 41
Robert Demachy (French,
1859–1936)
**The Seine at Clichy**   1906
or earlier
From *Camera Work*, no. 16
(October 1906)
Halftone photogravure from
gum bichromate original,
20.3 × 15.1 cm

Chapter 4  Style

## Dispelling the Myth of Naïveté

That Atget rarely dated a print has led to one of the most frustrating obstacles in analyzing his work. Now that the research conducted by the Museum of Modern Art, New York, has yielded the key to his system of numbering negatives, we are in a position at last to study the evolution of his style, which in turn has helped to dispel the myth that Atget was a naïve artist with little control over his work.[1] Such differences of style that were apparent often were passed off as being the product of differences in subject matter, thereby suggesting the absence of a strong artistic personality.

This myth of naïveté began to circulate in the press almost immediately after his death, when a larger audience grew from the little group of admirers who used to drop in at 17 *bis* Rue Campagne-Première to pay their respects during the last years of Atget's life. His work was included in the First Independent Salon of Photography held at the Théâtre des Champs-Elysées in June 1928, along with Berenice Abbott, Laure Albin Guillot, Hoyningen-Huene, Germaine Krull, Man Ray, Paul Outerbridge, and Nadar.[2] It was Atget's first exhibition, and others soon followed in America, the first being in New York in 1932, as part of a Surrealist show at the Julien Levy Gallery.

One of the earliest reviews of Atget's work appeared in *Variétés* in December 1928. Its author saw him both as a primitive and a visionary.[3]

Often the comparison was to the naïve painter Henri Rousseau, a notion repeated in an American periodical of January 1929 describing what Americans could see in Paris that season.[4] Pierre Mac-Orlan, the Montmartre poet who wrote the introduction to the first book of Atget's photographs in 1930, furthered the myth of Atget as the simple man.[5] With the exclusion of Berenice Abbott, who wrote her first article on Atget in 1929[6] – and hers was a voice crying in the wilderness – we do not find critics writing of Atget as a profoundly intelligent and sophisticated artist until the late 1960s.[7] Prior to this, more often than not, discussions of Atget's work revolved around the subject matter, emphasizing nostalgia to the exclusion of artistry.

## The Viewing Experience

Photography, more than any other medium, falls prey to confusion over the nature of the viewing experience, over the relationship of subject matter to image. We forget all too easily that the subject matter in a photograph is experienced by the viewer only at second hand, thus ensuring it to be a vicarious experience exclusively. What the viewer really encounters when looking at a photograph is a two-dimensional sheet of paper, the surface of which is marked by shapes and tones that function as signs and symbols. This is the viewer's actual experience.

The ambiguity between the vicarious and the actual experience creates a tension in the viewer that gives photography its unusual quality as an artist's medium, that lends to photography its mystery. Often enough, the more the photograph appears to function as a mirror, the more the mystery deepens. It is at this point, too, that a photographer's style may be at its most elusive – sensed, but indescribable.

Atget acquired the reputation of the photographer who hid his hand so deftly that the viewer was misled into thinking no photographer existed. On the surface there appeared to be something especially transparent about Atget's style to the point that viewers and critics alike tended to accept his photographs simply as windows through which one walked into the world of the subject matter without encountering the photograph. Hence the number of writings ostensibly about Atget, but in fact about Paris. Beneath the surface, however, lies something that has marked his style in a manner so profound that no other photographer has ever been able to imitate it. This uniqueness may be explained partially by the reverence with which Atget approached his subject, explaining why the viewer's response is so often to the subject matter.

If the essence of Atget's style is difficult to analyze, the external trappings are more easily described. Often the evolution of an artist's style will provide clues to its definition. Profound differences are apparent when we compare Atget's early photographs made around the turn of the century with those produced several decades later.

## Light

In the early views of Paris streets, light is external and illuminates its subject with an even clarity; it is for the most part the light of midday when shadows are at a minimum. This is the perfect light for the topographical photographer and the cataloguer of information, and may be seen at its most effective in such photographs as *Pontoise, Church of Saint-Maclou* (pl. 12) of 1902, or *Door, Hôtel de Cluny*, 1898 (pl. 2), made about four years earlier. The light in these images is factual and unemotional.

Later photographs frequently are marked by a subjective light that is more often concerned with reflecting mood than describing place. The deep, impenetrable shadows that dominate over half the composition in *Saint-Cloud, Banks of the Seine* (pl. 13), made in 1923, is an extreme example of this change in emphasis, but it is indicative nevertheless of Atget's greater awareness of the possibilities of light as a means of personal expression. A similar mystery is created in *Saint-Cloud*, 1919–1921 (pl. 19) by the presence of one lone tree trunk glowing white in the distance of a darkening wood. The reverse of this drama, although an equally personal image, may be seen in the tree trunks with vines in *Saint-Cloud* (pl. 17) of 1926 with its milky light.

Unlike the clinical light of earlier work that stresses literal and objective description, photographs made near the end of Atget's life show an increasing sensitivity to light as the subject. Light embraces with a gentle softness or grows from obscuring shadows to create images that are emotionally intimate and personally revealing. Nowhere in Atget's work is this change more in evidence than in his tree series. Trees are the subject of his most personal work. It was an enduring love that spanned his entire career. Trees are the subject of his last photographs. They are old friends, possibly even metaphors for his own life. Some he photographed over and over again through the years as they lost a limb, became more gnarled with age, more abused by life, and yet continued to survive with majesty and dignity.

## Stage Perspective

It is difficult to imagine that Atget's years in the theatre did not leave some mark on his photographs. In fact, the theatre may be said to have provided the single most individual element in his style. Whenever the ground is apparent in Atget's images, there is a slant to the perspective, sometimes disturbing, but always uniquely his own trademark. The ground invariably slopes upward and into the distance in the manner of the exaggerated perspective of stage scenery. This effect is obvious in such photographs as *Lampshade-Peddler*, 1899-1900 (cat. 6), *Corner of Rues de Bondy and Bouchardon*, 1909 (cat. 39), *Sceaux, Entrance to the Château*, 1924 (cat. 133), and *Thiais, Church*, 1925–1927 (cat. 109); and may be seen in many others throughout his career. It was, of course, the optical system of his camera that allowed Atget to produce photographs with this special perspective. He used a lens consisting of a number of components that could be reduced in order to vary the focal length of the lens. A short focal length gives a wide angle of view. The ostensible reason for such a decision would have been to include as much as possible within the photograph, especially the tops of buildings. But at the same time, it was a technique that allowed Atget to heighten the spatial experience.

With a shorter focal length, the bellows often intruded into the image, thereby frequently darkening the corners of the photograph. Sometimes this effect is so pronounced as to create an arch at the top of the image suggestive of the proscenium arch of the theatre. Although these were the characteristics of his camera, there was room for choice. The fact that they appear so often in his work is an indication that not only was the framing of the subject in this manner acceptable, perhaps it was even desirable.

## Form

If light and space are key elements in defining Atget's style, his use of form is equally important. A sense of form appears to have been one of his gifts from the very early years, but it grew stronger and more certain with time. One of the most stunning examples of this is to be found in the handling of the view of conically shaped trees in *Saint-Cloud, Park*, 1921–1922 (cover and frontispiece). More subtle, but with an equally certain sense, are his many views of stairs, such as *Saint-Cloud*, 1904 (cat. 111) and *Grand Trianon*, 1923–1924 (cat. 147).

A comparison of three photographs, *Bourg-la-Reine, Camille Demoulins' Farm*, 1901 (pl. 14), *Gentilly, Old House*, May–July 1915 (fig. 42), and *Charenton, Old Mill* (pl. 15), also May–July 1915, shows the range of his approach to formal problems. Atget's manner of seeing the objects in the farm courtyard of the first example has rendered them as virtual abstract shapes subtly distributed across the surface of a flat plane. By contrast, the second example deals with a traditional deep space occupied by objects that are fully three-dimensional. On the face of it, Atget has presented us with nothing more than a record of farm buildings in this image, seen in a straightforward manner. And yet, with but a moment's viewing we become aware that Atget recognized and took delight in the underlying, whimsical structure of geometrical solids and shapes, all held in balance by the asymmetrical position and organic form of the wagon's load.

The emphasis upon vertical columns of blocks that we see in the second image is carried to more radical lengths in *Charenton, Old Mill*. Here, Atget has seen the relationship between the vertical organization of geometrical solids and opposing horizontal rectangles as though it was the actual subject of the picture. Furthermore, he has used the negative space of blank areas in the sky and water to a degree that might have delighted Cézanne or even a Cubist painter.

In the fourteen years between the first and the last of these three examples may be seen the growth in complexity of Atget's vision from a relatively simple awareness of formal values to an extraordinarily sophisticated approach to solving pictorial problems. This maturity was already present in his photograph of the fireplace at Bagatelle (see pl. 5), made in 1913, in which he places his camera in order to ring a series of changes on the rectangular shapes of the fireplace, mirror, and the open door. Just the right portion of asymmetry was always introduced by Atget, a concept which a recent study of his work interprets as the possible influence of the asymmetrical symmetry of Rococo composition.[8] Given Atget's constant association with Rococo decorative art, the idea is intriguing.

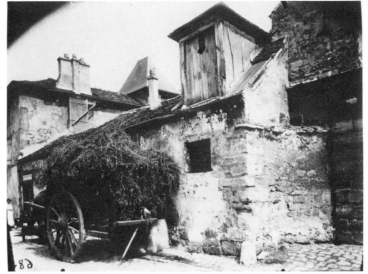

42

Fig. 42
Eugène Atget
**Gentilly, Old House**
May–July 1915
Gelatin silver print,
17.9 × 22.6 cm
(Cat. 102)

## The Accidental

The adventure of seeing in Atget's work, however, extends beyond its formal properties to other levels, the most mysterious of which is the appearance of the "accidental." This word is placed in quotation marks because the extent to which the photographer is the victim or the controlling agent is a moot point. The phenomenon of the apparently accidental incident or of the inclusion within the frame of an apparently insignificant object has been known to photographers since the beginning of the medium.[9] Some have delighted in it, others have deplored it, and the more astute have exploited it. Oliver Wendell Holmes, American physician, essayist, and poet, recognized the power of the so-called unintentional in the photograph when, in 1859, he wrote, "The more evidently accidental their introduction, the more trivial they are in themselves, the more they take hold of the imagination."[10] One critic has recently put a name to it – *punctum*: that which unexpectedly reaches out and pierces the viewer, thereby giving new meaning to the image.[11]

Atget's work is rife with such experiences. Often they are discovered by the viewer only through prolonged looking. Frequently, the impact and meaning of their presence will rely entirely upon the viewer's own idiosyncratic response, as though Atget presents the clues to a mystery to which each must find his own solution.

That we are left to discover the woman in white, cut through by Atget's frame, at the left edge of *Gentilly, Old House* (fig. 42), or to discover the tiny figures leaning from the windows at the right of *Pontoise, Church of Saint-Maclou*, 1902 (pl. 12), or to ponder the ghostly presences of moving figures in the same photograph, increases the human dimension of such images. Although the subject of *32 Rue Broca*, 1912 (fig. 43) is the front of a second-hand shop with its collection of inanimate, used objects, my attention is drawn to life, to the dog that moved twice and the parrot that shook its head but not its wings.

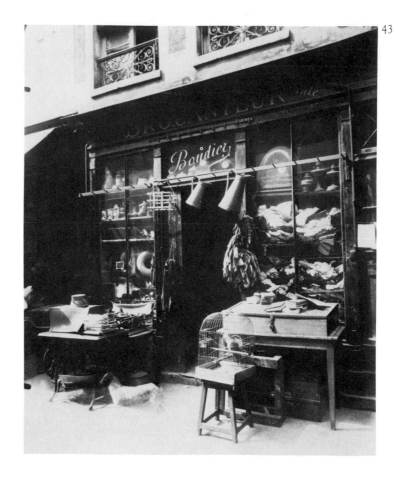

Fig. 43
Eugène Atget
**32 Rue Broca** 1912
Collodio-chloride (?) silver
print, 21 × 17.3 cm
(Cat. 53)

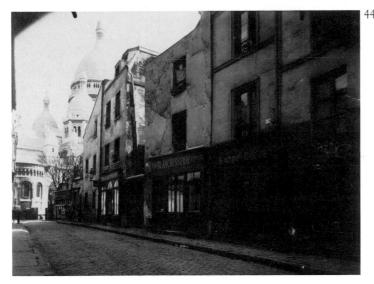

## Artist for Our Time

Although Atget's work may be seen as a continuation of the concerns of the nineteenth-century photographer, he is, in fact, an artist for our time. The test each generation must apply to the art of preceding generations is whether it finds therein its own reflection. We have come to expect that the photographic image be both provocative and evocative. Atget did more than any other photographer to prepare the way for our acceptance of the complexity of layered meaning. On the face of it, Atget's photographs record the passing of a civilization. Behind the face lie other implications.

Often the central thought of an image by Atget consists in the confrontation of two opposing ideas: the grandiose and the humble, the elegant and the commonplace, the past and the present, the static and the moving, the light and the dark. The symbolism that this engenders is especially prevalent in the Paris work. A photograph of a doorway with an ornately carved coat of arms may be the ostensible reason for the existence of that photograph (see fig. 4). But this tiny remnant of an aristocratic *ancien régime*, now surrounded by the rising tide of a bourgeois society and its petty commerce, reminds us that new life forever feeds on the decay of the old. Even the double image of a woman in the doorway adds its commentary to the flux of time.

The glancing nature of the vision with which he apprehends the world is an essential part of Atget's genius. In the guise of the accidental, it is reflective and questioning. So many of Atget's contemporaries, concerned with recording the Charlemagne fountain, would have photographed only the actual fountain set in its alcove. In Atget's photograph, however, the official and formal art of a past era competes with the apparently incidental inclusion of the popular and ephemeral art of contemporary posters (see fig. 6). The great white dome of Sacré-Coeur in *Rue du Chevalier-de-la-Barre*, March 1923 (fig. 44), rising as a modern

Fig. 44
Eugène Atget
**Rue du Chevalier-de-la-Barre**
March 1923
Collodio-chloride (?) silver print, 17.9 × 22.2 cm
(Cat. 61)

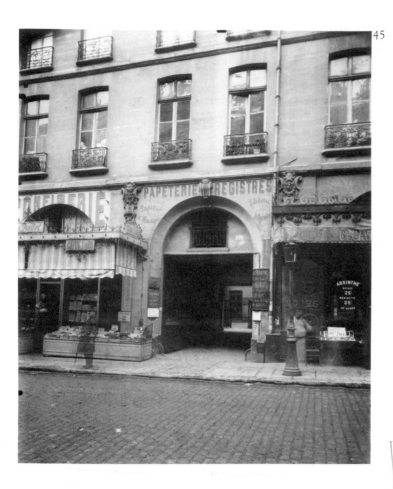

45

symbol of spirituality behind the shadowed street, cannot escape the question posed by the sign of "Blanchisserie, Fin, Gros" (Laundry, Retail, Wholesale) in the foreground. When two separate levels of existence are joined together each illuminates and enriches the other.

An awareness of the power that the intrusion of the small and apparently incidental occurrence into a photograph has in stirring the imagination of the viewer is not new. (We have already noted Oliver Wendell Holmes' early recognition of this phenomenon.) But, largely thanks to Atget, such occurrences have become an important element in the photographic vocabulary of our time. Whether it be through the existence of the ghostly figure of the gentleman standing on the sidewalk in *Saint-Lazare Convent Apartments, 103 Rue du Faubourg-Saint-Denis*, 1909 (fig. 45), or the enigmatic little shadow play in the stairwell below the sign "Libraire" in *Courtyard, 28 Rue Bonaparte*, 1910 (pl. 4), or the tiny face peering from the gloom of an open window in *Saint-Denis, Hôtel du Grand Cerf*, 1901 (cat. 98), Atget has made us appreciate, more fully than any other photographer before him, the profound mystery of the medium.

Fig. 45
Eugène Atget
**Saint-Lazare Convent Apartments, 103 Rue du Faubourg-Saint-Denis**
1909
Albumen silver print,
21.6 × 17.8 cm
(Cat. 36)

Eugène Atget   1857–1927

Among his most witty and magical images are the series of shop windows begun around 1910, possibly as a commission for the Bibliothèque nationale in Paris. The purpose of the Cubist painter was to break down traditional one-point perspective by giving us a many-sided view of things. The Surrealist painter blurred the lines between the world of reality and the world of dreams by creating unexpected relationships and juxtapositions. All this was accomplished only through the artificial means of contrived images. Atget, however, knew that the world creates its own mysterious juxtapositions. Nowhere is this more in evidence than in *Boulevard de Strasbourg*, 1912 (fig. 46), with its motionless rows of corseted mannequins and a single moving shift. Whether or not the motion of the garment is accidental we shall never know. The fact remains that its existence is bizarre and its implications enormous.

Fig. 46
Eugène Atget
**Boulevard de Strasbourg**
1912
Gelatin silver print,
22.5 × 17.7 cm
(Cat. 49)

Chapter 4 Style

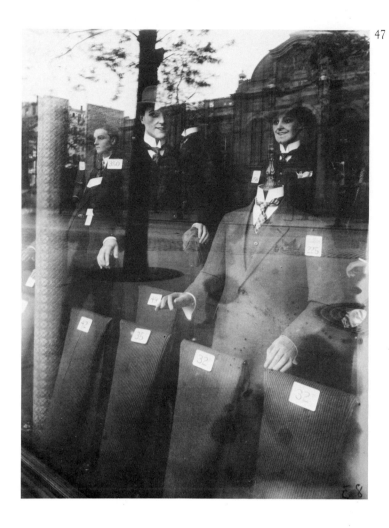

Atget also made the startling discovery that the world creates its own montage of objects through a kind of "layering" just waiting for the photographer's lens. Such photographs as *Avenue des Gobelins*, 1925 (fig. 47), pose questions about reality by shifting contexts and creating ambiguities through the layering of window reflections.

To assume that the principal value of Atget's work lies in its sociological or architectural documentation is to miss the true import of his art. Not every photograph Atget produced has grace or meaning. Often he may have photographed with little interest in the subject, only for the purpose of fulfilling a commission. Other photographs obviously derive from the personal satisfaction taken in the pleasure of visual experience or in the recognition of significant fact. Atget was an artist with a highly developed sense of pictorial logic. To experience an Atget photograph is to undergo an adventure in seeing. "It is the photographer's business to see," said H.P. Robinson in 1869.[12] No one saw better than Atget.

The real consequence of his art, however, is in the cumulative effect of the entire body of work. It seems apt to compare Atget's œuvre to a great Gothic cathedral. Rough and uneven when examined in detail, it is often enigmatic and at times disjointed in the manner of its construction. Like the cathedral, it contains many diverse parts: some shape its main structure, others provide networks of buttressing support, still others serve as fanciful ornamentation. Yet, like the cathedral, it rises heavenward as a whole: a hymn to the greatness and complexity of the human soul with its interweaving of grand aspirations and humble realities.

Fig. 47
Eugène Atget
**Avenue des Gobelins**
1925
Gelatin silver print,
22.7 × 16.7 cm
(Cat. 66)

# Plates

Note: More complete information on the plates
may be found in the catalogue section beginning
on page 104.

Pl. 1 *Market Porter*
1898–1900
(Cat. 3)

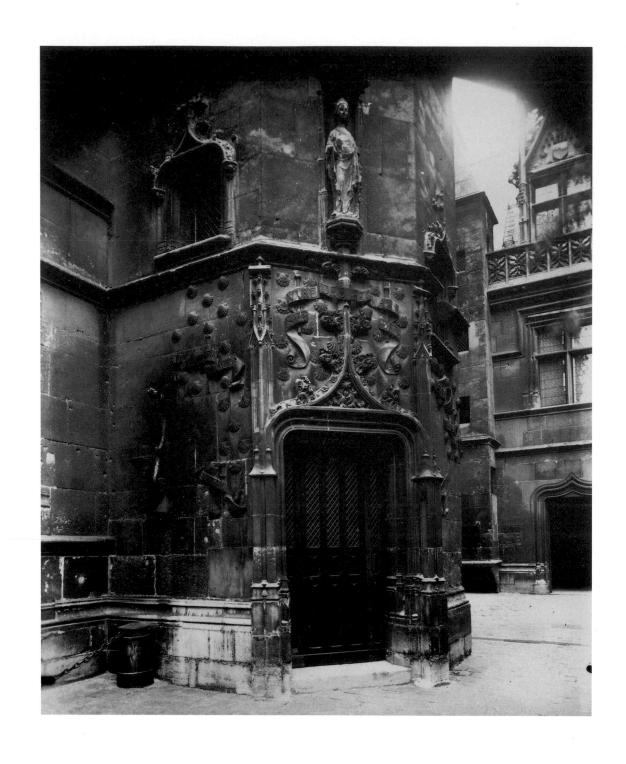

Pl. 2  *Door, Hôtel de*
*Cluny*  1898
(Cat. 1)

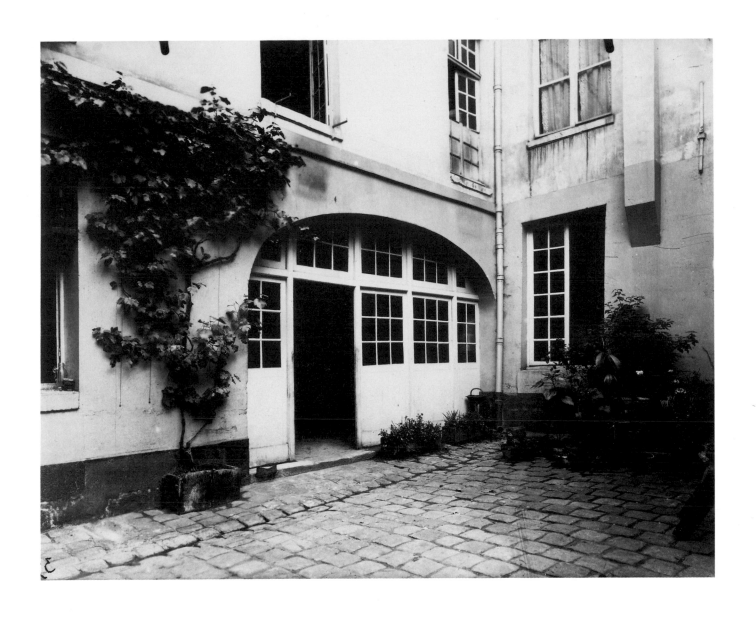

Pl. 3  *Courtyard, 7 Rue*
*de Beautreillis*  1900
(Cat. 9)

Pl. 4  *Courtyard, 28 Rue*
*Bonaparte*  1910
(Cat. 42)

Pl. 5  *Bagatelle, Fireplace*
1913
(Cat. 67)

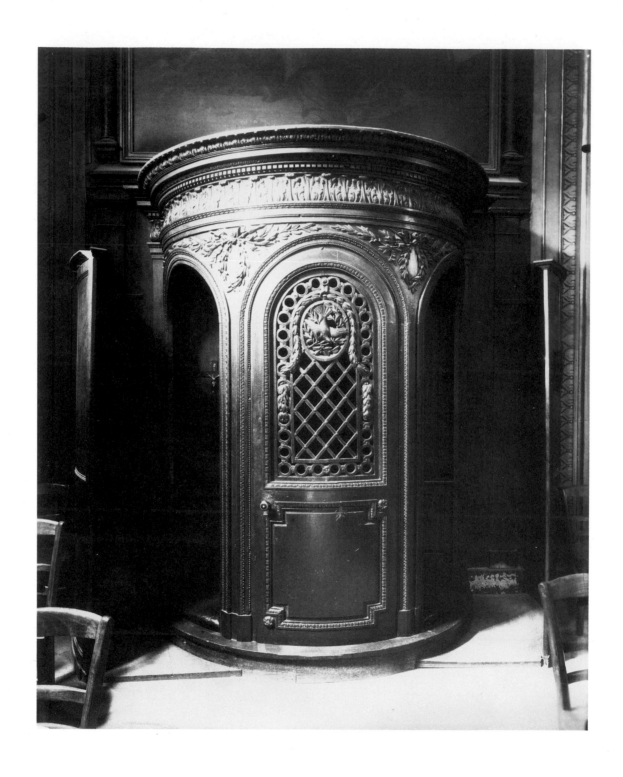

Pl. 6  *Saint-Germain-des-Prés*
1906–1907
(Cat. 20)

Eugène Atget  1857–1927

Pl. 7  *Door, 7 Rue*
*Mazarine*  1911
(Cat. 46)

Pl. 8  *Hôtel de Roquelaure,*
*246 Boulevard Saint-Germain*
1905–1906
(Cat. 18)

Eugène Atget  1857–1927

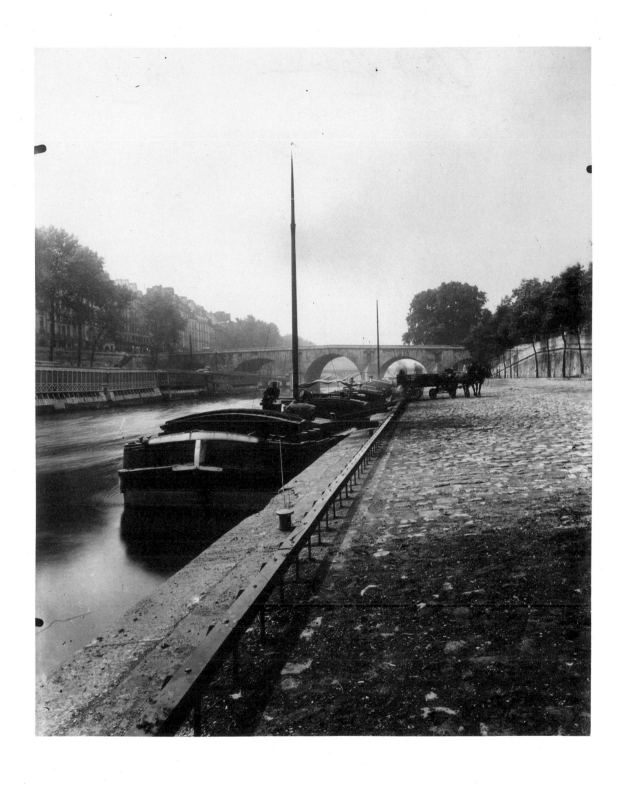

Pl. 9  *Pont Marie*  1912
(Cat. 52)

Pl. 10  *Boulevard de la
Chapelle*  June 1921
(Cat. 58)

Pl. 11  *Café, Boulevard*
*Montparnasse*  June 1925
(Cat. 64)

Pl. 12  *Pontoise, Church of
Saint-Maclou*  1902
(Cat. 99)

Pl. 13  *Saint-Cloud, Banks of
the Seine*  1923
(Cat. 107)

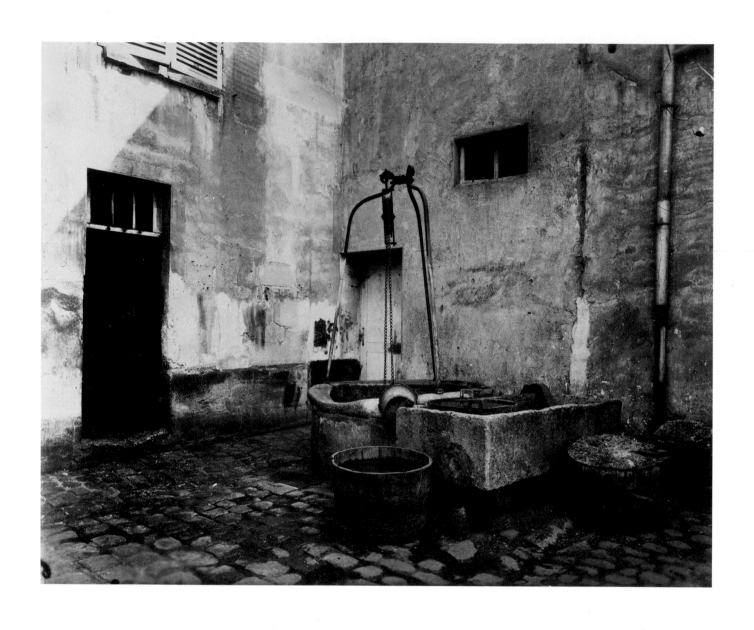

Pl. 14  *Bourg-la-Reine, Camille
Desmoulins' Farm*  1901
(Cat. 97)

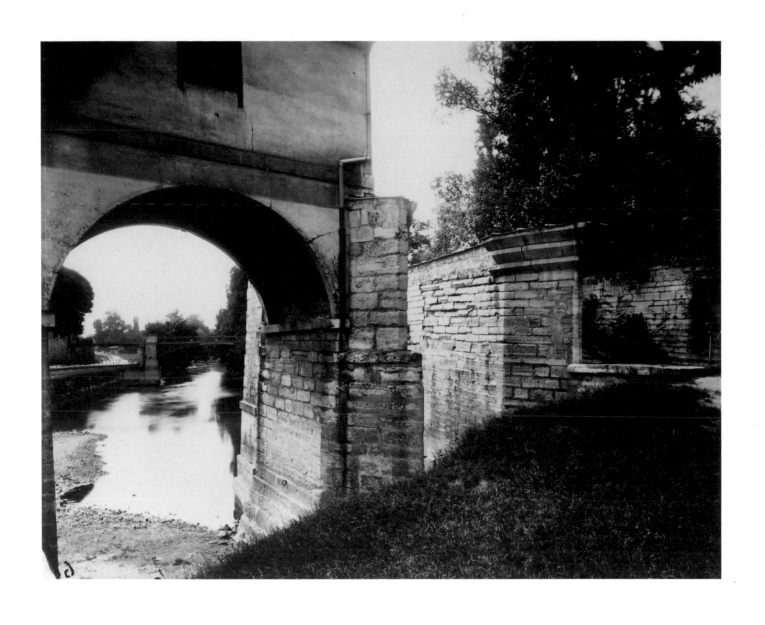

Pl. 15  *Charenton, Old Mill*
May–July 1915
(Cat. 101)

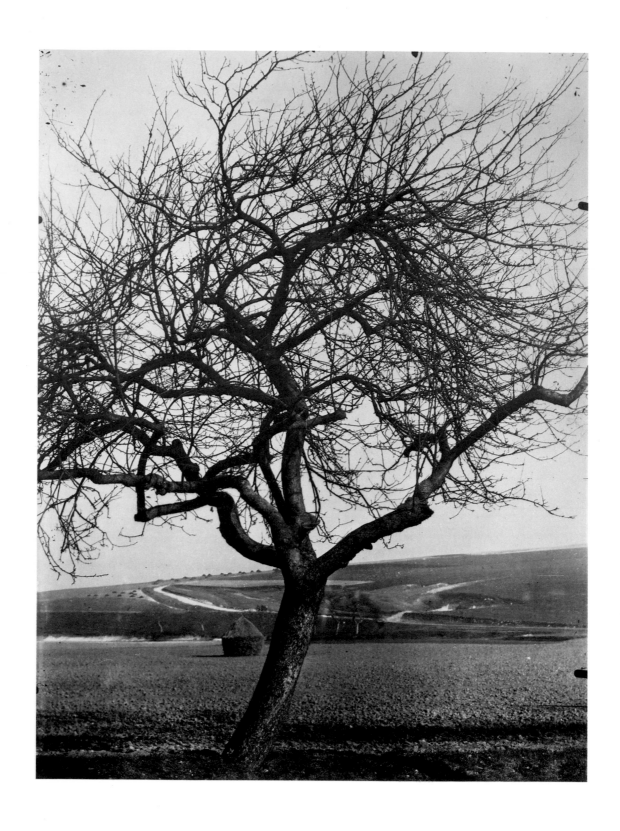

Pl. 16  *Apple Tree*  1900
(Cat. 74)

Eugène Atget  1857–1927

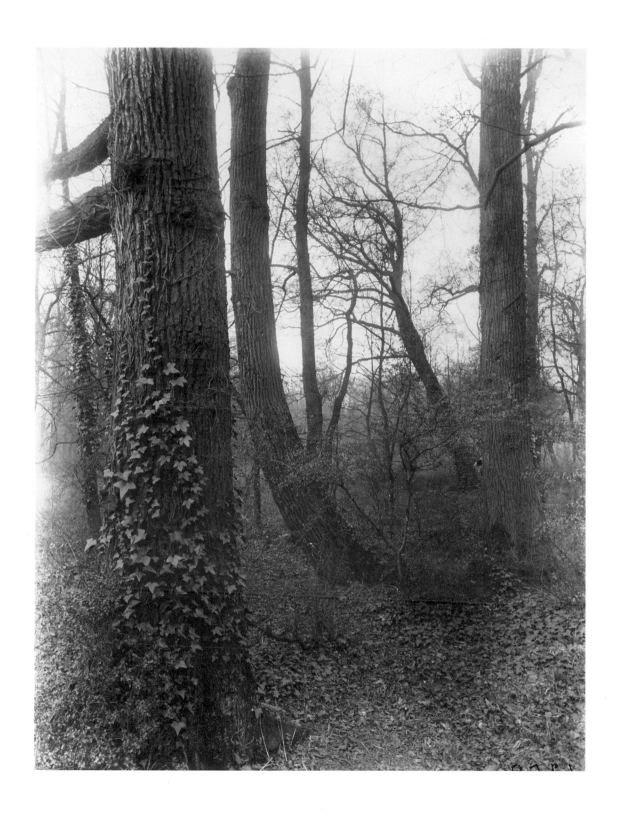

Pl. 17  *Saint-Cloud*  1926
(Cat. 94)

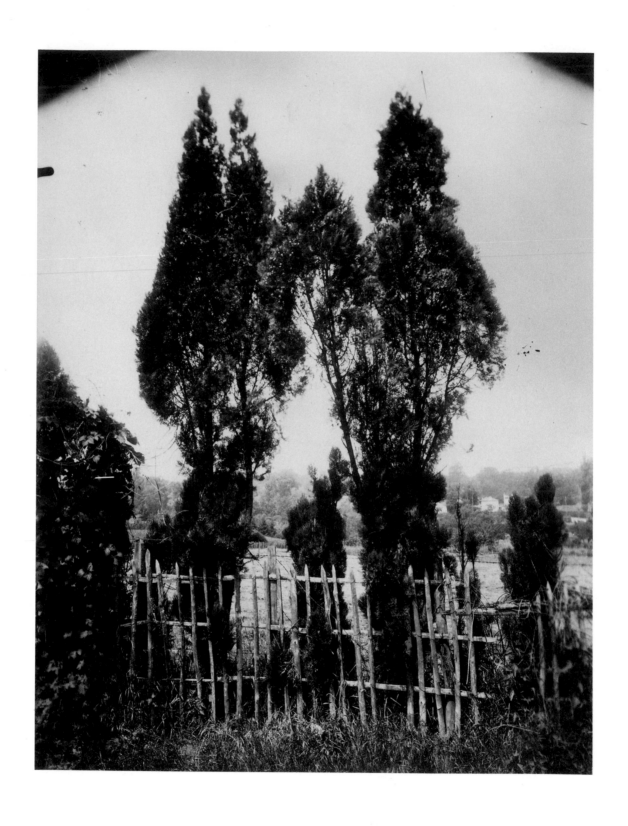

Pl. 18 *Cypresses* 1921
(Cat. 83)

Eugène Atget 1857–1927

Pl. 19  *Saint-Cloud*
1919–1921
(Cat. 78)

Plates

Pl. 20  *Saint-Cloud*
1915–1919
(Cat. 115)

Eugène Atget  1857–1927

Pl. 21 *Trianon, Pavillon*
*Français* 1923–1924
(Cat. 148)

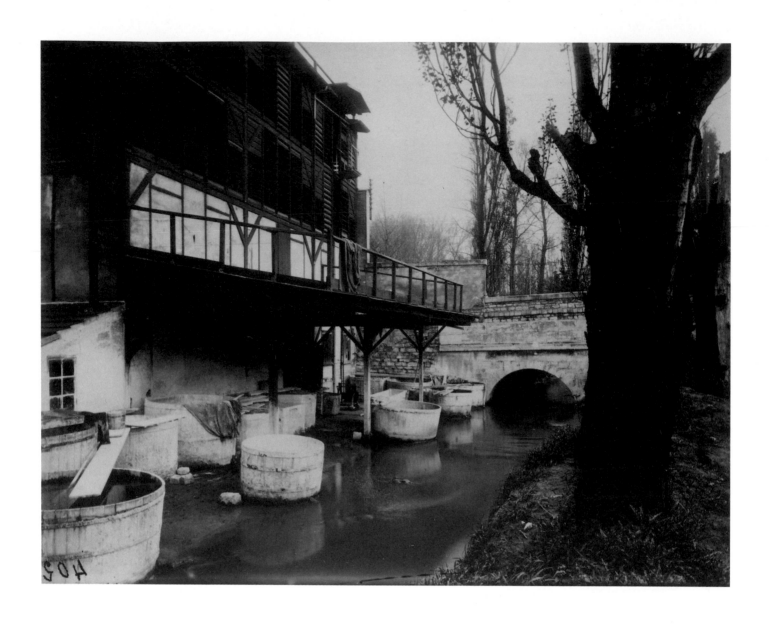

Pl. 22  *The Bièvre, Porte
d'Italie*  1913
(Cat. 54)

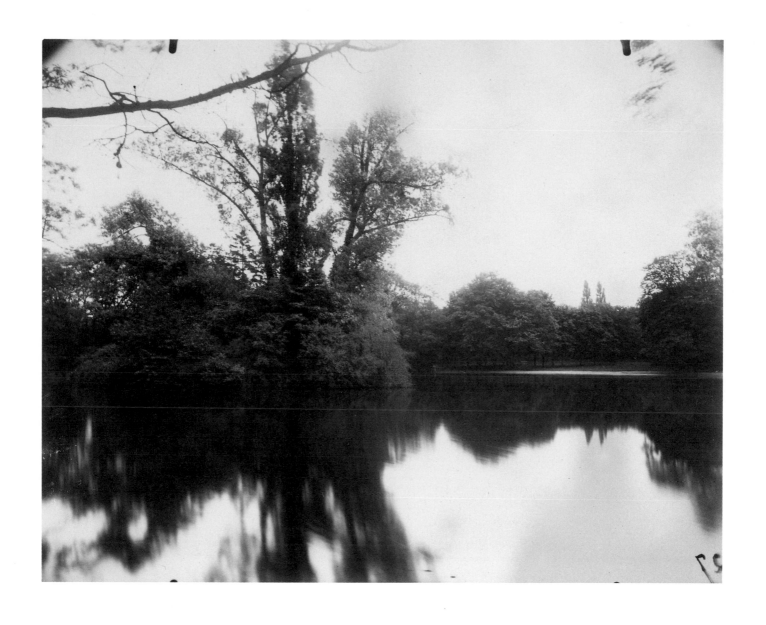

Pl. 23  *Bois de Boulogne*  1923
(Cat. 71)

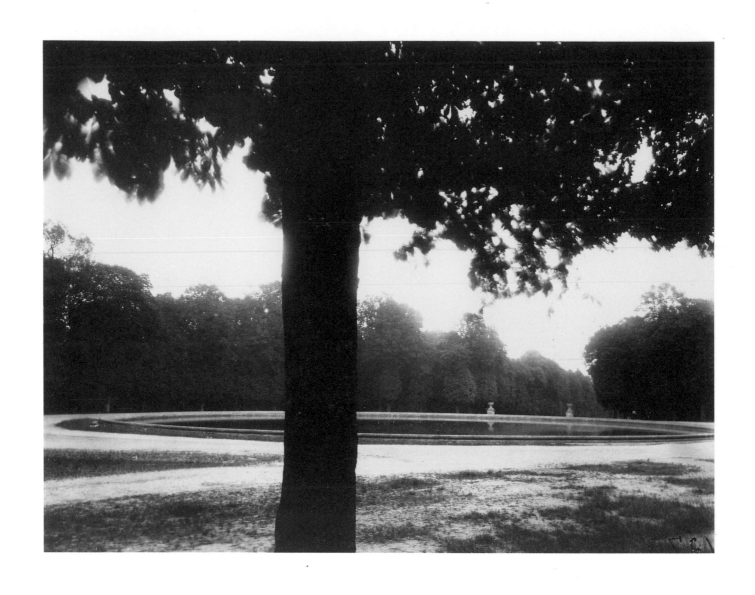

Pl. 24   *Saint-Cloud*
June 1926
(Cat. 96)

Eugène Atget   1857–1927

# Catalogue

**Photographs by Eugène Atget in the Collection of the National Gallery of Canada**

## Quantity and Provenance

As of date of publication (1984), the National Gallery owns 149 photographs by Eugène Atget, acquired between 1967 and 1974. All are original prints made during Atget's lifetime, with the exception of eight printed by Berenice Abbott from Atget's negatives, possibly in the 1930s. Although the bulk of the collection (i.e., 119 prints) was purchased from the Museum of Modern Art, New York, the remaining photographs were acquired from a private collector, or were the result of donations made by Dorothy Meigs Eidlitz of New York and St. Andrews, New Brunswick, and David M. Heath of Toronto, Ontario.

The work acquired from the Museum of Modern Art consists of duplicate prints from the Berenice Abbott collection. When Atget died in 1927, André Calmettes, executor of the estate, turned over some 2 000 negatives of Paris subjects to the Commission des Monuments historiques. The remainder – approximately 1 300 negatives and 5 000 prints – he set aside. Although this material also contained Paris views, most were of either non-architectural work or subjects outside the city, apparently of no interest to any of the Paris archives. In 1928, Berenice Abbott, who was working in Paris as a photographer, and who had known Atget during the last several years of his life, persuaded Calmettes to sell her the remainder of the estate. Her collection provided the images for *Atget: Photographe de Paris*, preface by Pierre Mac-Orlan, published by E. Weyhe, New York, 1930. It was also the source for most of the Atget exhibitions that were to follow over the years in America.

In 1968, the Museum of Modern Art (MOMA) purchased Abbott's Atget collection. A number of the images in her collection existed in more than one print. In 1970, the National Gallery began to purchase some of this duplicate material, eventually acquiring 119 prints from MOMA.

## Processes

All medium descriptions in the catalogue refer to prints. The posthumous prints by Berenice Abbott are all on gelatin silver paper with a semi-mat surface, contact printed from the original glass negatives. They are warm black and white in colour, with some light brown tints, possibly the result of toning, and were dry-mounted on mat board. The one exception to this is cat. 45, which was printed on a soft, textured, mat paper, and is an enlargement made from the original negative.

The remainder of the prints were made during Atget's lifetime and consist of three different papers: a light-weight albumen silver paper with its normal semi-gloss surface, a heavy-weight gelatin silver paper with a high-gloss surface, and a heavy-weight soft mat paper without any apparent emulsion. All the mat papers in the collection are identified simply as mat silver. Most are mat albumen paper, although there may be a possibility that some are mat collodion. It is difficult to distinguish between these two mat papers with the naked eye. Albumen papers were phased out shortly after World War I, but Atget was able to continue using them until at least 1923, which is the last date for a regular albumen paper in the National Gallery's Atget collection.

The colour of these prints varies from a medium, milk-chocolate brown for the regular albumen paper to a rich, dark chocolate for the gelatin paper. The mat papers contain softer, cooler browns. The highlights of the regular albumen and gelatin papers vary from warm and sometimes even pink whites (in some albumen and gelatin papers a pink dye was added during manufacture) to a light yellow typical of albumen papers.

The middle tones sometimes have a distinct reddish tint.

Nothing is known of Atget's reasons for printing some images on the mat paper. The collection contains mat papers printed from negatives dated from as early as c. 1899 (cat. 5) and as late as 1924 (cat. 131). In a number of instances, he printed the same negative on both mat and glossy papers. Certainly the glossy papers present a snappier image with more precise surface information. The mat papers are softer, more atmospheric, and emphasize a quality of light that is less descriptive and more emotional.

## Inscriptions

Inscriptions are recorded as they appear in Atget's hand, in graphite pencil, on the reverse of the print, complete with his personal style. Atget alternately used the comma and the dash for the same purpose – or frequently used neither. His use of capital letters was inconsistent, and the number for a street address sometimes appears after the street name, in the European fashion, and sometimes before. Prints by Atget that were dry-mounted by Berenice Abbott have the titles transcribed in another hand on the reverse of the mount. These have been accepted as literal transcriptions of the Atget inscription. A few unmounted prints have additional inscriptions in another hand. These are additions, made by MOMA, of information taken from a duplicate print. Atget was not always consistent in the amount of information he recorded on the back of a print. Abbott's reprints have no inscription.

## Titles

In keeping with accepted practice where Atget's work is concerned, titles are derived from his inscriptions, keeping as close as possible to the original, but eliminating the inconsistencies and the spelling errors, and conforming to such stylistic usages as the full spelling of *Saint*. When other prints are known to exist with fuller inscriptions than in the National Gallery's version, these have been added to the title. But the guiding principle in such changes has been to respect the spirit of Atget's own titles.

Atget's approach to titles shows more concern for place than for subject, as though he were calling our attention, not to the strict recording of a specific object, but to a significant moment of vision. Contrary to the recording practices of the topographical documentarian, who ensures that the title spells out the contents of the photograph, Atget let the photograph speak for itself in the matter of detail. Nineteenth-century French photographers had established the custom of ordering the information in titles or captions on different levels, beginning with the general and ending with the specific, e.g., *Paris. Notre-Dame Cathedral. The Red Door*.

Atget frequently went no further than the general. In fact, part of the individuality of his work lies in his understanding of each photograph as only one segment of reality. Through a number of such segments, the character of a place was established. For instance, Atget's photographs of Versailles stress the detail of the park rather than its grand plan. The latter was the approach taken by most of the commercial photographers of the time with their overall views. As a result, through hundreds of intimate glimpses, Atget presents us with a far more rich and rewarding experience of this enormous and complex heritage.

For the viewer, the effect of such a general approach to titling is to leave the door open to further enquiries. Atget presents us with a glimpse, not fully explained, and invites us, indeed challenges us, to make our own discoveries and decisions.

Notwithstanding the above, Atget sometimes did provide a detailed description of the object in the photograph. In the maquette he produced for a book on the art of Old Paris, his captions beneath the photographs included the brief place title followed by a descriptive paragraph outlining the history of the object photographed.

## Dating

Atget seldom dated his photographs. Sometimes only the month or the hour appears, as though these were the relevant factors in interpreting the image. Only five of the National Gallery's prints include a date in the inscription. The dating of all other photographs in the collection has been provided by MOMA, and is derived from inscriptions on the prints and albums in the MOMA collection or has been calculated from Atget's negative numbers. A chart listing the correlation between dates and negative numbers appears at the end of *The Work of Atget*, vol. 3, *The Ancien Regime*, New York: Museum of Modern Art, 1983.

## Numbering

Each work is identified by two numbers. The first is Atget's negative number, which is preceded by either one or two letters. The letters correspond to Atget's own series titles and hence those used by MOMA in their identification, with the exception of the D (for *Documents*) series. The latter represents the series designated as LD (*Landscape – Documents*) by MOMA. By making this minor change, the series designation can be kept bilingual, thus maintaining the same abbreviations for both English and French editions of the catalogue. The second number, which is preceded by P, as in P67:032, is the National Gallery's Photographs Collection departmental acquisition number. The first term refers to the year of acquisition.

## Atget's Series

According to Maria Hambourg, Atget had only one series in the beginning. Although it had no name, a consistent numbering sequence was maintained. This is our D series (*Landscape – Documents* in the MOMA designation). Its topic was the land, with images of fields, forests, and waterways, as well as the fauna and flora of France. Until 1900, the series also contained views of boats, farm buildings, and other rural structures. After 1900, any of these latter subjects found outside Paris were placed in the *Environs* series.

The earliest named series is *Art in Old Paris*. It begins in 1898 with negative numbers starting around 3000 and ends in April 1927 with no. 6721. A more detailed discussion of Atget's series and his system of numbering may be found in "Notes to the Plates" in the first three volumes of *The Work of Atget*, New York: Museum of Modern Art, 1981, 1982, and 1983.

Atget's series represented in the National Gallery's collection are AP: *Art in Old Paris*; D: *Documents*; E: *Environs* and *Art in the Environs*; i: *Interiors*; PP: *Picturesque Paris*; pp: *Parisian Parks* subseries; s: *Sceaux* subseries; sc: *Saint-Cloud* subseries; T: *Topography of Old Paris*; v: *Versailles* subseries. For the purpose of this catalogue, however, the number of series has been reduced to six groups, i.e., *Paris* (with *Parisian Parks* and *Bagatelle* appearing at the end of *Paris* as subgroups), *Documents*, *Environs*, *Saint-Cloud*, *Sceaux*, and *Versailles*, in that order. Each group respects one of Atget's principal themes, but sometimes cuts across the boundaries of his own series designations. Hence, a *Saint-Cloud* number may have been grouped with *Documents* because its subject matter shows more concern for trees than for the park, while in the beginning most *Saint-Cloud* and *Versailles* photographs belonged to the *Environs* series. Only later did Atget create the subseries for *Saint-Cloud*, *Sceaux*, and *Versailles*.

## Measurements

All measurements are in centimetres and correspond to the maximum size of the image, excluding the dark border created by the negative holder. Height precedes width.

# Paris

**1** *Door, Hôtel de Cluny* 1898
Inscribed: Porte Cluny
Albumen silver print,
21.5 × 17.9 cm
AP:3566 / P74:319
Purchased 1974

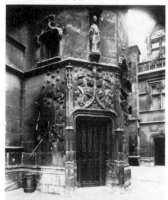

5th Arrondissement. Located on the Rue Du Sommerard, and built by the Monks of Cluny between 1485 and 1498 as their Paris residence, the Hôtel de Cluny is a remarkable example of the Flamboyant Gothic style. It was opened to the public as a museum of the Middle Ages in 1844. The pentagonal tower in Atget's photograph contains a circular staircase.

**2** *Former Amphithéâtre Saint-Côme, Rue de l'École-de-Médecine* 1898
Inscribed: Ancien Amphithéatre St Côme Rue de l'Ecole de Médecine
Albumen silver print,
22 × 18 cm
AP:3568 / P74:336
Purchased 1974

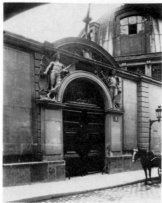

5th Arrondissement. Headquarters for the brotherhood of surgeons and barbers from 1656. The dome in the photograph was the anatomy theatre of the School of Surgery built by Charles and Louis Joubert between 1691 and 1695. In 1777 the building became the École Gratuite de Dessin, to be replaced by the École des Arts Décoratifs in 1875.

**3** *Market Porter* 1898–1900
Inscribed: Fort de la Halle
Gelatin silver print,
22.8 × 17.2 cm
P:355 (formerly 3250) / P74:322
Purchased 1974

Atget's photograph shows a porter, with his traditional smock and hat, at one of Paris' many markets. Along with the following five photographs, it was one of a small series on street trades made at the turn of the century.

**4** *Organ-Grinder* 1899
Gelatin silver print by Berenice Abbott,
21.6 × 16.8 cm
PP:360 (formerly 3124) / P68:046:25
Gift of Dorothy Meigs Eidlitz, St. Andrews, N.B., 1968

**5** *Rag-Picker* 1899–1900
Inscribed: Chiffonnier
Mat silver print,
23 × 17.8 cm
PP:363 (formerly 3276) / P70:129
Purchased 1970

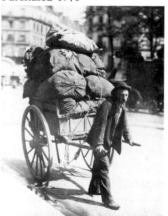

The rag-picker, a common sight on Paris streets for several hundred years, was an equally common figure in 19th-century popular iconography, symbolizing the natural philosopher.

**6** *Lampshade-Peddler* 1899–1900
Albumen silver print,
21.2 × 16.9 cm
PP: 3196 / P70:130
Purchased 1970

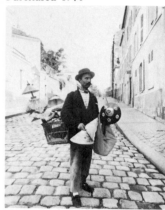

**7** *Postman* 1899–1900
Inscribed: Facteur
Albumen silver print,
21.9 × 17.9 cm
PP:3200 / P74:275
Purchased 1974

**8** *Bread-Woman* 1899–1900
Gelatin silver print by
Berenice Abbott,
22.3 × 16.9 cm
PP:3214 / P68:046:29
Gift of Dorothy Meigs Eidlitz,
St. Andrews, N.B., 1968

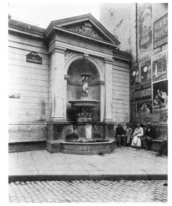

**9** *Courtyard, 7 Rue de
Beautreillis* 1900
Inscribed: Cour Rue
Beautreillis 7
Albumen silver print,
17.6 × 21.8 cm
AP:3962 / P74:307
Purchased 1974

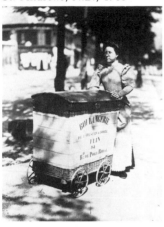

4th Arrondissement. The Rue
Beautreillis dates from 1556.
No. 7 was built as the home of
a bourgeois in 1596, and is still
known as one of the most
pleasant examples of 16th-
century domestic architecture
in Paris.

**10** *Fountain, Rue
Charlemagne* 1900
Inscribed: Fontaine
Charlemagne / Rue
Charlemagne / 1900
Albumen silver print,
21.5 × 17.4 cm
AP:3969 / P74:320
Purchased 1974

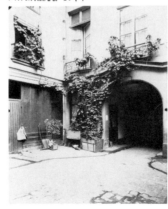

4th Arrondissement. The
street dates from the 7th cen-
tury, but was renamed in 1844
after the neighbouring Lycée
Charlemagne. The fountain,
next to No. 8, was installed in
1846.

**11** *Courtyard, 3 Rue des
Lions-Saint-Paul* 1900
Inscribed: Cour 3 Rue des
Lions St Paul
Albumen silver print,
22 × 17.7 cm
AP:3998 / P74:335
Purchased 1974

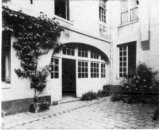

4th Arrondissement. Opened
in 1544, the street was called
originally Rue des Lions-Saint-
Paul. Although renamed Rue
des Lions even before Atget's
time, it continued to be
referred to by its old title.
No. 3 is an 18th-century man-
sion known as the Hôtel des
Parlementaires, named after
the resistance of the Parliamen-
tarians during the uprising of
the Fronde in Paris,
1648–1653.

**12** *Former Théâtre Doyen and
the House in Which the Massa-
cres of the Rue Transnonnain
Took Place* 1901
Inscribed: La Rue Beaubourg –
Encien theatre / Doyen et
maison ou ont eu lieu le /
14 avril – 1834 – les Massacres
de la Rue / Transnonnain –
R Beaubourg – Depuis
1851 / (IIIᵉ)
Albumen silver print,
21.4 × 17.7 cm
AP:4293 / P67:034
Purchased 1967

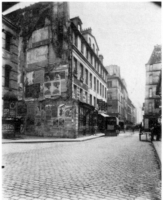

3rd Arrondissement. The Rue
Transnonnain, opened in the
early 13th century, formed
part of the Rue Beaubourg in
1851. The former Théâtre
Doyen, established on the Rue
Transnonnain before 1805
(later 62 Rue Beaubourg),
became the site of a bloody
massacre of insurrectionists on
14 April 1834 by the National
Guard under General Bugeaud,
known as the "butcher of the
Rue Transnonnain" – an event
memorialized by Honoré
Daumier in his lithograph, *Rue
Transnonnain, 1834*. The fact

that Atget placed this image in
his series *Art in Old Paris* sug-
gests that its subject may have
been as much concerned with
the wall of posters and the
vespasienne at the extreme left
as with the theatre and the
massacre. See cat. 27.

**13** *Former Théâtre Molière,
82 Rue Quincampoix* 1901
Inscribed: Ancien théâtre
Molière, fondé en 1791 – par
Boursault Malherbe / R quin-
campoix 82 (3ᵉ arr)
Albumen silver print,
21.8 × 18 cm
AP:4392 / P67:036
Purchased 1967

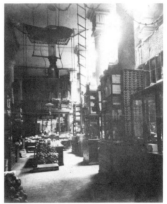

3rd Arrondissement. Rope
shop containing the remains of
the loges and galleries of the
Théâtre Molière founded in
1791 by Jean-François
Boursault-Malherbe (1752–
1842) and closed finally in
1832. Boursault (he later added
Malherbe) had been an actor
who turned to politics during
the Revolution. An enemy of
Robespierre, he was elected to
the Convention in 1791, even-
tually became its secretary,
then head of the Voirie de
Paris (department of roads and
transportation) in 1808 under
Napoleon. In 1829 he pur-
chased the Opéra-Comique.

**14** *Luxembourg Gardens*
1902–1903
Inscribed: Luxembourg
Mat silver print,
22.6 × 18 cm
AP:4644 / P74:294
Purchased 1974

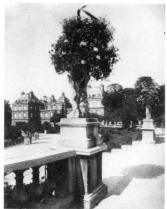

6th Arrondissement. View from the east terrace of the gardens toward the Luxembourg Palace. They are the only remaining Renaissance gardens in Paris. The palace was built for Marie de Medici in 1615 by Salomon de Brosse and decorated with paintings commissioned of Rubens in 1622. It was used as a prison during the Revolution, and with Napoleon it was reserved for the use of the Senate. Atget's photographs of this subject always seem to be more concerned with the gardens than with the building, although the earlier work also included people enjoying themselves in the park.

**15** *7 Rue de l'Estrapade*
1905
Inscribed: 7 Rue de L'Estrapade
Albumen silver print,
21.4 × 17.7 cm
AP:5032 / P74:269
Purchased 1974

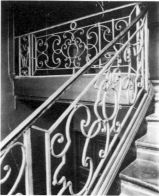

5th Arrondissement. Hallway of a private mansion built in 1726 by the entrepreneur Pierre Rivoix. The building was confiscated by the State under the Revolution. The author Pierre Loti was hospitalized there in 1866 when it served as quarters for the Institut Jubé. In 1869 it was converted to apartments in which lived, around the turn of the century, the zoologist Lacaze-Duthiers, the painter Baudouin, and the poet and dramatist Charles Péguy. The wrought-iron stair rail is Louis XVI.

**16** *Courtyard, Rue Saint-André-des-Arts* 1905
Inscribed: Cour / Rue St André des Arts
Albumen silver print,
21.3 × 17.2 cm
AP:5099 / P74:334
Purchased 1974

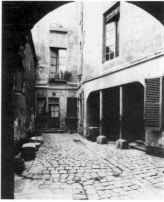

6th Arrondissement. One of the most important streets on the Left Bank in the Middle Ages, although it did not receive its present name until the 16th century. The building is unidentified. Atget often concentrated on courtyards because they were usually closer in spirit and appearance to the building's origins.

**17** *The Mint, Quai de Conti*
1905–1906
Inscribed: La Monnaie quai Conti
Albumen silver print,
22 × 17.6 cm
AP:5224 / P74:305
Purchased 1974

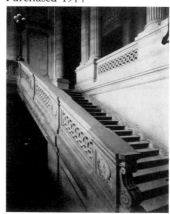

6th Arrondissement. The Quai de Conti was constructed in 1662 and given its present name in 1670 when it became the residence of the Princesse de Conti, niece of Mazarin. For brief periods at the end of the 18th century it was also called Quai de la Monnaie, when the Conti mansion was purchased by the City and the Mint was built on its site by the architect Jacques-Denis Antoine from 1771–1777. Its grand staircase, surrounded by Ionic columns, reflects both the elegant and sober spirit of Louis XVI architecture, of which the Mint is the earliest example.

**18** *Hôtel de Roquelaure, 246 Boulevard Saint-Germain*
1905–1906
Inscribed: Hotel de Roquelaure / Bd St Germain 246
Albumen silver print,
22.5 × 18.1 cm
AP:5289 / P74:289
Purchased 1974

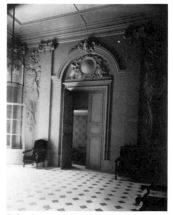

7th Arrondissement. The Hôtel de Roquelaure was begun in 1722 by Lassurance and completed in 1733 by Leroux. It was purchased in 1726 by the Duc de Roquelaure, Marshal of France. Confiscated during the Revolution and used as an asylum for contagious skin diseases, it was returned to private ownership and became the residence of the Prince et Duc de Parme, Archchancellor of France and President of the Senate, in 1808. Extensive restorations were carried out at this time by the State. Since 1840 it has been the Ministry of Public Works. The wall decorations, with pilasters and trophies, are typical of 18th-century French classical style. See cat. 19.

**19** *Hôtel de Roquelaure,*
*246 Boulevard Saint-Germain*
1905–1906
Inscribed: Hotel de Roquelaure
Mat silver print,
17.8 × 22.5 cm
AP:5307 / P74:282
Purchased 1974

According to Maria Hambourg, Atget usually photographed his interiors in public buildings, such as the Hôtel de Roquelaure, because access to such places was so much easier than to private residences. This detail of *boiserie* or panelling from the Roquelaure is a beautiful example of the transition between the Rococo of Louis XV and the Classicism of Louis XVI. The balance of the mirror image of the motif's basic framework is typical of the new Classical style, but there is still a holdover from the earlier Rococo in the subtle imbalances created by the floral arrangements. Atget's use of light to make the design glisten has turned the bas relief into a sensuously visual treat. See cat. 18.

**20** *Saint-Germain-des-Prés*
1906–1907
Inscribed: St Germain des Prés
Albumen silver print,
21.8 × 18.1 cm
AP:5344 / P72:319
Purchased 1972

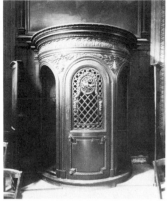

6th Arrondissement. Saint-Germain-des-Prés is the oldest church in Paris. Parts of the present structure date from the 10th century, when the original monastery, built between 542 and 558 by Childebert, son of France's first Christian King, Clovis, was destroyed four times by the Normands. It contains the tombs of Descartes, Mabillon, Montfaucon, and Boileau. Atget's photograph shows a confessional, beneath a painting by Jean-Hippolyte Flandrin, that is decorated in the style of Louis XVI. The dove in the grillwork symbolizes the Holy Spirit.

**21** *Cloître Saint-Honoré, Rue des Bons-Enfants* 1906
Inscribed: Cloitre St Honoré / cote de la rue des Bons Enfants (1e)
Albumen silver print,
21.6 × 17.7 cm
T:17 / P72:306
Purchased 1972

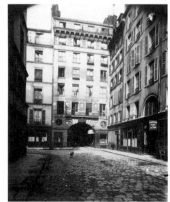

1st Arrondissement. The Rue des Bons-Enfants had its origins as a road between Paris and Clichy in the 12th century. Its name derived in the 13th century from the Collège des Bons-Enfants, although for a time before the 14th century it was also known as the Rue des Écoliers-Saint-Honoré. The collegiate church of Saint-Honoré was built on the Rue Saint-Honoré in 1204, but its courtyard or cloister, shown in the photograph, was entered from the Rue des Bons-Enfants. The church was demolished in 1792, and a number of houses were built in and around the courtyard. The building in the background of Atget's photograph is a fine example of late 18th-century architecture, although the top is a 19th-century addition. These houses were demolished and the cloister was closed in 1913.

**22** *Remains of the Hôtel de Saint-Chaumond, 226 Rue Saint-Denis* 1907
Inscribed: Restes de l'hotel St Chaumont / 226 rue St Denis (2e)
Albumen silver print,
21.8 × 17.8 cm
T:149 / P72:316
Purchased 1972

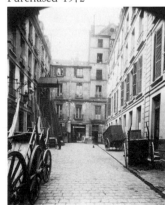

2nd Arrondissement. The Rue Saint-Denis was originally part of a Roman highway from Lutetia (Paris) to Saint-Denis, Pontoise, and Rouen. It served as the royal route for triumphal processions of medieval kings making their way to Notre-Dame. The Marquis de Saint-Chamond (subsequently changed to Saint-Chaumond), Richelieu's ambassador, built a mansion at Nos. 224 and 226 after 1631. In 1683 the Hôtel de Saint-Chaumond was purchased by the Filles de l'Union-Chrétienne as an orphanage. In 1734 the convent built a lodging in the style of Louis XV which now forms part of the courtyard of No. 226. In 1790 the convent was closed.

**23** *Rue Montorgueil seen from Rue Tiquetonne* 1907
Inscribed: Rue Montorgueil – Vue prise de la rue Tiquetonne (2e)
Albumen silver print,
21.5 × 18.1 cm
T:171 / P67:037
Purchased 1967

2nd Arrondissement. Dating from the 13th century, this section of the street was originally named Montorgueil because it led to Mont Orgueilleux (Mount Pride), the summit of which is now occupied by the Rue Beauregard, some eight blocks further up the street. A number of aristocrats built homes on the street in the 18th century, several of which were noted for their wrought-iron balconies. In the 19th century the street was known as a centre of the oyster trade, and in Atget's time was looked upon as one of the most picturesque and characteristic of the older streets of Paris. See cats. 26 and 40. The painted sign of

the angel blowing a trumpet at the right of the photograph may partially explain Atget's choice of location along the street.

---

**24** *Hôtel du Duc de Coislin, 41 and 43 Rue Greneta* 1907
Inscribed: Hotel du Duc de Coislin / 41 et 43 rue Grenéta (2ᵉ)
Albumen silver print, 21.7 × 17.8 cm
T:182 / P72:314
Purchased 1972

2nd Arrondissement. The street dates from the union of three streets in 1868 and retains the name of that section to the west of the part shown in the photograph. In 1313 that part of the street upon which the Hôtel de Coislin stood was known as Percée, and at the end of the 14th century as Renard-Saint-Sauveur. The Duc de Coislin built his mansion at Nos. 41 to 43 at the end of the 17th century, with a smaller house at No. 39. Both were demolished in 1909.

---

**25** *Cabaret Empire, 51 Rue Saint-Sauveur* 1907
Inscribed: Cabaret empire 51 Rue / St Sauver (2ᵉ)
Albumen silver print, 22.2 × 18 cm
T:199 / P72:308
Purchased 1972

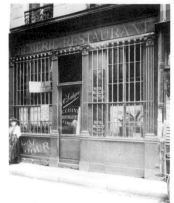

2nd Arrondissement. One street north of the above (cat. 24), Saint-Sauveur had acquired its name by 1285 from the church located thereon. No. 51 was a restaurant, apparently known in Atget's time as the Cabaret Empire, which he photographed for its grillwork.

---

**26** *The Compas d'Or, 51 Rue Montorgueil* 1907
Inscribed: Au Compas d'or 51 Rue Montorgueil (2ᵉ)
Albumen silver print, 21.6 × 18 cm
T:204 / P67:041
Purchased 1967

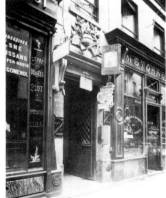

2nd Arrondissement. See cat. 23. Atget was interested in signs, even the confusion of a welter of signs, and especially in the heraldic emblems of the *ancien régime*, as in the bas relief over the entrance to No. 51 with its compass. Many of these were rapidly disappearing, as numbers and street names became more customary (see cat. 32). It is not clear whether this compass has any

relation to the Auberge Au Compas d'Or further along the street (see cat. 40). The one may have derived from the other.

---

**27** *Rue des Deux-Écus during Demolition* September 1907
Inscribed: Rue des deux écus pendant sa démolition / 7bre 1907 (1ᵉ)
Albumen silver print, 18.1 × 21.9 cm
T:214 / P67:040
Purchased 1967

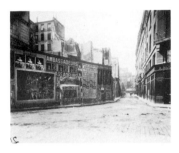

1st Arrondissement. The name of this street dates from about 1325. The extension of the Rue du Louvre eliminated the western end of Rue des Deux-Écus in 1888. In 1907 demolition of its south side broadened it to form the continuation of the Rue Berger, which had been constructed in 1860, and from which it derived its new name.

---

**28** *Corner of Rues du Jour and de la Coquillière, from Les Halles* 1907
Inscribed: Coin Rue du Jour et / Coquillière Vue prise des / Halles (1ᵉ)
Albumen silver print, 21.7 × 17.9 cm
T:218 / P67:033
Purchased 1967

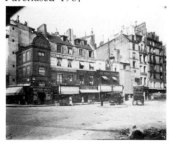

1st Arrondissement. The view is seen from Paris' central market, Les Halles. Constructed in 1292, Rue Coquillière, at the left of the photograph, was named after a wealthy family, Coquillier, who owned the surrounding land. Between the 13th and the 17th centuries a number of mansions were constructed at this end of the street, including the first Hôtel de Nesle (later the Hôtel d'Orléans) and the Hôtel de la Reine (later the Hôtel de Soissons). The Rue du Jour dates from an earlier period, but received its present name as a contraction of Séjour, a country lodge built by Charles V in the 14th century. As a public market place, Les Halles dates from 1135. The houses on this corner are all from the 17th century. The narrow building at the left in Atget's photograph was the chapter house, before the Revolution, for the Church of Saint-Eustache. Next to it is the sign of the Cadran d'Or, and next to that is the Hôtel de Royaumont, a town house built by the Abbé de Royaumont, Bishop of Chartres, in 1612. Part of the house was rented in 1627 to the Comte de Montmorency-Bouteville, with whom it became a notorious rendezvous for duellists. In Atget's time, the painted sign next door advertised a café, *Au Beau Noir*.

**29** *Cabaret de l'Enfant-Jésus,*
*33 Rue des Bourdonnais* 1908
Inscribed: Cabaret de LEnfant
Jesus / Rue des Bourdonnais 33
(1ᵉ arr)
Albumen silver print,
21.5 × 17.7 cm
T:264 / P67:032
Purchased 1967

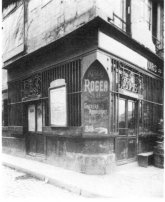

1st Arrondissement. The original street dates from the 13th century, if not earlier, but received its name finally in 1852 from one of four short streets when they were joined together at that time. The building in Atget's photograph belonged to the Comte d'Hauterive in 1858, and is located between the Rue de Rivoli and the Rue Saint-Germain l'Auxerrois (see cat. 30). The bar or restaurant on the ground floor was known for its grillwork.

**30** *Rue des Bourdonnais* 1908
Inscribed: Rue des Bourdonnais (1ᵉ arr)
Albumen silver print,
22 × 17.9 cm
T:280 / P67:038
Purchased 1967

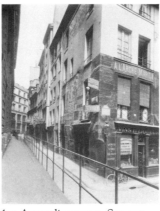

1st Arrondissement. See cat. 29. Atget's photograph was made at the corner of the Rue Saint-Germain l'Auxerrois and Rue des Bourdonnais, looking north along the latter. This part of the street had been called Thibaut-aux-Dés since the early 13th century and Thibautodé since the 15th. Behind Atget, the street at one time sloped down to the banks of the Seine, passing under an arch over which ran the Quai de la Mégisserie. The arch was called the Arche Marion after the woman who ran the bath houses on the river from 1565. Hence, the name on the old house in Atget's photograph. Some of the houses on this part of the street date from at least the 17th century. In the 18th century, the painter Noël Hallé (1711–1781) or the descendants of the painter Daniel Hallé (1614–1675) are believed to have lived halfway along the block at No. 14. Jean-Baptiste Greuze (1725–1805) also had his studio on this street in 1778.

**31** *Rue du Maure seen from Rue Beaubourg* 1908
Inscribed: Un coin de la rue du Maure / Vue prise de la rue Beaubourg (3ᵉ)
Albumen silver print,
21.7 × 17.9 cm
T:311 / P72:312
Purchased 1972

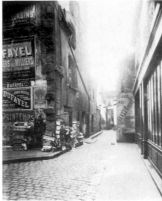

3rd Arrondissement. Early in the 14th century the street was called Jehan-Palée, after the founder of the Hôpital de la Trinité, and in 1606 the Cour du Maure, after a signboard. The Abbots of Clairvaux, followed by Reigny, had a town house in this short street from 1321 to 1788. In 1559 the street had become such a den for thieves it was closed off at either end with iron gates. The fact that Atget, in his inscription, referred to this as "a corner of the Rue du Maure," suggests that the reason for the photograph was the picturesqueness of the old street.

**32** *À la Cloche d'Or, 193 Rue Saint-Martin* 1908
Inscribed: A la Cloche d'or 193 / Rue St. Martin (3ᵉ)
Albumen silver print,
21.9 × 18 cm
T:318 / P72:311
Purchased 1972

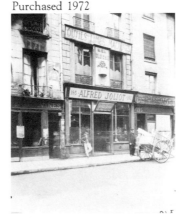

3rd Arrondissement. In 1851 three old streets dating from before 1130 were joined together and named after the most northern section, which ends at the Blvd Saint-Denis. According to Maria Hambourg, most of Atget's photographs of signs were made between 1900 and 1902 and were a product of an aspect of the campaign to save Old Paris. The tradition of using wrought-iron pendants, painted signboards, and sculptured relief signs as the means of identifying a building had given way in the 19th century to street names and numbers as a result of increasing literacy. By Atget's time, many of these signs were disappearing. See cat. 26.

**33** *Home of de La Reynie,*
*Lieutenant-General of Police,*
*34 Rue Quincampoix* 1908
Inscribed: habitation de la Reynie / Lieutenant de police 34 rue / Quincampoix (4ᵉ)
Albumen silver print,
21.8 × 17.8 cm
T:349 / P67:039
Purchased 1967

4th Arrondissement. The street is the result of the union in 1851 of two streets dating from at least the beginning of the 13th century, taking its name from one of them, originally Quiquenpoist, in 1203. Most of its buildings are of the 17th and 18th centuries. Gabriel-Nicolas de La Reynie (1625–1709), the first Lieutenant-General of the Paris Police, was thought to have

lived here. De La Reynie was appointed head of police by Louis XIV in 1667, and is known for having cleaned up the streets of Paris, installed street lamps, and established street patrols. Atget's interest may have been caught more by the decorative arch in the doorway than by the house's historic importance.

---

**34** *The Louvre, Fireplace*
1908
Inscribed: Louvre (cheminée)
Albumen silver print,
21.4 × 18.2 cm
AP:5567 / P74:273
Purchased 1974

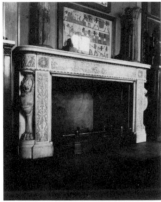

The part of the Louvre known as the Charles X Museum was redecorated and opened in 1827. The fireplaces in this photograph and the following (cat. 35) are probably additions made at that time. Four of the rooms were devoted to the display of Egyptian antiquities. This one is the Salle du Scribe, named after one of the works on display. The relief frieze along the top of the fireplace contains references to the winged animals and gods of Mediterranean antiquity. Fireplaces, as a focus for ornamentation, figured prominently in studies of decorative art in Old Paris around the turn of the century. They are a conspicuous subject in Atget's interior views.

**35** *The Louvre, Fireplace*
1908
Inscribed: Louvre / Paris Louvre
Albumen silver print,
21.8 × 17.8 cm
AP:5570 / P74:270
Purchased 1974

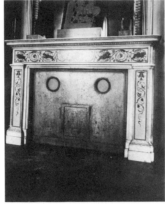

See cat. 34.

---

**36** *Saint-Lazare Convent Apartments, 103 Rue du Faubourg-Saint-Denis* 1909
Inscribed: Maison de Rapport du Couvent St Lazare / Fb St Denis 103 (10ᵉ)
Albumen silver print,
21.6 × 17.8 cm
T:465 / P72:307
Purchased 1972

10th Arrondissement. The Rue du Faubourg-Saint-Denis has its origins in a road dating from the 8th century. It was the direct link between Paris and the rich Abbey of Saint-Denis, and it derived its name from the fact that it was the main street of the faubourg (suburb) outside the Saint-Denis gate of the Philip

Augustus Wall, built in 1190. The Grey Nuns took up residence in 1656 in a building that now occupies Nos. 94 to 114, Rue du Faubourg-Saint-Denis, across from the Saint-Lazare Prison, established a few years earlier, hence the convent's name. The convent consisted of three main buildings, a courtyard, and a garden. The prison was destroyed in 1789, and the convent was closed in 1790 and sold to a private buyer in 1797, when it was turned into apartments. Atget's photograph shows one (?) of the entrances to the courtyard, along with its grillwork and façade, which date from the 18th century.

---

**37** *Premises of the* Bulletin des Halles *in 1846, 33 Rue Jean-Jacques-Rousseau* 1909
Inscribed: Maison du Bulletin des Halles / (1846) 33 Rue Jean Jacques Rousseau (1ᵉ)
Albumen silver print,
21.7 × 18 cm
T:498 / P72:305
Purchased 1972

1st Arrondissement. In 1868 two streets dating from at least the 13th century were joined under the name Jean-Jacques-Rousseau, one of the streets having gone by that name since 1791. Rousseau (1712–1778) lived on the street at one time. No. 33 was the premises for the newspaper the *Bulletin des Halles* from 1846 to 1877. Paris' central market, Les Halles, was only a few blocks away. The Hôtel Bordeaux was

at the same location around the same time. As with similar works by Atget, the principal reason for the photograph lies in the decorative elements of the building – the clock, the relief sign, and the grillwork. See cat. 38.

---

**38** *Salle de la Redoute, 35 Rue Jean-Jacques-Rousseau*
1909
Inscribed: Salle de la Redoute Rue Jean Jacques Rousseau 35 / (1ᵉ arr)
Albumen silver print,
21.7 × 18 cm
T:497 / P72:309
Purchased 1972

1st Arrondissement. See cat. 37. Whether Atget frequently photographed building by building along a street, as in these two examples, is not known. His approach was not always so systematic. In 1637 Pierre Séguier (1588–1672), Chancellor, enlarged to vast proportions the original mansion dating from the 16th century, in which had lived, among others, Henry IV's mother. The Academie française held its meetings in Séguier's private residence from 1638 until his death, when the king acquired the property. During the 18th century it was used by the Farmers-General, first as a meeting place, then as a warehouse. Under Napoleon it became a dance hall, known as the Bal de la Redoute. Part of the building (Nos. 35 and 37 in Atget's photograph), deriving its name from the dance hall, was used

as a masonic hall beginning with the July Monarchy. In 1877 the Bourse du Travail (the Labour Exchange) moved into the Salle de la Redoute. Most of the remaining part of the Hôtel Séguier was demolished to make way for the extension of the Rue du Louvre between 1880 and 1888.

---

**39** *Corner of Rues de Bondy and Bouchardon* 1909
Inscribed: Coin de la rue de Bondi et Bouchardon, 10ᵉ
Albumen silver print,
22 × 18.1 cm
T:605 / P72:315
Purchased 1972

10th Arrondissement. The Rue Bouchardon was the extension in 1854 of the former Impasse de la Pompe. In 1864 it was named after the sculptor Edme Bouchardon (1698–1762). In Atget's photograph, Rue Bouchardon is in the background, and runs north from left to right. The Rue de Bondy enters in the foreground from the right, and represents the end of the street. The name de Bondy originated in 1771, and was replaced in 1944 by René Boulanger (1901–1944). In making the photograph, Atget had his back to the old Théâtre de la Porte Saint-Martin, which must have been a familiar spot for him.

**40** *Auberge Au Compas d'Or, 64 Rue Montorgueil* 1909
Inscribed: Auberge du Compas d'or / 64 Rue Montorgueil / (2ᵉ)
Albumen silver print,
21.6 × 17.9 cm
AP:5690(?) / P67:035
Purchased 1967

2nd Arrondissement. The Auberge Au Compas d'Or (the Inn of the Golden Compass) was established in 1510. The famous Restaurant Philippe was opened there in 1840. Atget's photograph, made in the courtyard behind the Inn, shows a corner of the hangar used as the terminus for the coaches that had run, and still continued to do so, to Creil and Dreux. Both the Inn and the ancient wooden shed were looked upon as picturesque tourist attractions in the early 20th century. See cats. 23 and 26. Atget photographed the shed from a variety of positions.

---

**41** *Residence of the Commander of the Guard, 40 Rue Meslay* 1909
Inscribed: Hotel du Commandant / de la garde de Paris / 40 Rue Meslay / (3ᵉ)
Albumen silver print,
21.8 × 17.8 cm
AP:5701 / P72:310
Purchased 1972

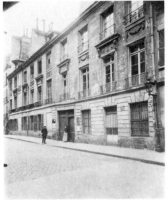

3rd Arrondissement. The original street dates from 1696, and the name from 1723, after Rouillé de Meslay, Conseiller d'État. No. 40 was an 18th-century mansion, with splendid Louis XVI bas reliefs and grillwork, occupied in 1771 by the Commander of the Guard and Captain of the Watch Firmin Le Laboureur, and in 1793 by Poultier, a member of the Convention and Commander of the Police. The building was demolished in 1913.

---

**42** *Courtyard, 28 Rue Bonaparte* 1910
Inscribed: Cour 28 Rue Bonaparte
Albumen silver print,
17.3 × 21.3 cm
AP:954 / P74:268
Purchased 1974

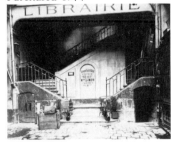

6th Arrondissement. Although the street was given its present name only in 1852, it is a union of several old roads connecting at its northern end the Place Saint-Germain-des-Prés with the Seine. No. 28 was inhabited, around 1676, by the ecclesiastical historian Jean de Launoy, famous for exposing

false legends. The building is noted for its courtyard and staircase.

---

**43** *Carmelite Market, Place Maubert* 1910–1911
Gelatin silver print by Berenice Abbott,
22.7 × 16.8 cm
PP:236(?) / P68:046:26
Gift of Dorothy Meigs Eidlitz, St. Andrews, N.B., 1968

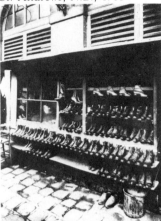

5th Arrondissement. Although the present Place Maubert dates from the 1880s, it is the site of the original public square going back at least to the 12th century, when students assembled there for lectures. By the time of Francis I, it had become a place of public torture and execution, and especially notorious for the burning of Huguenots. Public hangings continued until the mid-18th century. The Carmelite Convent stood on its southern boundary from 1313 to the Revolution. From 1818 its cloisters became a market place. At the end of the 19th century it also became a centre for selling fagends of tobacco.

**44** *Interior – Mlle Sorel of the Comédie-Française, Avenue des Champs-Élysées* 1910
Gelatin silver print by Berenice Abbott,
22.9 × 17.2 cm
i:755 / P68:046:28
Gift of Dorothy Meigs Eidlitz, St. Andrews, N.B., 1968

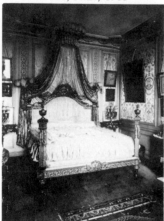

8th Arrondissement. Although the Champs-Élysées had its beginnings in the 17th century, it was not until the mid-19th century that it became the fashionable home of the rich, the elegant, and the powerful. When Atget photographed interiors, they were usually those of public buildings and embassies, for ease of access. Access to private residences, however, would have been through friends, and none more obvious than his theatrical connections, which in this instance allowed him to photograph at No. 99, in the apartment of Cécile Sorel (1873–1966), the most famous actress of the Comédie-Française of her time. The bed, a superb example of Louis XV furniture, also had its own reputation, having descended from, it was rumoured, Madame du Barry.

**45** *Interior – Photographer* 1910
Gelatin silver print by Berenice Abbott,
58.1 × 42.5 cm
PP:250 / P68:046:83
Gift of Dorothy Meigs Eidlitz, St. Andrews, N.B., 1968

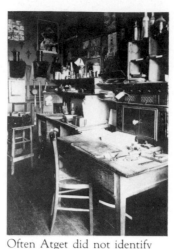

Often Atget did not identify the location of the interiors of private residences. When he photographed the interior of his own home, either he did not identify the subject or he used a general title to classify rather than particularize. In this instance, Atget's photograph shows his own studio. On his table are piles of folders, labelled, containing his prints, scissors for trimming, a straight razor (possibly for making slits in album pages for holding the corners of his prints), and a rubber stamp with his name and address that he used to mark the backs of most of the prints. The shelves contain his photographic chemicals. The Marquis de Rochegude's *Guide à travers le vieux Paris* (1903) lies on a shelf. Several glass negatives are in a wooden stand against the wall over the desk, four printing frames have been placed on the stool, and three darkroom safe lights with chimneys hang from the wall. Beside his desk appears to be a wet bench for processing. Especially fascinating are the images that adorn the walls, ranging from small photographs to advertisements to reproductions of paintings of history, genre, and landscape subjects. It is difficult to construe this as a typical photographer's studio of the turn of the century.

**46** *Door, 7 Rue Mazarine* 1911
Inscribed: Porte 7 Rue Mazarine
Albumen silver print,
22.1 × 17.8 cm
AP:5751 / P74:312
Purchased 1974

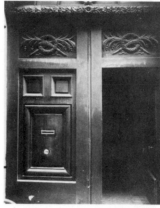

6th Arrondissement. The Rue Mazarine had its origins in the counterscarp that ran along the outside of the Philip Augustus Wall at the end of the 12th century. By the mid-16th century it was still just a path. With the demolition of the ramparts, houses began to spring up along its length. The street received its present name in 1687, when Cardinal Mazarin founded the Collège des Quatre-Nations (Palais de l'Institut), behind which it runs. According to Maria Hambourg, between 1908 and 1913 Atget filled at least four albums with photographs of doors. The doors of No. 7, decorated with their beautiful examples of Louis XVI Classicism, are considered to be of special importance. It is typical of Atget that he should have left one door open, to break the picture plane, to create a tension between the fully lit door and the deep shadow of the doorway, where most commercial photographers would have opted for the full symmetry and the complete information of the closed doors.

**47** *Port du Louvre* 1911
Inscribed: Port du Louvre
Albumen silver print,
18.1 × 21.6 cm
PP:305 / P74:295
Purchased 1974

1st Arrondissement. The Quai du Louvre had its origins in a hauling road along the Seine by the early 13th century. Part of it was constructed as a quay by Francis I in 1530, with the entire length reconstructed in 1810. It received its present name in 1868. In the days when shipping on the Seine was essential to trade in the capital, a number of the quays operated as busy ports. The Port du Louvre had been one of the most important since the 13th century. Even in Atget's time, the evidence of the photograph shows it still to be an active port. The dome of the Palais de l'Institut on the Left Bank is seen at the extreme right of the photograph.

**48** *Boulevard de Strasbourg*
1912
Inscribed: Bd de Strasbourg
Gelatin silver print,
22.2 × 17.3 cm
PP:378 / P74:329
Purchased 1974

10th Arrondissement.
Although the original boulevards of Paris date from 1670, when Louis XIV had them constructed on the site of the fortified walls that he had recently razed, the Boulevard de Strasbourg was a product of Napoleon III's reconstruction of Paris and was opened in 1852. It joined the Boulevard Saint-Denis with the Gare de l'Est, and provided one of the chief north-south arteries on the Right Bank. It contained a number of fashionable enterprises such as the hairdresser's salon in Atget's photograph. This, and the following photograph, was one of a series of shop windows begun by Atget around 1912, possibly because he thought the Bibliothèque nationale might be interested. Although as images they are much more complex, they relate to his photographs of street trades made around 1900 (see cats. 3 to 8) in that they explore the outward manifestations of Paris' commercial life. See cats. 49, 53, and 66.

**49** *Boulevard de Strasbourg*
1912
Inscribed: Bd de Strasbourg
Gelatin silver print,
22.5 × 17.7 cm
PP:379 / P70:122
Purchased 1970

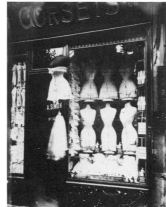

Atget's shop windows of this period capitalize on something that existed in his photographs at least as early as 1900 – reflections in windows. In the close-ups of grillwork and sculptured signs at the entrances to bars and restaurants in the early period, reflections from the street frequently overlie glimpses of interiors beyond the glass and, in more than one instance, of faces peering from inside. Even the photographer's own reflection is sometimes present. How much this layering of different worlds was consciously explored by Atget in his early photographs is hard to say, but the complexity of the layered image in the later work is so sophisticated as to suggest conscious design. In this photograph, the theatrical setting for the mannequins provided by the reflections creates a sombre and dramatic world for the headless torsos, erotic fashions, emblematic objects, and whimsical signs. See cats. 48 and 66.

**50** *Boulevard de Strasbourg*
1912
Gelatin silver print by
Berenice Abbott,
23.3 × 16.9 cm
PP:379 / P68:046:30
Gift of Dorothy Meigs Eidlitz,
St. Andrews, N.B., 1968

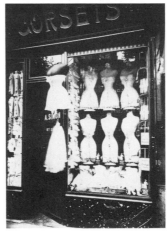

See cat. 49

**51** *Tinsmith, Rue de la Reynie*
1912
Inscribed: Etameur rue de la Reynie
Gelatin silver print,
22 × 17.2 cm
PP:380 / P74:308
Purchased 1974

1st and 4th Arrondissements. The original street has its origins at least as early as the 13th century. The section east of the Boulevard Sebastopol was named after Gabriel-Nicolas de La Reynie in 1822 (see cat. 33). The short section west of the boulevard was joined to it in 1851. The subject of the photograph relates

to the shop windows made in the same year (see cats. 48 and 49) and to the earlier street trades (see cats. 3 to 8). Atget's extreme, oblique view takes full advantage of the formal qualities of the tinsmith's wares.

**52** *Pont Marie* 1912
Inscribed: Pont Marie
Albumen silver print,
21.8 × 17.7 cm
PP:321 / P74:274
Purchased 1974

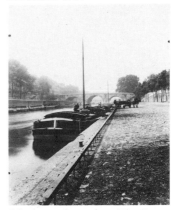

4th Arrondissement. The Pont Marie, which joins the Île Saint-Louis with the Right Bank, was constructed from 1614 to 1628 and was named after its builder. In 1788 the remaining houses on the bridge were demolished. The bridge's incline was reduced in 1851, and it has remained the same since. In Atget's time, the port in the foreground was known as the Port Saint-Paul, while the Quai des Célestins runs parallel to it. The barges show that the port was still active. On the opposite side of the Seine may be seen a row of bath houses.

**53** *32 Rue Broca* 1912
Inscribed: 32 Rue Broca
Collodio-chloride (?) silver
print, 21 × 17.3 cm
PP:391 / P74:299
Purchased 1974

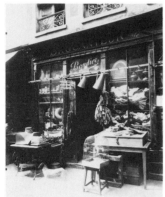

5th Arrondissement. The origins of the street are found in an old road dating from at least the 12th century. It received its present name in 1890 after a surgeon named Broca (1824–1860). In Atget's time, the Bièvre River (see cat. 54) still flowed nearby. In the 14th and 15th centuries, the homes along the street (at that time called Rue de l'Oursine) were known for their beautiful properties that ran down to the banks of the Bièvre. By the 19th century it had become a typically picturesque Paris street, narrow and winding, lined with houses of the 18th century and earlier. Atget lived only six streets away. His photograph was probably part of the series of shop windows begun around this time (see cats. 48, 49, and 66). Of special interest is the contrast between the castoffs, which are the stock in trade of the second-hand shop, and the remaining traces of elegance to be seen in the Louis XVI style of the wrought iron on the upper-storey windows.

**54** *The Bièvre, Porte d'Italie* 1913
Inscribed: La Bievre – Porte d'Italie
Mat silver print,
17.9 × 22.6 cm
PP:402 / P74:261
Purchased 1974

13th Arrondissement. The Bièvre River has an unhappy history. Its source is near Versailles, and it flows westerly through the Bièvre Valley to enter southeast Paris, where it now ends in one of its great collector sewers. Its name originates from the Celtic word for beaver, which inhabited its banks at one time. Although the river kept its pastoral appearance near Paris even into the 18th century, already during the 16th century it had acquired a reputation for the pollution caused by the many dyeworks along its banks. Herds still grazed by its shores and the frozen ponds were still used as skating rinks by Parisians in the 1870s, but by that time it had become a sewer of industrial and human waste, serving along its length starch mills, paper mills, distilleries, saltpetre works, dyeworks, glue factories, tanneries, breweries, launderies, soap, candle, and acid works. Eventually, in order to hide its muddy stench, it had to be covered over. The job was started in 1828 and not completed until well into the 20th century. At the time of Atget's photograph, sections still remained open near the Place d'Italie where it collected waste from the Gobelins Factory, fulfilling its "mournful purpose," as one tourist wrote in 1909. It is now simply an underground sewer running through southeast Paris and emptying into the Seine. Atget's photograph may belie the river's sordid end, although it contains the evidence of its exploitation by one small enterprise.

**55** *Fête du Trône* 1914
Inscribed: Fête du Trône
Albumen silver print,
17.8 × 22.8 cm
PP:502 / P74:337
Purchased 1974

11th and 12th Arrondissements. Atget may be referring, by its popular name, to an annual fair that takes place on and near the Place de la Nation for several weeks after Easter known as the Foire aux Pains d'Épice. His photograph shows a carousel equipped with airships named after the famous aeronauts of the time. The Place de la Nation (named in 1880) had been called the Place du Trône from 1660, at which time a throne had been erected on the site for Paris to pay homage to Louis XIV. During the Revolution its guillotine had operated more assiduously than any of the others, having carried out 1 306 decapitations in six weeks; among its victims were André Chenier and the sixteen Carmelite nuns from Compiègne. Atget seemed to have been fascinated by certain aspects of carnivals, for on a number of occasions he photographed carousels and the makeshift stages of the side-shows. There is an obvious relationship between the subject of these photographs and those of the street trades. (See also cat. 65).

**56** *Luxembourg Gardens* 1919–1921
Inscribed: Jardin du Luxembourg
Albumen silver print,
18 × 22.1 cm
D:956 / P74:321
Purchased 1974

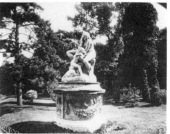

6th Arrondissement. During the reign of Louis-Philippe (1830–1848), sculpture began to make its appearance on the lawns of the Luxembourg Gardens. Among these, in a grass plot to the north of the fountains, Atget photographed Gabriel-Joseph Garraud's (1807–1880) marble *La Première Famille sur la Terre* (1844). See cat. 14.

**57** *Prostitute Taking her Shift, La Villette* April 1921
Gelatin silver print by Berenice Abbott,
23.5 × 17.5 cm
PP:12 / P68:046:27
Gift of Dorothy Meigs Eidlitz, St. Andrews, N.B., 1968

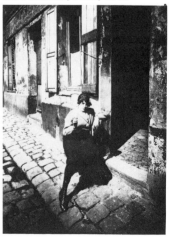

19th Arrondissement. The dreary district of La Villette, with its industrial canals, slaughterhouses, and warehouses, was Atget's first residence c. 1878. In Atget's photograph, a prostitute is on duty to lure customers into the brothel. In 1921 Atget was commissioned by the painter André Dignimont (1891–1965) to photograph prostitutes for a book he was preparing.

**58** *Boulevard de la Chapelle*
June 1921
Inscribed: Bd. de la Chapelle
Mat silver print,
17.1 × 22.7 cm
PP:21 / P74:332
Purchased 1974

18th Arrondissement. The Farmers-General Wall, which surrounded Paris from 1784 to 1859, had boulevards and roads parallelling its perimeter. After the demolition of the Wall, several of these along its northern section were united in 1864 under the name of Boulevard de La Chapelle, from the village of the same name located between the Wall and Montmartre. The buildings on the Boulevard are neither very old nor have they any special significance. By the time Atget made this photograph he was no longer concerned with the documentation of the more strictly historical or picturesque aspects of the city that had been of interest to the preservationists of Old Paris. It bears a close relationship to the shop window series begun *c.* 1912 (see cats. 48, 49, 53, and 66). Atget must have delighted in the purity of the building's forms in contrast to the fanciful elegance of the

lettering and the bizarre mystery of the shop window itself.

**59** *Notre-Dame* March 1922
Inscribed: Notre Dame
Albumen silver print,
17.5 × 22 cm
AP:6319 / P74:278
Purchased 1974

4th Arrondissement. The Cathedral of Notre-Dame is the most obvious of the historic monuments of Paris, and for this reason Atget never included it in his early work. Too many photographers had already supplied in abundance the kind of documentation of Notre-Dame required by the collectors of Old Paris. But in his old age, he could afford to please himself. During the last five years of his life, according to Maria Hambourg, he photographed the cathedral regularly, but always in his own eccentric way – either from a distance, or in almost microscopic detail (see cat. 63). His favourite view was from the Quai de Montebello where, as Hambourg has suggested, he could make a pictorial link between the branches of the trees and the Gothic tracery of the cathedral.

**60** *Luxembourg Gardens*
August 1922
Inscribed: Luxembourg
Albumen silver print,
22.1 × 18.1 cm
AP:6383 / P74:315
Purchased 1974

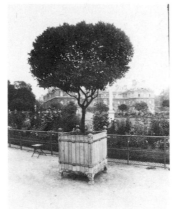

6th Arrondissement. The view is from the west terrace looking toward the Luxembourg Palace (see cat. 14).

**61** *Rue du Chevalier-de-la-Barre* March 1923
Inscribed: Rue du chevalier de la Barre
Collodio-chloride (?) silver print, 17.9 × 22.2 cm
AP:6418 / P74:317
Purchased 1974

18th Arrondissement. This street was already in existence in the 17th century, but did not receive its present name until 1885. Lefèvre, Chevalier de La Barre, was killed in 1766 at the age of 19, a victim of religious intolerance. It was on the site of No. 59, shown in the foreground of the photograph, that the Romans were thought to have erected their temple to Mercury. It seems strange that Atget should photograph the Sacré-Coeur Basilica, a building so foreign to the architectural monuments of Paris, apart from the fact that it was brand new, having been begun in 1876 and completed in 1919. And yet he photographed it a number of times before it was

finished, showing the scaffolding around its dome in various stages. The vantage point, nearly identical each time, provides such an oblique view of the basilica that one is forced to wonder if it is the real subject of the picture. Yet to anyone such as Atget, who took a delight in visual experience, the cluster of great white domes rising like balloons behind the typically picturesque old houses of the street must have seemed like an unreal fantasy. The street itself, since it is the title Atget gave to the photograph, might be taken as the subject, too.

**62** *Rue des Chantres* 1923
Inscribed: Rue des Chantres
Collodio-chloride (?) silver print, 21.6 × 18 cm
AP:6425 / P74:316
Purchased 1974

4th Arrondissement. The Rue des Chantres runs through one of the oldest and most historic quarters of Paris on the Île de la Cité. By 1540 it already had its present name, derived from the fact that the church's cantors lived along it. The street was one of several within the Cloître Notre-Dame, a veritable village of priests and canons that occupied the area between the present site of the Cathedral and the north shore of the island. The Cloister was protected from the outside world by surrounding walls. It was in existence before the present Cathedral, and the Rue des

Chantres is believed to have run along the side of the house in which Héloise, her uncle Canon Fulbert, and her lover Abélard all lived in the early part of the 12th century. Atget's photograph, with its austere contrasts, suggests an ancient mood of forbiddingly rigid religious convictions.

**63** *Notre-Dame* 1924
Inscribed: Notre Dame
Mat silver print,
17.7 × 22.6 cm
AP:6512 / P74:314
Purchased 1974

4th Arrondissement. A bas relief detail of Notre-Dame Cathedral in the form of a quatrefoil, showing Christ flanked by two angels, and a kneeling figure at the left, who may have been a donor or an important official in the Church. There appears to be the remains of a similar figure at the right. Photographs such as these formed part of a group that Atget classified as *Art in Old Paris*, a series that he had begun before the turn of the century.

**64** *Café, Boulevard Montparnasse* June 1925
Inscribed: Café Bd Montparnasse
Gelatin silver print,
17.4 × 22.1 cm
AP:6596 / P70:131
Purchased 1970

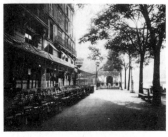

6th and 14th Arrondissement. Shown here is the Café de la Rotunde, a favourite meeting place for artists and writers after the turn of the century. Construction of the Boulevard du Montparnasse began in 1761; it received its name in the early 19th century. The setting remained pastoral for many years until the appearance of a number of country cafés that provided music and dancing for couples. By the end of the century the area began to replace Montmartre as the artistic and Bohemian quarter of Paris. Atget himself moved there in 1899. Cafés and bars appear in Atget's earlier work only by reason of their architectural ornamentation, but in his last years they become the subject of photographs for other reasons, perhaps because they were favourite haunts of his own, or perhaps because of their significance to the artistic community. Among the Café's clientele were Guillaume Apollinaire, André Derain, Max Jacob, Amadeo Modigliani, and Maurice Vlaminck. It was closed in 1958.

**65** *Fête du Trône* 1925
Gelatin silver print by Berenice Abbott,
17.1 × 22 cm
PP:68 / P73:091
Gift of David M. Heath, Toronto, 1973

11th and 12th Arrondissements. Many of Atget's most symbolically complex images are his photographs of shop windows (see cats. 48, 49, 53, 58, and 66). The subject of this photograph is a display of the chairs, shoes, and photo-graphs of a giant and a midget in a side-show, probably as part of the Place du Trône (Place de la Nation – see cat. 55) annual fair.

**66** *Avenue des Gobelins* 1925
Inscribed: Avenue des Gobelins
Gelatin silver print,
22.7 × 16.7 cm
PP:83 / P74:323
Purchased 1974

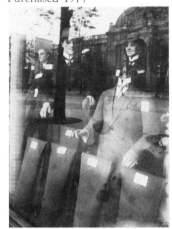

13th Arrondissement. Atget continued to photograph shop windows even after the First World War (see cats. 48, 49, 53, 58, and 65). Not only are these photographs symbolically complex, they are graphically sophisticated. Reflected in the background of the window of a men's clothing shop, with its mannequins, is the Gobelins Factory, famous for its tapes-tries, and a state institution for over 300 years. Parts of its buildings date from the 17th century, but the museum, with its cupola, was built in 1914 (see cat. 54). The Avenue des Gobelins was originally an extension of the old Rue Mouffetard, itself having been an extension of the Roman road from Lutetia (Paris) to Italy. In 1869 the extension became the Avenue des Gobelins.

# Bagatelle

**67** *Bagatelle, Fireplace* 1913
Inscribed: Bagatelle
Albumen silver print,
22.2 × 17.9 cm
AP:6091 / P70:123
Purchased 1970

This fireplace in Bagatelle (see cat. 69) is decorated in the French Neoclassical style of Louis XVI. Atget's oblique view allows the mirror over the fireplace to play with the shapes of the open door and its doorway, giving a percep-tion of space to the room that would have been lost in a more conventional view of the fireplace.

**68** *Entrance to Bagatelle* June 1921
Inscribed: Entrée de Bagatelle
Albumen silver print,
17.9 × 22.1 cm
E:6928 / P74:291
Purchased 1974

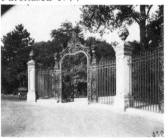

The wrought-iron gate at the entrance to Bagatelle is a mix-ture of Louis XV and Louis XVI styles. See cats. 67, 69, and 70.

**69** *Bagatelle* August 1922
Inscribed: Bagatelle
Albumen silver print,
18.1 × 21.6 cm
AP:6393 / P74:298
Purchased 1974

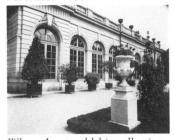

When Atget sold his collection of negatives of Old Paris to the State, he claimed that he had photographed everything there was to photograph in Old Paris. Nevertheless, he continued to return to the subjects of his earlier years, perhaps out of habit, perhaps out of personal preference. Bagatelle was one of these. It is located on the western edge of the Bois de Boulogne. When, in 1775, the Comte d'Artois (future Charles X) purchased the little house in the park built by the Maréchal d'Estrées in 1720, Marie Antoinette teased him about its ruined condition. He made a bet with her that he could erect a new building on the spot in less than three months. His architect Bellanger, in fact, completed it in 64 days. Fittingly, its original name was Folie-Bagatelle. It is an elegant, domed palace, one of the most perfect examples of the early Louis XVI style of architecture. In 1806 Napoleon took it over as a palace for his son, the King of Rome, and with the Restoration it was given to the Duc de Berry. Its last owner was Sir Richard Wallace, from whose heirs the city of Paris purchased it in 1905. See cats. 67, 68, and 70.

**70** *Bagatelle* 1922
Inscribed: Bagatelle
Mat silver print,
18.1 × 23 cm
AP:6394 / P74:262
Purchased 1974

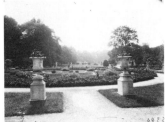

Bagatelle (see cats. 67, 68, 69, 82, and 84) was noted not only for its architecture but also for its 59 acres of gardens designed by an English landscape architect on the model of Parc Monceau.

# Parisian Parks

**71** *Bois de Boulogne* 1923
Inscribed: Bois de Boulogne
Albumen silver print,
18 × 22 cm
pp:27 / P74:264
Purchased 1974

Photographs of the Bois de Boulogne, at the western end of the city, form a subseries of Paris photographs that began in 1923. The Bois was Louis Napoleon's gift to Paris in 1852, on the understanding that the city would make certain improvements. It became one of Baron Haussmann's first projects, and was completed with the assistance of the young landscape architect Adolphe Alphand. It is remarkable how many of these late photographs of the Bois, as well as those made along the Seine, are similar in mood and often in graphic character to Monet's series of paintings, *Mornings on the Seine*, exhibited in 1898.

**72** *Bois de Boulogne* 1923
Inscribed: Bois de Boulogne
Albumen silver print,
18.2 × 22.2 cm
pp:29 / P72:320
Purchased 1972

See cat. 71.

# Documents

**73** *Apple Tree, Abbeville*
before 1900
Inscribed: Pommier /
Abbeville
Albumen silver print,
16.9 × 20.8 cm
D:106 / P74:306
Purchased 1974

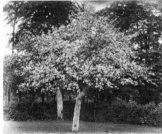

Some of Atget's earliest photographs, even before 1898, are of trees and plants. In the beginning, probably, they were produced as source documents for painters. In time, he may also have had clients who collected such photographs for scientific purposes. Atget's notebooks list the name and address of at least one of these, a Monsieur Deschamps, Librarian at the Jardins des Plantes. The Director of the Maison Hachette (publishers) was interested in the gardens of Old Paris, as well as in photographs of such other places as Saint-Cloud. The earlier photographs of this kind, although they do show

elegance (for example, see cat. 74), they do not have the complexity of personal vision that begins to appear between 1910 and 1914 (cat. 76) or the intensity of the later images made after 1920 (cat. 96).

**74** *Apple Tree* 1900
Inscribed: Pommier
Mat silver print,
23.1 × 18.1 cm
D:894 / P74:327
Purchased 1974

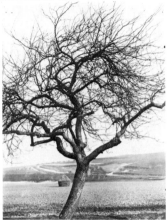

See cat. 73.

**75** *Saint-Cloud* 1906
Inscribed: St Cloud
Gelatin silver print,
22.6 × 17.9 cm
E:6610 / P74:324
Purchased 1974

Atget did not photograph tree roots until on a visit to Saint-Cloud in 1906. Maria Hambourg has pointed out that this may have been the product of photographing

decorative ornaments or possibly out of an interest in the sources of Art Nouveau. It is interesting to note that photographs of such ornamentation had already been made in the previous year (see cat. 146, or even cat. 19). Or he may have had in mind a client who was a botanist. In either case, the reappearance of roots as subjects in the 1920s (cat. 93) also suggests a personal motive with symbolic connotations. As forms, of course, they are a photographer's delight – not easy to control, but a challenge with rich graphic possibilities.

**76**  *Villeneuve-l'Étang*
1910–1914
Inscribed: Villeneuve L'Etang
Albumen silver print,
22 × 18.2 cm
D:738 / P74:250
Purchased 1974

In a number of photographs of trees made around this time, Atget exploited the presence of shadows in a manner that is unconventional. His purpose would appear to have been both graphic and symbolic. Such an eccentric vision may have had more appeal for himself than for clients. Typically, Atget has identified the photograph by place rather than by subject. This attitude toward titling confirms that much of his work was personal rather than a function of documentary recording.

**77**  *Saint-Cloud, Beech*
1919–1921
Inscribed: St Cloud
Mat silver print,
21.7 × 17 cm
D:1011 / P74:252
Purchased 1974

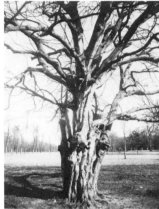

One of the Museum of Modern Art's versions of this subject is identified by Atget as a beech. Often Atget photographed the same tree over the years (see cat. 92). This appears to have been one of his favourites. There is another view of the same beech tree that shows his case with photographic supplies lying on the ground and just visible behind the trunk – an unusual intrusion (for Atget) of the presence of the photographer. The deciduous trees were usually photographed in winter, early spring, or late fall, without leaves, to show the full tracery of their limbs and, more than incidentally, because of their graphic possibilities.

**78**  *Saint-Cloud*  1919–1921
Inscribed: St Cloud
Mat silver print,
17.7 × 22.8 cm
D:1013 / P74:333
Purchased 1974

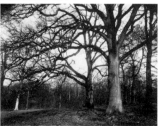

**79**  *Saint-Cloud, Acacia*
1919–1921
Inscribed: St. Cloud – Acacia
Albumen silver print,
17.2 × 21.3 cm
D:1016 / P74:238
Purchased 1974

**80**  *Old Oak*  1921
Inscribed: Vieux chêne
Albumen silver print,
22.1 × 18.2 cm
D:1034 / P74:256
Purchased 1974

Although Atget identified the tree, he did not give its location. It is the same tree, however, that appears in cat. 82, described as Bagatelle.

**81**  *Willows, La Varenne*
1921
Inscribed: Saules
Albumen silver print,
21.7 × 18.2 cm
D:1027 / P74:300
Purchased 1974

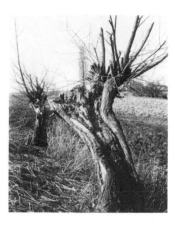

**82**  *Bagatelle*  1921
Inscribed: Bagatelle
Albumen silver print,
17.3 × 21 cm
D:1033 / P74:263
Purchased 1974

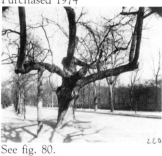

See fig. 80.

**83**  *Cypresses*  1921
Inscribed: Cyprès
Mat silver print,
17.7 × 22.1 cm
D:1053 / P74:330
Purchased 1974

**84** *Rose Garden* 1921
Inscribed: Roseraie
Albumen silver print,
18 × 21.9 cm
D:1059 / P74:290
Purchased 1974

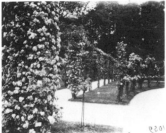

Bagatelle (see cat. 69) is famous
for its dazzling rose garden.
The variety shown here is the
Tosca.

**85** *Saint-Cloud* 1922
Inscribed: St Cloud
Albumen silver print,
18.1 × 21.5 cm
D:1103 / P74:239
Purchased 1974

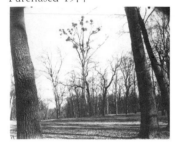

**86** *Saint-Cloud* 1922
Inscribed: St Cloud
Albumen silver print,
17.9 × 22 cm
D:1112 / P74:266
Purchased 1974

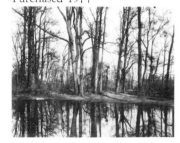

**87** *Laburnum* 1922
Inscribed: Cytise
Mat silver print,
22.8 × 18.1 cm
D:1129 / P74:249
Purchased 1974

**88** *Wisteria* 1922–1923
Inscribed: Glycine
Albumen silver print,
22.1 × 17.9 cm
D:1180 / P74:296
Purchased 1974

**89** *Water-Lilies* 1922–1923
Inscribed: Nymphaea
Albumen silver print,
21.7 × 18 cm
D:1196 / P74:272
Purchased 1974

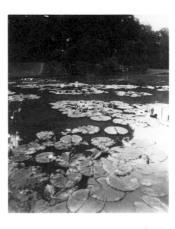

**90** *Dwarf Sunflowers*
1922–1923
Inscribed: Petits soleils
Albumen silver print,
22.3 × 18.3 cm
D:1168 / P74:328
Purchased 1974

**91** *Saint-Cloud* March 1923
Inscribed: St Cloud
Albumen silver print,
18.3 × 22 cm
sc:1171 / P74:260
Purchased 1974

**92** *Saint-Cloud, Beech* 1924
Inscribed: St Cloud
Mat silver print,
23 × 17.9 cm
sc:1224 / P74:243
Purchased 1974

One of the Museum of
Modern Art's versions of this
subject is identified by Atget
as a beech. Photographed four
or five years after the view
shown in cat. 77, this same
tree has lost a limb or two in
the meantime.

**93** *Saint-Cloud* 1924
Inscribed: St Cloud
Mat silver print,
22.7 × 17.5 cm
sc:1228 / P74:326
Purchased 1974

See cat. 75.

**94** *Saint-Cloud* 1926
Inscribed: St Cloud
Gelatin silver print,
23 × 17.8 cm
sc:1258 / P74:251
Purchased 1974

Photographs such as this and the following one (cat. 95) are excellent examples of Atget's talent for taking an essentially disorderly subject and ordering its randomness into a coherent pictorial logic.

**95** *Saint-Cloud* 2 April 1926
Inscribed: St Cloud / 2 avril
1926 / 9h. matin
Gelatin silver print,
22.6 × 17.8 cm
sc:1267 / P74:325
Purchased 1974

See cat. 94.

**96** *Saint-Cloud* June 1926
Inscribed: St Cloud / juin 1926
Gelatin silver print,
17.9 × 22.8 cm
sc:1273 / P70:128
Purchased 1970

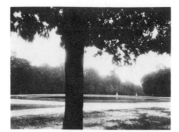

There are a number of variations of this image, possibly made on the same day, one with the tree dead centre and without the light halation around the trunk, and one with the tree trunk at extreme left and closer to the camera. These are proof that the subject of the photograph was not the ornamental pond, as some might suppose (for all Atget had to do to photograph the pond was to step away from the tree), but the formal and graphic relationships between foliage, sky, pond, tree trunk, and background. The photograph was obviously made for the pure pleasure of making a picture.

## Environs

**97** *Bourg-la-Reine, Camille Desmoulins' Farm* 1901
Inscribed: Bourg la Reine
(Ferme
Albumen silver print,
17.9 × 21.8 cm
E:6039 / P74:338
Purchased 1974

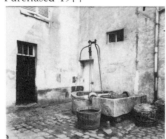

Camille Desmoulins (1760–1794), friend of Danton, was a revolutionary journalist whose writings helped inspire the storming of the Bastille in 1789. He died under the guillotine on the same day as Danton, and his wife Lucille

(1771–1794) followed ten days later. Atget must have been thoroughly versed in the story and obviously influenced by it in his search for old and picturesque rural architecture. The formal qualities of this photograph are so strong that one is led to believe it represents an early example of Atget's also taking pleasure in making a picture for its own sake. In Atget's time, Bourg-la-Reine was a small village 5½ miles to the southwest of Paris, near Vaux-de-Cernay and Antony (see cats. 100 and 106).

**98** *Saint-Denis, Hôtel du Grand Cerf* 1901
Inscribed: St Denis – Ancien
relai de poste d'Ecouen
Albumen silver print,
17.9 × 21.9 cm
E:6172 / P74:311
Purchased 1974

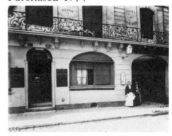

Even in Atget's time, Saint-Denis, a suburb north of Paris, was looked upon as an unattractive industrial town. It is celebrated, however, because the Basilica of Saint-Denis, built by the Abbé Suger in the 12th century, was the first large building in the Gothic style in France, and because it became the burial place for the Kings of France. The Grand Cerf was the choice hotel for the tourist's guide books. Atget's interest in the hotel, in the first instance, was as an example of the survival of old sculptured commercial signs. (See cat. 26). At one time, the hotel had been a posting-house for the coachs for Écouen, which Atget duly noted.

**99** *Pontoise, Church of Saint-Maclou* 1902
Inscribed: Pointoise – Eglise St
Maclou
Mat silver print,
18 × 22.1 cm
E:6339 / P74:276
Purchased 1974

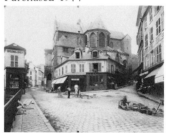

In Atget's time, Pontoise was a small town of no more than 8 000 inhabitants, situated on the banks of the Oise, about 20 miles northwest of Paris. As the capital of Vexin, it was often involved in the wars between France, England, and Normandy. The Church of Saint-Maclou is a mixture of 12th- to 16th-century Gothic. Its transept and choir date from 1140 to 1165, its façade is 15th to 16th century, and its single tower is from 1547. The church was not necessarily the sole excuse for making the photograph. Atget also may have been concerned with the picturesqueness of the combination of old ecclesiastical and domestic architecture. The Impressionist painter Camille Pissarro (1830–1903) lived intermittently in Pontoise between 1866 and 1884, and had gathered around him there the younger painters Cézanne, Guillaumin, and Vignon.

**100** *Vaux-de-Cernay, the Château's Gate* 1910
Inscribed: Vaux de Cernay –
Grille de château
Gelatin silver print,
22.1 × 17 cm
E:6737 / P74:310
Purchased 1974

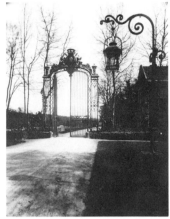

Vaux-de-Cernay is in the Valley of the Chevreuse to the southwest of Paris, beyond Versailles. In Atget's time, the ruins of the Cistercian abbey (founded 1128) and the Château belonged to Baron Henri de Rothschild. The abbey had been partially restored by its previous owner, Baron Nathaniel de Rothschild. Since it was private property, the gate was all that was visible to the tourist.

**101** *Charenton, Old Mill*
May–July 1915
Inscribed: Charenton –
Vieux Moulin
Albumen silver print,
17.6 × 21.9 cm
E:6808 / P74:279
Purchased 1974

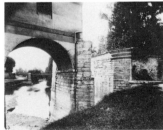

Charenton, a suburb to the southeast of Paris, is at the confluence of the Marne and Seine Rivers. During a lull in the war, when the German army had been pushed back from the Marne, Atget was able to travel to Charenton between May and July 1915. He made a number of photographs of the old mill. This example is the most daring of them all, as though he had thrown caution to the winds and decided to wrestle with the essence of the formal problems with which the subject challenged him. These are among the last photographs he made until the war was over (see cat. 102).

**102** *Gentilly, Old House*
May–July 1915
Inscribed: Gentilly – Vieille maison
Gelatin silver print,
17.9 × 22.6 cm
E:6823 / P74:297
Purchased 1974

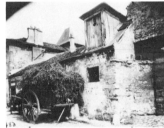

In Atget's time, Gentilly was still an old village just outside Paris, to its south and on the road to Sceaux. It was a part of the country he knew well and indeed preferred, because Paris' industrial sprawl had avoided, as yet, its southern countryside. He could find here a rustic and picturesque rural land still unchanged by modern progress.

**103** *Versailles,*
*5 Place Hoche* 1921
Inscribed: Versailles –
5 Place Hoche
Albumen silver print,
21.9 × 18.1 cm
E:6965 / P74:313
Purchased 1974

Even after the war, Atget continued to search for good examples of architecture from the *ancien régime*. This one, in the town of Versailles, is a fine specimen from the period of Louis XVI, with its sculptured garlands over the upper windows typical of the French Classical style.

**104** *Auvers, Old Farmhouse*
1922
Inscribed: Auvers
(Vieille ferme)
Albumen silver print,
18.3 × 21.9 cm
E:6993 / P72:318
Purchased 1972

Auvers, a small village to the north of Paris and near Pontoise, drew some of the major artists of the latter half of the 19th century. Among those who painted there were Corot, Daumier, Daubigny, Pissarro, Cézanne, and Van Gogh, who is buried there. Atget returned on more than one occasion to photograph this old farmhouse, having first gone there sometime between 1900 and 1910.

**105** *Clamart, an Old Corner* 1923
Inscribed: Clamart
(Vieux coin)
Albumen silver print,
21.7 × 17.9 cm
E:7012 / P74:287
Purchased 1974

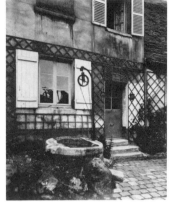

Clamart was a small village to the southwest of Paris. In Atget's time, the journey could be made in one hour by tramway. He spent much of his time in the immediate years after the war photographing picturesque rural houses. Both the wells and the courtyards presented him with a social meaning as well as a visual challenge. His title for the photograph, *Old Corner*, implies more of a social significance than an architectural function.

**106** *Antony, Château* 1923
Inscribed: Antony – Chateau
Albumen silver print,
17.9 × 21.8 cm
E:7018 / P74:292
Purchased 1974

In Atget's time, Antony was a small village 7¹/₂ miles to the south of Paris, and just south of Sceaux. The ride could be made by electric tramway in about 45 minutes. Although Atget's identification refers to a château, the photograph shows a simple country manor house dating from either the time of Louis XVI or the Directoire. The chapel is a later addition.

**107** *Saint-Cloud, Banks of the Seine* 1923
Inscribed: St Cloud (Bords de Seine)
Albumen silver print,
18.3 × 22 cm
E:7022 / P70:125
Purchased 1970

Atget made this photograph near the Pont de Sèvres, probably on the same day as cat. 108 and facing in the opposite direction to the latter. The gangplank is the same in both. The fact that over half the picture area consists of deep shadow makes it one of the most unusual photographs of his later period, suggesting, in

a way, a link with certain visual concepts of the pictorialists.

**108** *Saint-Cloud, Banks of the Seine* 1923
Inscribed: St Cloud
Albumen silver print,
18 × 21.7 cm
E:7025 / P74:248
Purchased 1974

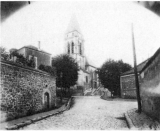

Beyond the trees can be seen the Pont de Sèvres, which joins Paris to Sèvres and Saint-Cloud. See cat. 107.

**109** *Thiais, Church* 1925–1927
Inscribed: Thiais (Eglise)
Gelatin silver print,
22.9 × 17.9 cm
E:7148 / P72:313
Purchased 1972

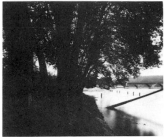

Thiais was a small village a few miles to the southeast of Paris near Ivry.

# Saint-Cloud

**110** *Saint-Cloud* 1904
Inscribed: St Cloud
Gelatin silver print,
17.8 × 22.8 cm
E:6453 / P74:254
Purchased 1974.

According to Maria Hambourg, this may be the earliest photograph of Saint-Cloud by Atget. All that remains now, and indeed in Atget's time, of the royal summer retreat are 1 000 acres of park with its steps, terraces, cascades, fountains, and statuary. The Château, used by the kings and queens of France since the 16th century and by both Napoleon I and Napoleon III, was finally destroyed during the Franco-Prussian War of 1870 (see cat. 118).

**111** *Saint-Cloud* 1904
Inscribed: St Cloud
Albumen silver print,
17.5 × 21.7 cm
E:6507 / P74:281
Purchased 1974

These terrace stairs, as do all stairs in Atget's photographs, provide him with an excuse to respond to the abstract visual games of repeated forms, receding planes, and mathematically harmonious rhythms. But in the setting of the park, against

the dark masses of the trees, the full flavour of a civilization's quest for ceremony and its need to impose order on nature is in evidence.

**112** *Saint-Cloud* 1906
Inscribed: St Cloud
Albumen silver print,
22 × 18.2 cm
E:6606 / P74:267
Purchased 1974

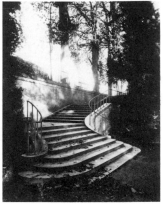

Although light is frequently the dominant subject of Atget's late work, there is, in such early photographs as this example, evidence of a playful attitude towards the problems it frequently causes the photographer. Instead of destroying the photograph, the burn-out of the overexposure in the background creates a mood that is the strength of the picture.

**113** *Saint-Cloud* 1907
Inscribed: St Cloud
Mat silver print,
17.6 × 23.6 cm
E:6657 / P74:236
Purchased 1974

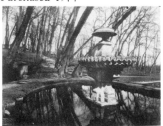

The fountain, known as Le Champignon (The Mushroom), is of 17th-century origin. It stands in a basin

overlooking the Grand Jet to the left of the Cascade (see cat. 114).

**114** *Saint-Cloud* 1907
Inscribed: St Cloud
Albumen silver print,
21.8 × 18 cm
E:6660 / P74:237
Purchased 1974

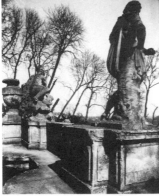

The figures of the river gods, which form part of the Grande Cascade (see cat. 127), were made by Lambert Sigisbert Adam in 1730–1734 to replace the original sculptures.

**115** *Saint-Cloud* 1915–1919
Inscribed: St Cloud
Albumen silver print,
17.6 × 21.5 cm
D:780 / P74:280
Purchased 1974

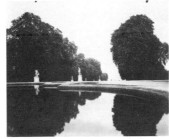

Although Atget covered the whole panorama of the basin, curiously the photographs were not all made at the same time, or even in the same year (see cat. 117). This appears to be the earliest, and is certainly one of the strongest. Before it was destroyed in 1870, the Château looked out upon the basin. The sculptures are 19th-century additions. Diana, goddess of the hunt, seen at the

left, is a copy of the original *Diane à la Biche* in the Louvre.

**116** *Saint-Cloud* 1921
Inscribed: St Cloud / 7 h. matin
Albumen silver print,
18.1 × 22.1 cm
D:1067 / P74:244
Purchased 1974

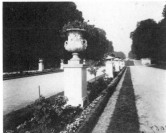

The view is along the Allée de Marnes toward the terrace stairs in cat. 124. In order to achieve the most dramatic light possible to enhance the presence of the urns on their pedestals, Atget made the photograph at 7 am.

**117** *Saint-Cloud* 1921
Inscribed: St Cloud
Albumen silver print,
17.2 × 21.5 cm
D:1070 / P70:124
Purchased 1970

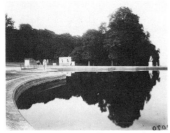

Atget made this photograph at 7 pm. Diana of the Hunt is seen at the extreme right (see cat. 115). The basin stands at the beginning of the Allée de Marnes.

**118** *Saint-Cloud, Park*
1921–1922
Inscribed: St Cloud (Parc
Albumen silver print,
18.3 × 21.8 cm
D:1082 / P70:126
Purchased 1970

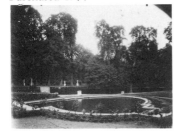

This view of the park is one of Atget's best known and most elegant photographs. The garden, shown here and known as the Terrasse du Château, is on the original site of the Château before it was destroyed in 1870 (see cat. 110). The terrace stairs beyond the conifers may be seen in cat. 122.

**119** *Saint-Cloud* 1921–1922
Inscribed: St Cloud
Albumen silver print,
17.8 × 21.8 cm
D:1085 / P74:253
Purchased 1974

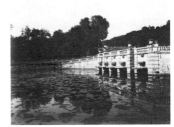

Now known as the Bassin du Fer à Cheval (the Horseshoe Basin), it was originally called the Bassin des Cygnes in 1670. According to William Howard Adams, it may have been designed by Girard. The terrace among the trees in the background is the one shown in the background of cat. 118.

**120** *Saint-Cloud* 1922
Inscribed: St Cloud
Albumen silver print,
18.2 × 22 cm
sc:1146 / P74:340
Purchased 1974

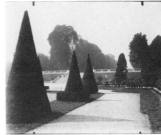

See cat. 125 for a related view of the pond.

**121** *Saint-Cloud* 1922
Inscribed: St Cloud
Albumen silver print,
22.2 × 18.1 cm
sc:1150 / P70:127
Purchased 1970

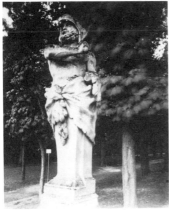

The sculpture of Hercules, shown with his club over the shoulder, has been rendered in the ancient Greek form of a term with the upper body terminating below in a shaft or pillar. Atget's long exposure has introduced an element of mystery in the movement of the leaves in contrast to the static nature of the term.

**122** *Saint-Cloud* 1922
Inscribed: St Cloud
Albumen silver print,
21.8 × 18 cm
sc:1160 / P74:241
Purchased 1974

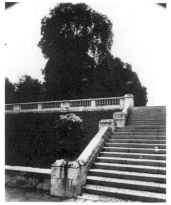

These are the terrace stairs
leading up from the Terrasse
du Château (cat. 118) and
onto the Allée de Marnes.

**123** *Saint-Cloud, Fountain*
1922
Inscribed: St Cloud / Fontaine
Albumen silver print,
21.7 × 18 cm
sc:1161 / P74:271
Purchased 1974

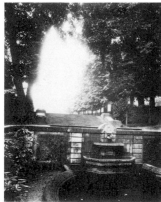

See cat. 126 for another view
of the fountain.

**124** *Saint-Cloud, October*
*Morning* 1922
Inscribed: St Cloud / Octobre
matin
Albumen silver print,
17.6 × 22 cm
sc:1163 / P74:247
Purchased 1974

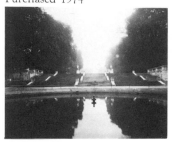

**125** *Saint-Cloud* October
1922
Inscribed: St Cloud
Albumen silver print,
17.9 × 21.9 cm
sc:1165 / P74:242
Purchased 1974

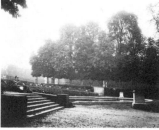

See cat. 120 for a related view
of the pond.

**126** *Saint-Cloud, Park* 1923
Inscribed: Parc de St Cloud
Gelatin silver print,
22.4 × 17.8 cm
sc:1177 / P74:255
Purchased 1974

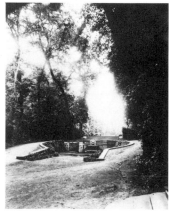

See cat. 123 for a closer view
of the fountain.

**127** *Saint-Cloud, Cascade*
1923
Inscribed: St Cloud / Cascade
Albumen silver print,
18.2 × 21.6 cm
sc:1179 / P74:259
Purchased 1974

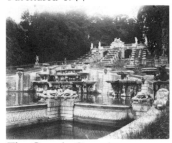

The Grande Cascade was
designed by Antoine Lepautre
(1621–1691) and was completed
probably in the 1660s. It is
said to be the outstanding
water-piece of the 17th cen-
tury. Commercial photog-
raphers, contemporaries of
Atget, photographed the
Cascade, but none so success-
fully as Atget. Jules Haute-
coeur, in a photograph in the
National Gallery's collection,
took the conventional view,
from a distance, to show the
entire piece and its setting,
with the result that the
Cascade appears flat and loses
its scale. By staying close to
his subject, Atget succeeded in
transmitting the full monu-
mental and tortured quality of
the piece.

**128** *Saint-Cloud* 1923
Inscribed: St Cloud
Mat silver print,
22.4 × 17.9 cm
sc:1195 / P74:257
Purchased 1974

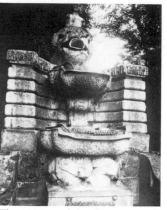

This is one of the fountains of
the Grande Cascade recessed
behind the left archway at the
top of the Cascade (see cat.
127). Atget photographed this
particular fountain on more
than one occasion over the
years before the figure of the
boy had lost its arms.

**129** *Saint-Cloud* 1923
Inscribed: St Cloud
Albumen silver print,
17.8 × 22 cm
sc:1209 / P74:339
Purchased 1974

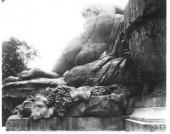

In the centre at the top of the
Grande Cascade are the two
river gods, the Seine and the
Marne. Between them is a
huge urn pouring out the
waters of both rivers (see cats.
114 and 127). The photograph
represents one of the gods,
with the urn to the right.

**130** *Saint-Cloud* 1923
Inscribed: St Cloud
Albumen silver print,
18.2 × 21.9 cm
sc:1215 / P74:245
Purchased 1974

Detail of a mask, with water spout, of the Grande Cascade.

**131** *Saint-Cloud, Park* 1924
Inscribed: Parc de St Cloud
Mat silver print,
22.7 × 17.9 cm
sc:1240 / P74:258
Purchased 1974

View of the terrace behind the top of the Grande Cascade, showing the urn between the two river gods (see cats. 114, 127, 128, and 129). Atget photographed the Cascade over a period of years, building a detailed record.

## Sceaux

**132** *Sceaux, Rue Voltaire* 1922
Inscribed: Sceaux (Rue Voltaire)
Gelatin silver print,
22.8 × 17.8 cm
E:6988 / P74:302
Purchased 1974

In Atget's time, Sceaux was a small suburb of just over 5 000 population, 5½ miles to the south of Paris, a 1-hour journey by tramway, or ½-hour by train. The town provided him with picturesque courtyards and old country houses. The Rue Voltaire is a reminder of the fact that Voltaire wrote three of his tragedies at the Château nearby.

**133** *Sceaux, Entrance to the Château* 1924
Inscribed: Sceaux – Entrée de château
Mat silver print,
22.5 × 17.7 cm
E:7063 / P74:303
Purchased 1974

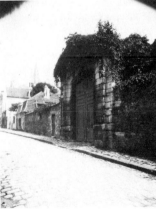

Colbert, Louis XIV's superintendent and master planner, built the original Château de Sceaux in 1673. Its gardens were designed by André Le Nôtre (1613–1700). The estate was sold in 1700 to the Duc du Maine, offspring of Louis XIV and the Marquise de Montespan. The Duchesse du Maine turned it into a miniature Versailles and Saint-Cloud, complete with canals, cascades, sculpture, fountains, grand alleys, and a brilliant literary court that included Voltaire. The Château was entirely destroyed during the Revolution to be replaced by a stockbroker's mansion in 1856. Only a small piece of land near the church remained open to the public in Atget's time. The entrance gate to the Château is one of the few parts of the original building to have survived.

**134** *Sceaux* June 1925
Inscribed: Sceaux
Gelatin silver print,
17.8 × 22.6 cm
s:71 / P74:318
Purchased 1974

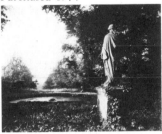

Several of the more obvious aspects of Atget's Sceaux Park photographs are the desolation of the landscape and the victory of nature over man's artifice. The small section of the Park that was open to the public had gone to ruin. The once grand alleys are overgrown with weeds. Ornamental pools are clogged with mud and slime. Weathered and abused statuary, one-time symbol of the elegance of the *ancien régime*, now prey to creeping vines, stand vacantly surveying a forlorn landscape. Perhaps in Atget's mind, these mournful sights summed up a lifetime of recording the glories of a civilization dead and gone. The sculptured figure in the photograph looks out over the Allée de la Duchesse. At its base is a pond, which included a fountain, that marked the beginning of the cascade. Atget made 66 photographs in the park at Sceaux between March and June, 1925. It was the only time he photographed the park, and the results were one of the most consistent and moving series of his career.

## Versailles

**135** *Versailles, Park* 1901
Inscribed: Versailles (Parc
Mat silver print,
17.1 × 21.8 cm
E:6074 / P74:277
Purchased 1974

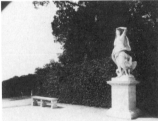

Atget made repeated trips annually to Versailles from 1901 to 1906, possibly skipping 1904, and does not seem to have returned again until the years 1923 to 1926. Between 1901 and 1906, the photographs made up six series called *Les Environs de Paris: Versailles et les deux Trianons*. The product of the last years formed an album known as *Versailles Trianon*. Very quickly, Atget solved his pictorial problems by using the dense mass of foliage as a dramatic setting for the sculpture and the buildings, and by stressing the detail of Versailles rather than its grand plan. One other factor becomes evident in Atget's photographs at this time, his sardonic wit, as though a commentary upon a world of frivolity frozen in stone, doomed forever to live in the empty gesture. The subject of this photograph is not so much that of Étienne Le Hongre's (1628–1690) sculpture *L'Air* (1680–1684), which represents one of the four elements, but of the relationship between it, the empty bench,

and the two tiny, isolated sculptures in the left distance. They stand by the ramp that leads from the Parterres d'Eau (Water Gardens) at the front of the Palace down to the Tapis Vert.

**136** *Versailles* 1901
Inscribed: Versailles
Albumen silver print,
17.1 × 21.8 cm
E:6075 / P72:317
Purchased 1972

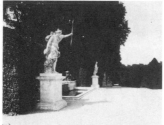

Versailles had its origins in Louis XIII's purchase of a small parcel of land for a hunting lodge in 1624. Its present-day magnificence, however, began in 1661 when Louis XIV commissioned the great architect and landscape designer André Le Nôtre (1613–1700) to draw up a general plan for a grand summer residence. When the vast gardens were completed in 1668, they proved to be so out of proportion to the original buildings that the architect Louis Le Vau (1612–1670), and subsequently Jules Hardouin-Mansart (1646–1708), was asked to design a huge new palace. From 1666, under the direction of Charles Lebrun (1619–1690), sculpture began to spring up throughout the gardens. Leading off from the Parterres d'Eau in front of the Palace is the Allée des Trois Fontaines. In the foreground is *Diana* (also known as *Evening*, 1680) by Martin Desjardins (1637–1694). Immediately behind is the Evening Fountain, and beyond that is *Venus* (or *Noon*) by Gaspard Marsy (1624 / 25–1680). Atget photographed *Diana* a number of times, and at least once showing the relationship between it and *L'Air* (cat. 135) just

around the corner of the hedge at left.

**137** *Petit Trianon* 1902
Inscribed: Trianon
Albumen silver print,
22.2 × 18 cm
E:6239 / P74:301
Purchased 1974

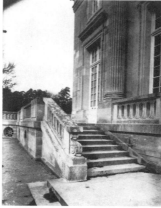

The Trianons are a complex of retreats away from the main palace and at the northern extremity of the small arm of the Grand Canal (see cat. 147). The Petit Trianon is seen here from the side and looking toward its front terrace. It was built between 1761 and 1768 by Jacques Ange Gabriel (1698–1782) for Louis XV, who spent much time there with Madame du Barry. After his ascension to the throne in 1774, Louis XVI gave it to his wife, Marie Antoinette, as a summer retreat.

**138** *Petit Trianon* 1902
Inscribed: Petit Trianon
Mat silver print,
17.8 × 23.8 cm
E:6242 / P74:265
Purchased 1974

In 1783, Marie Antoinette had the English gardens of the Petit Trianon extended northward to include a toy village, known as the Hameau (or hamlet). Rustic buildings with thatched roofs were erected around a little artificial lake. Here, the Queen and her ladies-in-waiting played at being peasants. The little wooden bridge in Atget's photograph spans a creek and provides access from the Queen's House to other buildings in the Hameau. (See cat. 149).

**139** *Trianon, Pavillon Français* 1902
Inscribed: Trianon
Albumen silver print,
17.8 × 22 cm
E:6283 / P74:293
Purchased 1974

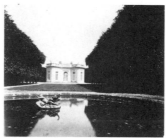

Atget referred to this simply as the Trianon, without bothering to identify it as the Pavillon Français. It was built in 1750 by Gabriel for Louis XV as part of the Grand Trianon complex, and was used for picnics. Its name derives from its location in the French Gardens. It is the most famous example of a Rococo folly in French architecture, but nevertheless still shows a strong Classical influence. The masks over its windows represent the four seasons, and the severity of its balustrade is broken by groups of children and urns. (See also cat. 148).

**140** *Versailles Park, Vase by Cornu* 1902
Inscribed: Versailles (Parc) / Vase par Cornu / 1902
Mat silver print,
18 × 22.7 cm
E:6312 / P74:288
Purchased 1974

Surrounding the Bassin de Latone are a number of marble vases depicting mythological scenes. This one, by Jean Cornu (1650–1710), was made in 1683 and represents the Sacrifice to Diana. Atget photographed a number of such vases, often in close detail and from various sides, and complete with the graffiti of the time. In this instance, he has positioned his camera to take advantage of the asymmetry of the diagonal lines.

**141** *Versailles, Park* 1902
Inscribed: Versailles (Parc)
Mat silver print,
17.6 × 23.6 cm
E:6350 / P74:284
Purchased 1974

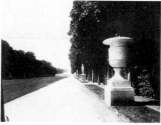

The Tapis Vert, shown here, is the main avenue between the Palace and the Bassin d'Apollon and Grand Canal, and was part of Le Nôtre's original plan to provide a grand vista from the Palace, through the gardens and the forest, for as far as the eye could see. The photograph is a surprisingly early example of Atget's ability to see the world

in broad, abstract shapes, and to exploit this vision with both grace and strength.

**142** *Versailles, Cyparissus by Flamen* 1902
Inscribed: Versailles
Gelatin silver print,
22.7 × 17.9 cm
E:6363 / P74:309
Purchased 1974

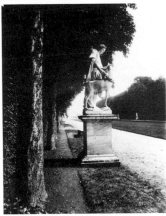

Anselme Flamen's (1647–1717) sculpture of *Cyparissus* (1687) stands near the end of the Tapis Vert (see cat. 141) close to the Bassin d'Apollon. The view in Atget's photograph is toward the Palace, which may be seen faintly in the background. Cyparissus was hunting one day and accidentally killed his pet deer. Grief drove the boy to attempt suicide, when Apollo took pity on him and turned him into a cypress. The sculpture represents the young shepherd placing a garland of flowers around the animal before its death.

**143** *Versailles, Bassin de Neptune* 1902
Inscribed: Versailles – Bassin de Neptune
Albumen silver print,
21.4 × 17.8 cm
E:6377 / P74:331
Purchased 1974

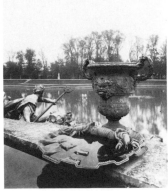

The Bassin de Neptune sits quietly off the main path just to the north of the Palace, beyond the Parterres du Nord and at the end of the Allée des Marmousets. Designed by Jean-Baptiste Tuby (1630–1700), its construction was begun under Louis XIV and was completed in 1683. The metal vase (1682) is by Martin Carlier (16 ?–after 1700).

**144** *Versailles, the Orangery* 1903
Inscribed: Versailles (Orangerie)
Albumen silver print,
17.9 × 22.9 cm
E:6442 / P74:304
Purchased 1974

The Orangery lies at the southern extremity of the cross-axis to the Bassin de Neptune and beside the Palace. A gigantic greenhouse, it was built by Jules Hardouin-Mansart between 1684 and 1686. In the winter, it housed the ornamental trees and shrubs that decorated the Orangery garden during the summer. It forms the foundation for the Parterres du Midi, the south side of the Palace's main terrace. It also had living quarters for members of the Royal Family. The two figures who have accidentally made their appearance on the terrace at the top of the building during Atget's exposure give a sense of its scale.

**145** *Versailles, the Orangery* 1903
Inscribed: Versailles (orangerie)
Albumen silver print,
18.1 × 22.3 cm
E:6449 / P74:283
Purchased 1974

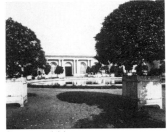

See cat. 144.

**146** *Grand Trianon* 1905
Inscribed: Gd Trianon
Albumen silver print,
18.2 × 21.8 cm
E:6592 / P74:286
Purchased 1974

Nothing delighted Atget's eye more than stairs. Stair rails especially present a difficult challenge for the photographer, since they are essentially two-dimensional (see cat. 15). In this instance, the sheer beauty of the decorative motif of the rail has convinced him to treat it in the simplest possible way, with the result that it sings with its own rhythm and light. Atget also photographed the end design by itself at the same time. These stairs descend from the terrace that runs along the Gallery and the Garden Drawing Room of the Grand Trianon down to the gardens in front of the Garden Façade. The Trianon palace itself, and possibly the stair rail, was designed by Jules Hardouin-Mansart (see cat. 147).

**147** *Grand Trianon*
1923–1924
Inscribed: Gd Trianon
Albumen silver print,
17.8 × 21.7 cm
v:1210 / P74:240
Purchased 1974

The name Trianon comes from that of a hamlet bought out by Louis XIV in order to enlarge his estate at Versailles. In 1670 he built on that spot a pavilion covered with blue and white porcelain, giving it the name of the Porcelain Trianon. In 1687 it was replaced by a marble palace designed by Jules Hardouin-Mansart (1646–1708). It was the first of the Trianon complex of retreats away from the main Palace that was eventually to include the Pavillon Français and the Petit Trianon together with the Hameau (see cats. 137, 139, 148, and 149). The view shown here is the end of the wing known as the Trianon sous Bois. It was the last part of the Grand Trianon to be completed, and is stylistically more subdued than the main building. It contained the living quarters. The masks over the windows on the Trianon sous Bois date from 1705 and are by four sculptors: Jean Hardy (1653–1737), Pierre Lepautre (1659 / 66–1744), Claude Poirier (1656–c.1731), and Jean-Baptiste Poultier (1653–1719). That the smiling bust can be seen through the wrought-iron railing is probably no accident. If one were to place all of Atget's photo-

graphs of stairs side by side, what a visual fugue would result – now playful rhythms rippling over stone, now the solemn and measured beat of pomp and ceremony. Always they define space in his photographs in a richly satisfying manner.

---

**148** *Trianon, Pavillon Français* 1923–1924
Inscribed: Gd Trianon
Gelatin silver print,
17 × 21.8 cm
v:1225 / P74:285
Purchased 1974

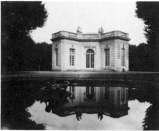

The Pavillon Français stands in the French Gardens between the Grand Trianon and the Petit Trianon, and hence the confusion as to which it properly belongs. It preceded the Petit Trianon by a dozen years. Atget sometimes identified it as part of the Grand Trianon and sometimes simply as the Trianon (see cat. 139). In the twenty-year interval between the two photographs of the Pavilion, the building may have lost some of its roof ornamentation but Atget's vision of it has gained significantly. He has seen the virtue of hiding the sculpture in the pool by placing it in deep shadow. Although in both instances he used the dense foliage like theatrical wings to create a dramatic setting for the luminous building, in the late example he had a more subtle purpose than simply to channel the eye. The organic shapes of the crowns of the trees on either side of the building echo the movement of the children on the balustrade, turning the roof terrace into a stage upon which a distant drama is being enacted. Meanwhile, below and confined within the pincer shape of the shadowed reflections in the pool, that drama is repeated for a darker purpose.

---

**149** *Petit Trianon, the Hameau* June 1926
Inscribed: Trianon
Gelatin silver print,
18 × 22.9 cm
v:1260 / P74:246
Purchased 1974

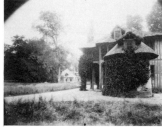

In keeping with his titling practices, Atget identified this photograph as part of the larger complex of the Trianon without bothering to specify it as the Hameau (see cat. 138). The view is from the end of the Queen's House across the lake toward the other cottages in the hamlet. If Atget numbered his negatives in the exact sequence of exposing them, then this image is the last but one made at Versailles. In any event, it is among his final photographs of the Versailles series, having been taken on a trip in June 1926. Valentine, his companion for 25 years and more, died on June 20 of that year. Whether it was this loss that brought the series to an abrupt end is not known. Although Atget continued to photograph for the remaining year of his life, he never returned to Versailles.

# Notes

## Notes to Chapter 1

1. A Bonnardot, "La photographie et l'art," *La Revue nouvelle des Arts*, 1855, pp. 37–47.
   Henri Delaborde, "La photographie et la gravure," *La Revue des Deux Mondes*, 1 April 1856, pp. 617–638.
   L'Abbé Moigno, "Défense de la photographie," *Revue photographique*, 5 March 1857, pp. 262–264.

2. Maria Morris Hambourg, "A Biography of Eugène Atget" in John Szarkowski and Maria Morris Hambourg, *The Work of Atget: The Art of Old Paris*, volume 2 of a projected 4-volume work, New York: The Museum of Modern Art, 1982.

3. Jean Leroy, *Atget: Magicien du vieux Paris en son Époque*, Joinville-le-Pont: Pierre Jean Balbo, 1975, pp.[11–12]. Compare with Hambourg, pp. 10, 35.

4. Hambourg, p. 11.

5. Hambourg, p. 11.

6. Quoted in Hambourg, p. 11.

7. Quoted in Hambourg, p. 12.

8. Quoted in Hambourg, p. 12.

9. *Bulletin de la Société française de Photographie*, vol. 24, no. 10 (1878), pp. 271ff.

10. *Encyclopaedia Britannica*, 11th ed., vol. 10, p. 68.

11. *Bulletin de la Société française de Photographie*, vol. 23, no. 11 (November 1879), pp. 283–284.

12. *Ibid.*, vol. 27, no. 1 (January 1881), p. 10.

13. Hambourg, p. 12.

14. Letter from André Calmettes to Berenice Abbott (in French), *c.* 1928, in Szarkowski and Hambourg, vol. 2, appendix A, pp. 32–33; and Berenice Abbott, *The World of Atget*, New York: Horizon Press, 1964, pp. xi-xiii (translated into English by B. Abbott).

15. Hambourg, p. 12.

16. Calmettes to Abbott.

17. *Ibid.*

18. Hambourg, note 36, p. 36.

19. Leroy, p. [18].

20. Calmettes to Abbott.

21. Leroy, p. [20].

22. Hambourg, p. 13.

23. *Ibid.*, pp. 13–14.

24. "Information et nouvelles," *La Revue des Beaux-Arts*, no. 98 (Feb. 1892), p. 30, quoted in Hambourg, p. 33.

25. "Carnet de la curiosité," *Art et Critique*, no. 89 (1892), pp. 78–79, quoted in Hambourg, *Ibid.*, appendix B, p. 33.

26. Calmettes to Abbott.

27. Florent Fels, "L'art photographique: Adjet" [sic], *L'Art vivant*, February 1931, p. 28.

28. Jacques Hillairet, *Dictionnaire historique des rues de Paris*, Paris: Les Éditions de Minuit, 1963.

29. A. de Champeaux, "L'Art décoratif dans le vieux Paris," *Gazette des Beaux-Arts*, 32nd year, no. 3 (1 September 1890) to 37th year, no. 5 (1 November 1895).

30. Hambourg, p. 17.

31. Hambourg, note 44, pp. 36–37.

32. Calmettes to Abbott.

33. Hambourg, p. 16.

34. Hambourg, p. 16.

35. Abbott, p. ix.

36. Leroy, p. [38].

37. Hambourg, p. 19.

38. *Ibid.*

39. Leroy, p. [30].

40. A list of lectures is given in Hambourg, appendix C, pp. 33–34.

41. Leroy, p. [31].

42. Hambourg, p. 22.

43. Hambourg, p. 24

44. *Ibid.*, p. 21.

45. Hambourg, p. 27.

46. Leroy, p. [38].

47. Hambourg, p. 28.

48. Calmettes to Abbott.

49. Atget to Paul Léon, 12 November 1920, in Leroy, p. [39].

50. Abbott, p. xx.

51. Hambourg, p. 37, note 52.

52. Karl Baedeker, *Paris et ses Environs: Manuel du Voyageur,* Paris: Paul Ollendorff, 1907.

53. Hambourg, p. 39, note 101.

54. Atget to Léon, 22 November 1920, in Leroy, p. [40].

55. A. Dunoyer de Segonzac to Jean Leroy, 10 March 1964, in Leroy, p. [42].

56. Hambourg, p. 35.

57. Atget to Léon, 12 November 1920, in Leroy, p. [39].

58. Atget to Léon, 29 November 1920, in Leroy, p. [40].

59. Leroy, p. [36].

60. Paul Hill and Thomas Cooper, "Man Ray," *Dialogue with Photography,* New York: Farrar, Straus, Giroux, 1979, p. 18.

61. *Ibid.,* p. 18.

62. *Ibid.,* p. 17.

63. Leroy, p. [44].

64. Fernand Bournon, *La Voie publique et son Décor: colonnes, tours, portes, obélisques, fontaines, statues, etc.,* Paris: H. Laurens, 1909.

65. Abbott, p. ix.

66. Calmettes to Abbott, *Ibid.,* p. xii.

67. Leroy, p. [46].

## Notes to Chapter 2

1. Hans Georg Puttnies, *Atget,* exhibition catalogue, Cologne: Galerie Rudolf Kicken, 1980, p. 22.

2. H.J.P. Arnold, *William Henry Fox Talbot, Pioneer of Photography and Man of Science,* London: Hutchinson Benham, 1977, pp. 164–165.

3. C. Nodier, J. Taylor, and A. de Cailleux, *Voyages pittoresques et romantiques dans l'Ancienne France,* vol. 16, [Paris]: Dauphiné, 1854, p. ii.

4. Michael Twyman, *Lithography 1800–1850,* London: Oxford University Press, 1970, p. 236.

5. [Sir David Brewster], in *The Edinburgh Review,* no. 154 (January 1843), p. 332.

6. *La Mission héliographique,* [Paris]: Musée de France, 1980, pp. 15–16.

7. *Ibid.,* p. 17.

8. *Ibid.,* p. 21.

9. *La Lumière,* vol. 1, no. 21 (29 June 1851), p. 82.

10. *La Mission héliographique,* p. 28.

11. [Thomas Sutton], review of Blanquart-Evrard's *La Photographie, ses origines, ses progrès, ses transformations* in *Photographic Art Journal,* London, vol. 1 (1870), pp. 42–43.

12. Isabelle Jammes, *Blanquart-Evrard et les Origines de l'Édition photographique française,* Geneva: Librairie Droz SA, 1981, p. 134.

13. *Ibid.,* pp. 221, 259.

14. Francis Wey, "Des progrès et de l'avenir de la photographie," *La Lumière,* vol. 1, no. 35 (5 October 1851), p. 138.

15. Jammes, p. 58.

16. Francis Wey, "Album de la Société héliographique. Second article," *La Lumière,* vol. 1 (10 August 1851), p. 107.

17. Ernest Lacan, "Exposition universelle. Photographie," *La Lumière,* vol. 5 (22 September 1855), p. 151.

18. _____, "Épreuves photographiques avec ciels," *La Lumière,* vol. 2 (7 August 1852), p. 130. For a discussion of the early history of this technique see the author's "Notes on the Early Use of Combination Printing" in Van Deren Coke, ed., *One Hundred Years of Photographic History,* Albuquerque: University of New Mexico Press, 1975, pp. 16–18.

19. L.D. Blanquart-Evrard, *Traité de Photographie sur Papier,* 1851, pp. 50–51.

20. For a more detailed description of the rôle of pictorial effect in the training of the art student and its impact upon the photographer see the author's *Charles Nègre, 1820–1880,* Ottawa: National Gallery of Canada, 1976, pp. 18–21.

21. Wey, *La Lumière,* 9 February 1851, p. 3.

22. Wey, *La Lumière,* 27 April 1851, p. 47.

23. Wey, *La Lumière,* 9 February 1851, p. 3.

24. Wey, *La Lumière,* 18 May 1851, p. 58.

25. *La Lumière,* 26 June 1852, p. 105.

26. Gustave Le Gray, *Photographie. Traité nouveau sur Papier et sur Verre,* Paris: Lerebours et Secretan, 1852, p. 2.

27. A.R., "Exposition de Londres," *La Lumière,* vol. 1 (28 March 1851), p. 27.

28. Jonathan Richardson, *An Essay on the Theory of Painting*, London: John Churchill, 1715, p. 121.

29. *The Journal of Eugène Delacroix*, trans. Walter Pach, New York: Grove Press, Evergreen Edition, 1961, p. 645.

30. Puttnies, p. 22.

## Notes to Chapter 3

1. John Fraser, "Atget and the City," *The Cambridge Quarterly*, vol. 3 (summer 1968), p. 207.

2. Steven Z. Levine, *Monet and his Critics*, New York: Garland Publishing, 1976, pp. 144–210.

3. *Camera Work*, no. 19 (1907), p. 21.

4. Jean Leroy, "Atget et son temps, 1857–1927," in *Terre d'Images*, vol. 5 / 6, no. 3 (1964), p. 372.

5. A. de Champeaux, "L'Art décoratif dans le vieux Paris," *Gazette des Beaux-Arts*, 1 September 1890, p. 185.

6. *Ibid.*, p. 187.

## Notes to Chapter 4

1. For explanations of the numbering system see M.M. Hambourg in *The Work of Atget*, vol. 1, *Old France*, pp. 154–155, and Barbara L. Michaels, "An Introduction to the Dating and Organization of Eugène Atget's Photographs," *The Art Bulletin*, vol. 61, no. 3 (September 1979), pp. 460–462.

2. Pierre Bost, "Spectacles et promenades," *La Revue hebdomadaire*, vol. 6, no. 24 (16 June 1928), pp. 356–359.

3. Albert Valentin, "Eugène Atget," *Variétés*, vol. 1, no. 8 (15 December 1928), p. 405.

4. Walter Hank Shaw, "What Americans are seeing in Paris," *Arts and Decoration*, January 1929, p. 90.

5. Pierre Mac-Orlan, *Atget: Photographe de Paris*, New York: E. Weyhe, 1930.

6. Berenice Abbott, "Eugène Atget," *Creative Art*, vol. 5, no. 3 (September 1929), pp. 651–656, reprinted in Beaumont Newhall, *Photography: Essays and Images*, New York: Museum of Modern Art, 1980, pp. 235–237.

7. See especially the following:
John Fraser, "Atget and the City," *The Cambridge Quarterly*, , vol. 3 (summer 1968), p. 207.
John Szarkowski, "Atget's Trees," in *One Hundred Years of Photographic History*, ed. Van Deren Coke, Albuquerque: University of New Mexico Press, 1975, pp. 161–165.
_____, "Atget and the Art of Photography," *The Work of Atget*, vol. 1, *Old France*, New York: Museum of Modern Art, 1981, pp. 11–26.

M.M. Hambourg. "A Biography of Eugène Atget," *The Work of Atget*, vol. 2, *The Art of Old Paris*, New York: Museum of Modern Art, 1982, pp. 9–31.
Roberta Hellman and Marvin Hoshino, "On the Rationalization of Eugène Atget," *Arts Magazine*, vol. 56, no. 6 (February 1982), pp. 88–91.

8. Hellman and Hoshino, *op. cit.*

9. William Henry Fox Talbot, "Queen's College, Oxford. Entrance Gateway," *The Pencil of Nature*, London: Longman, Brown, Green and Longmans, 1844, pl. 13.
Francis Wey describes how a study of daguerreotypes with a microscope may reveal secrets that nature herself does not always provide, *La Lumière*, vol. 1, no. 5 (9 March 1851), p. 18.

10. Oliver Wendell Holmes, "The Stereoscope and the Stereograph," *The Atlantic Monthly*, vol. 3 (June 1859), p. 746.

11. Roland Barthes, *Camera Lucida. Reflections on Photography*, New York: Hill and Wang, 1981, p. 25. (Originally published as *La Chambre claire*, Paris: Éditions du Seuil, 1980.)

12. H.P. Robinson, *Pictorial Effect in Photography*, London: Piper and Carter, 1869, p. 18.

# Index

**Prepared by Roy Engfield**

This index covers the contents of Chapters 1 to 4 and the introductory note to the Catalogue. Photographs by Atget are listed under title; all other photographs and works of art appear under the name of the artist. All titles of photographs have been set in **bold italic**. Page numbers in italics refer to illustrations (figures, plates, catalogue). Publications are listed under author as well as title.